Putting the Arts in the Picture

Putting the Arts in the Picture

REFRAMING EDUCATION IN THE 21ST CENTURY

EDITED BY NICK RABKIN AND ROBIN REDMOND

Columbia College Chicago is an urban institution committed to open access, opportunity, and excellence in higher education. It provides innovative degree programs with a "hands-on minds-on" approach in the visual, performing, media, and communication arts to nearly 10,000 undergraduate and graduate students. The only cultural policy center in the nation located at an arts-centered college or university, the Center for Arts Policy at Columbia College Chicago develops knowledge about how the arts contribute to communities and democratic life, and promotes policies designed to enhance the arts' capacity to play those roles.

Copyright © 2004 by Center for Arts Policy at Columbia College Chicago
Published by Columbia College Chicago

Cover Photograph by Scott Fortino

Design by Creative and Printing Services, Columbia College Chicago

For Information:
CENTER FOR ARTS POLICY
COLUMBIA COLLEGE CHICAGO
600 SOUTH MICHIGAN AVENUE
CHICAGO, IL 60605
HTTP://ARTSPOLICY.COLUM.EDU

Printed in the United States of America.
335514941

Library of Congress Control Number: 2004111847
ISBN: 0-929911-11-3

About the Cover

PHOTOGRAPH BY SCOTT FORTINO

This photograph and others by Scott Fortino are included in the Midwest Photographers Project at the Columbia College Chicago's Museum of Contemporary Photography. The Museum's Manager of Education, Corinne Rose, often uses Fortino's images to prompt student writing when schools visit the museum. She writes:

> Scott Fortino's elegant, highly formal, and unpeopled images made in Chicago schools, prisons, and on the lakefront provide enough contextual detail to inspire rich narratives, but also allow students to freely project their own ideas and experiences into the scene. We begin by simply asking students "what do you see?" "What do you think this picture is about?" and "What makes you think that?" We encourage them to notice and talk about details within the picture.
>
> The students love to tell and listen to stories, so toward the end of their visit to the Museum, we typically choose a selection of Fortino's images, hand out paper and pencils, and engage each other in dialogue. The idea of writing a formal essay is intimidating for many of the urban teens with whom we work. Most write below their grade level and are often self-conscious about their writing. I emphasize storytelling rather than grammar and spelling. I encourage the students to write by prompting them to imagine themselves or someone else in the picture and to tell a story about how they got there or what is happening to them. I ask them to observe details in the photograph and imagine other details that a picture cannot show – noises and smells, for instance.
>
> Most kids, even the reluctant writers get absorbed in this exercise, and their teachers often whisper 'I've never seen them all working so hard at writing.' When they have finished, I ask each student to read his or her story aloud. We applaud each writer and use the opportunity to discuss the diversity and similarities of their responses to Fortino's images and their personal experiences.

Rose's approach is a simple but elegant example of how children can learn across the curriculum as they learn in the arts, the subject of this book. We invite you to respond to Scott Fortino's photograph as well. Put yourself in the picture and ask yourself how you got there, how you feel, and what you expect to happen next. Imagine details that are not revealed by the photograph. Ask yourself what the photograph and your story suggest about the schools our children attend.

Table of Contents

Acknowledgements

This book reflects a long effort to think about the arts and education from an interdisciplinary perspective that began within philanthropy. In January 2000, a group of about 150 corporate and foundation grantmakers in education, child development, and the arts gathered at the J. Paul Getty Trust in California with the explicit purpose of escaping their silos and exploring common ground between programs interested in strengthening educational and developmental opportunities for young people and programs that supported the arts and culture. *Learning and the Arts* found enormous potential in an interdisciplinary approach to education that made the arts a central element. Presenters at that conference including Elliot Eisner, Shirley Brice Heath, Rudy Crew, Steve Seidel, James Catterall, Dick Deasy, and Ken Robinson laid much of the intellectual foundation for this book. We owe them a great deal. Together they raised the next question: how could the potential of the arts be activated broadly for children in schools and communities across the country? (Conference proceedings are available online at http://giarts.org/pdf/Learning.pdf)

That question motivates the *Learning and the Arts* initiative of the Chicago Center for Arts Policy at Columbia College Chicago. It is a question that has resonance for a much broader spectrum than the funders at the initial conference. It has resonance for all who have an interest and a stake in improving American

education and chances for our young people.

Our efforts have been supported by the interest, wisdom, intelligence, generosity, and enthusiasm of many people, beginning with the funders of the original conference, the J. Paul Getty Trust, the Geraldine R. Dodge Foundation, and the John D. and Catherine T. MacArthur Foundation. Each of them has provided support for our continuing work. J.P. Morgan Chase Foundation has provided additional generous support.

We extend our deepest appreciation to writers Dan Weissmann, Madeleine R. Grumet, Michael Wakeford, Shirley Brice Heath, and Sir Ken Robinson who have shared their extraordinary insights and understanding of how the arts improve education for children in schools and communities, why they work, and the cultural, historical, and political landscape that shapes and limits the arts within education.

Irma Friedman, Victoria Malone, and Fred Fine, our colleagues at the Chicago Center for Arts Policy, have been selfless in their support and abiding interest in our work on *Learning and the Arts* and this publication. Sadly, Fred passed away this year, but his abiding faith in the relationship of creativity and democracy lives on. We thank them and graduate assistants Chou Ming Chia and Meghan Van Wyck, and intern Meghan Savage for their help along the way.

An outstanding and talented group of researchers, practitioners, policymakers, and funders have served as key advisors in the development of this book. They guided us and challenged us to understand the historic tension between education and the arts. They urged us consistently to turn the next corner, ask the next question, and take on issues beyond our comfort zone. Then they helped us find pathways through our confusion. We are especially grateful to Arnold Aprill, executive director of the Chicago Arts Partnerships in Education (CAPE); Paul Goren, vice president of the Spencer Foundation; and Larry Scripp, director of the Research Center for Learning Through Music at the New England Conservatory of Music. We also thank Liora Bresler, professor of Education at the University of Illinois at Urbana Champaign; Gail Burnaford, chair and associate professor of Education at Florida Atlantic University; Elisa Callow, program director for the Irvine Foundation; James Catterall, professor of Education at the University of California, Los Angeles; Ross Danis, program director, Education at the Geraldine R. Dodge Foundation; Howard T. Everson, vice-president of the College Board; Susan Goldman, professor and co-director of the Center for the Study of Learning, Instruction and Teacher Development at University of Illinois at Chicago; Thora

Jacobson, director of the Samuel S. Fleisher Art Memorial; Leonard Lehrer, dean of the School of Fine and Performing Arts at Columbia College Chicago; Vincent Marron, executive director of the A+ Schools Program; Charles Payne, professor of History, African American Studies and Sociology at Duke University; James W. Pellegrino, professor and co-director of the Center for the Study of Learning, Instruction and Teacher Development at the University of Illinois at Chicago; Judith Rényi, executive director of the NEA Foundation for the Improvement of Education; Diedre Searcy; Steve Seidel, director of Harvard University's Project Zero; Kathleen Straus, president of the Michigan State Board of Education; Robert Stake, professor of Education at the University of Illinois at Urbana Champaign; Carlos Tortolero, executive director of the Mexican Fine Arts Museum; Steven Tozer, professor of Policy Studies at the University of Illinois at Chicago; Kim Alan Wheetley, director of the Southeast Center for Education in the Arts; and Connie Yowell, program officer for Human and Community Development at the MacArthur Foundation.

Columbia College Chicago is an urban liberal arts college with a focus on the arts and media. It has a great stake in the communities and schools from which its students come, and as an arts-oriented college, it has a particular stake in advancing the place of the arts in education. It has been a truly generative atmosphere for our work. We are particularly grateful for the faith and support we have received from President Warrick L. Carter and Provost Steve Kapelke, who are responsible for creating the college's dynamic and creative environment. Cynthia Weiss, Amanda Lichtenstein, Tricia Hersey, Daniel Lopez and other artists who work in Arts Integrated Mentoring (AIM), Columbia College Chicago's arts integration program in eight Chicago elementary schools, have been a source for great ideas and inspiring stories. Several others affiliated with Columbia assisted with the development of the manuscript, and offered thoughtful critiques that prompted important improvements: Cheryl Johnson-Odim, dean of Liberal Arts and Sciences; Carol Anne Stowe, director of Early Childhood Education; Jo Cates, dean of the library; and Corinne Rose, manager of education of the Museum of Contemporary Photography.

Dan Weissmann's memorable accounts of inspiring arts education programs could not have been written without the help and generosity of Judy Hornbacher, former director of the Minneapolis Public School District's Arts for Academic Achievement program; Debra Ingram, principal investigator at the Center for Applied Research and Educational Improvement at the University of Minnesota;

Melinda Russo and Scott Sikkema from the Chicago Arts Partnerships in Education; Kassie Davis, director of the arts and culture program at the Chicago Community Trust; Hardy Schlick; principal Tamara Witzl and the staff and students of Telpochcalli Elementary School in Chicago; Raphael Estrella; principal Bernadette Butler, teachers Jim Kirk, Steve Lutz, Dave Rench, and the staff and students of Agassiz Elementary School in Chicago; Jacqueline Russell, executive director of the Lookingglass Theater Company; Chris Fisher and the staff and students of Southwest High School in Minneapolis; Laura Wiley and David Feiner, and the young members of the Albany Park Theater Project; Susan Rogerson and the members of Artists for Humanity; and the staff and students of the Conservatory Lab Charter School in Boston.

Similar generosity was extended to Madeleine Grumet by Nancy Carstedt, Jen Yourist, Nick Jaffe, and the staff and students at the Chicago Children's Choir Academy; Aric Arnold, Lauri Malee, Angie Phiefer, Tricia Rowland, Andy Wang, and staff and students at the Hawthorne School in Chicago; poet Anna West and the staff and students at Spry Academy in Chicago; and Tomás Revollo, Amy Vecchioni, Linda Garcia, and the staff and students at Waters School in Chicago.

Many other individuals welcomed and encouraged our inquiries, and have provided invaluable intelligence and insight along the way: David Perkins, former Co-Director of Harvard University's Project Zero; Mark Turner, interim chair, Department of Cognitive Science at Case Western Reserve; Robert Root-Bernstein, professor, College of Natural Science at Michigan State University; Robert Horowitz, Teachers College of Columbia University; Betty Jane Wagner, professor in the College of Education at Roosevelt University; Victoria Chou, dean of the College of Education at University of Illinois at Chicago; John Kreidler, executive director of Cultural Initiatives Silicon Valley; Terry L. Baker, senior research scientist at the Education Development Center; George Noblit, director of Evaluation, Assessment & Policy Connections at the University of North Carolina, Chapel Hill; and Lawrence Zbikowski, associate professor of Music at the University of Chicago.

Nick Rabkin and Robin Redmond
July 2004
CHICAGO CENTER FOR ARTS POLICY
COLUMBIA COLLEGE CHICAGO

Learning and the Arts

NICK RABKIN

In the fall of 1987, Chicago teachers struck for the ninth time in eighteen years. When the bitter strike was settled, the city's first African-American mayor, Harold Washington, pledged to develop a new plan to fund and improve the schools within three months, and invited grassroots activists to join an education summit. Washington died just a month later, but school reform had arrived on the Chicago political agenda. A week after the Mayor's death, education secretary William Bennett branded Chicago's school system the nation's worst, making it politically impossible for Washington's successors to duck the issue.

In less than a year, reform legislation was passed in the state capital. Elected councils of teachers, parents, and community members were given authority in every school to hire principals, manage budgets, and write school improvement plans. Many hoped this new energy would lift the dead hand of bureaucracy from the schools, allowing a multitude of committed educators and creative community leaders to reinvent education in Chicago. They hoped reform would improve the prospects of a student body that was largely poor, just ten percent white, and more often than not dropped out before completing high school. They believed it would reverse decades of benign and malign neglect, organizational chaos, corruption, financial disinvestments, and educational sclerosis. That was a tall order.

By 1991, when I joined the staff of the John D. and Catherine T. MacArthur

Foundation, Chicago had a national reputation for dynamism in school reform. It was a beacon of hope and possibility for thousands of communities that, like Chicago, were failing to educate a large proportion of their students. National and local foundations were providing significant financial support to the school reform movement in Chicago, and MacArthur made a long-term commitment to support reform-oriented policy work, grassroots advocacy, and interventions in schools themselves.

I was MacArthur's senior program officer for the arts. MacArthur took a particular interest in sustaining the cultural vitality of its home city. Education in the arts is, of course, a critical element of a sustainable cultural system, so promoting arts education was part of my job. I quickly understood that the reform movement was the impetus for change in the schools. If the movement didn't embrace arts education, I could not succeed.

THE ARTS AND THE HIERARCHY OF EDUCATIONAL NEED

Grassroots efforts to improve Chicago schools began with an African-American student boycott in 1963. 70 percent of Chicago's African-American students protested the deplorable conditions of their schools. By the 1980s, reformers in Chicago and across the country had established that urban systems generally were failing to meet the needs of their students, particularly their low-income students. Alarming proportions of children and young people were not learning to read, write, and compute competently. They were disengaged from education and failing to develop essential discipline and good work habits. They were not developing higher order skills—the ability to problem solve, think creatively and critically, communicate clearly, and work in teams—that were of growing importance in the changing economy. Urban districts across the country had disinvested in systems that served children who were largely poor and minority. They were failing to maintain and modernize old, overcrowded buildings and introduce new technologies.

These needs became the highest priorities of school reform in districts across the country, and arts education competed with them. In low-income districts like Chicago, there was not enough money in the budget for everything. Arts education was not a priority for policymakers faced with tough choices. Chicago stripped its elementary schools of all art and music teachers during a structural financial crisis in 1979, precisely because art was viewed as something separate from academic improvement. I wanted to know if evidence existed that challenged this

prevailing view. Learning in the arts would matter to reformers and education policymakers only if it had effects that "transferred" to their priorities. I wanted to know if there were approaches to arts education that made it relevant to general education improvement in schools like Chicago's, and if the arts could be reconciled with reform. Arts education would remain on the margins of educational policy until, and unless, reformers and policymakers of all races were convinced it could contribute to changing the norm of student failure that characterized so many schools and districts.

MacArthur's education program director and I looked for educational research that indicated evidence of transfer. We found some suggestive studies, and we identified scattered schools and projects that believed their commitment to arts education had made a big difference to students. We thought it was significant that these schools often described their work in terms that linked arts education with broader learning goals. They sometimes called their approach "integrated arts education" because it strategically linked learning in an art form to learning across the curriculum. But we agreed that the evidence was anecdotal and not compelling enough to convince a skeptical school reform community; we did not yet clearly understand the contours of integrated arts education. When we were invited to collaborate with the General Electric Fund to support studies that might build a more compelling case, we signed on.

NEW EVIDENCE OF VALUE

The Arts Education Partnership published reports on those studies in a collection called *Champions of Change: The Impact of the Arts on Learning* (Fiske, 1999). *Champions* opened with an analysis (Catterall, Capleau & Iwanaga, 1999) of a large database assembled by the Department of Education. It showed that low-income students who were high arts participators did better in school and in life than peers who were low arts participators. Another study (Seidel, 1999) showed how the production of a high school Shakespeare festival under the direction of theater professionals transformed the classic plays from an educational ordeal into a challenging adventure for students. Another (Heath with Roach, 1999) showed that after-school arts programs had significantly more positive effects on low-income youth than did high-quality sports or community service programs. Low-income youth in after-school arts programs did better across a wide range of variables from school grades to leadership. Yet another (Burton, Horowitz & Abeles, 1999) found evidence that transfer occurred in schools that evoked arts-related competencies in

other subjects, arguing that transfer is a far more dynamic and complex phenomenon than the conventional notion of a linear connection between prior learning and new problems.

One study (Catterall & Waldorf, 1999) was of particular significance. It observed that standardized test scores were rising faster in Chicago schools participating in an arts integrated program than in comparable schools that did not practice arts integration.

Seven studies are a mere drop in the ocean of education research. But the significance of these studies is heightened by findings in three that implicate the arts in improving educational outcomes for low-income students, where the needs are the greatest. Chicago schools suffered deeply from a constellation of problems typical of urban systems serving large numbers of low-income and minority students. If Chicago schools improved because of an arts education program, that program's work had national significance.

ARTS INTEGRATION: A CHANGE STRATEGY

This volume hopes to augment *Champions* (Fiske, 1999) by further exploring the role of the arts in education and learning and by thinking through the implications of this connection for educators, artists, policymakers, parents, and philanthropists. It disaggregates arts integration from conventional arts education, and examines its features as a pedagogical strategy, how and why it works, its educational and developmental benefits, and the challenge of making it available widely in schools and in after school programs.

We are in a position to extend this research because over the last fifteen years or so, a dedicated group of artists, educators, and researchers has developed arts integration far beyond the work and research we examined in the early 1990s. Serious evaluation studies completed in the last few years now provide strong answers to the questions raised then: There is transfer. Students make substantial gains in the basics. Students become better thinkers, develop higher order skills, and deepen their engagement and their inclination to learn. Arts integration's effects are significant for all kinds of students, but they may be most substantial for low-achieving students.

What is the strategy? At its best, arts integration makes the arts an interdisciplinary partner with other subjects. Students receive rigorous instruction in the arts and thoughtful integrated curriculum that makes deep structural connections between the arts and other subjects. This enables students to learn both deeply.

The practice of making art, and its performance or exhibition, becomes an essential part of pedagogy and assessment, but not just in art or music class. These activities become part of the routine of studying history, science, reading and writing, and math.

Much learning occurs outside school, of course. We see principles of arts integration at work in non-school programs as well. The best of these programs consistently offer collaborative performances and exhibitions of student work to public audiences as an authentic cultural resource, but approaches to instruction vary. Some provide rigorous instruction in a pre-professional, quasi-conservatory environment. Many don't provide instruction in the conventional sense at all, but embed learning in the production of the artwork. Students in these programs take on the responsibilities and the risks of being cultural producers, not just cultural consumers.

Integrated arts education is not arts education as we generally think of it. It is designed to promote transfer of learning between the arts and other subjects, between the arts and the capacities students need to become successful adults. It is designed to use the emotional, social, and sensory dimensions of the arts to engage students, and leverage development and learning across the curriculum. It is designed to amplify learning in the arts by escaping the confines of formal aesthetic and technical instruction. It connects the content of art to students' personal experiences and their need to make meaning from the world. Arts integration does not conform to any of the stereotypes of arts education. It requires serious engagement and learning in the art form and broadens the "arts for art's sake" focus of conservatory education. It makes creative production a core practice and value, and rejects the standards-free, non-cognitive approach of creative expression or recreation. We might call it the arts for learning's sake.

There should be no question about whether the arts belong in the curriculum and in children's lives. There should be no question that if we want to maximize the power of arts education—cognitively, socially, and emotionally—if we want to meet the challenges of students in low-income and low-performing districts like Chicago, arts education must be integrated.

But questions remain. Arts integration has been practiced in a just a few corners of the education universe. Few education policymakers have seen these programs at work, and scholarly evaluations of the programs are easily lost in the mountain of education reports, research, and policy discourse. The prevailing sense of what is important in education still demands answers of arts integration: Does

integrated arts education contribute to learning the basics, to improving student engagement with education in general, and to developing higher order thinking, particularly for those children who are farthest behind or likely to fall back? Some might ask if arts integration is a more likely path to significant improvements than, say, more creative instruction in the sciences or social studies.

SHOW AND TELL

The first task of this volume is to show that integrated arts education is an effective strategy for improving education and learning. In the opening chapter, veteran education journalist Dan Weissmann chronicles what he saw and learned from visits to arts integrated programs in Chicago, Minneapolis, and Boston—during and after school hours. Weissmann describes lessons that integrate the visual arts and science, drama and reading, filmmaking and social studies, and music and math, in typical schools in these urban districts. He shows clearly how these lessons operate on multiple levels, promoting student engagement, greater mastery of reading, writing and math, and higher order thinking. He shows that students with enormous learning challenges may be their biggest beneficiaries. He shows how, once arts integration takes root, it can transform learning, the lives of individual students, and the belief systems and culture of a school—the purposes of school reform. And he shows that the choice that must be made by educators is not between arts integration and creative instruction in science or social studies. Rather, he shows that arts integration is a pathway toward more creative instruction in all subjects.

Weissmann's narrative and cited research make it obvious that arts integration has enormous power, but there are two reasons we need to know more. First, skeptics will have every right to continue saying that we are presenting anecdotal evidence, and that the research shows correlations between arts integration and outcomes, not causality. Short of formal proof of causality, which is a rare phenomenon in education research, we need a plausible explanation of why arts integration is the most likely cause of some deeply valuable outcomes in education. Second, such an explanation can make an important contribution to the practice of arts integration. A good theory will be informed by the practice and make it more effective.

New thinking about cognition has deepened our understanding of how we learn, and our capacities to think and behave intelligently (Bransford, Brown, Cocking, Donovan & Pellegrino, 2000; Eisner, 1998; Gardner, 1983; Fauconnier & Turner, 2002; Perkins, 1992; Root-Bernstein & Root-Bernstein, 2001).

Curriculum scholar Madeleine Grumet, who has been the dean of education schools at Brooklyn College and the University of North Carolina at Chapel Hill, is informed by these theories, and adds a new perspective in chapter two. She carefully examines concrete arts integrated lessons, observing how children participate in them, and the ways artists and teachers link the content of arts learning to learning in other subjects. She shows how these lessons admit the child's world into the curriculum, how arts content engages children's sensory and emotional experiences and understanding, and how the structural analogies between art and other subjects are exploited to activate transfer. Grumet calls attention to the careful planning, diligent reflection, and playful execution of effective lessons, demonstrating that integration restores art to teaching in multiple ways.

Grumet's perceptive analysis shows that arts integration has deep connections to sustained currents in American education. In particular, it draws on the educational philosophy of John Dewey and on traditions of constructivist and progressive education. Historian Michael Wakeford picks up this thread in chapter three. He traces the pendulum swings of the currents shaping and criticizing schools, education, and the arts themselves, that, in turn, have shaped the case for arts in the curriculum. Sometimes advocates emphasized practical, vocational, and skills-based justifications for arts education. Sometimes they emphasized cultural justifications and focused on moral development, social harmony, and order. Sometimes they emphasized the perspective of individual development, the construction of knowledge, self-knowledge, and creativity. And sometimes they stressed the historical value of great art and the rigors and standards of learning in the arts themselves. As education reform gathered power in the closing years of the twentieth century, a new imperative to provide quality education to all American children emerged. Arts integration has been a practical and creative response to the dual challenge of establishing a secure place for the arts in the curriculum and of successfully educating all children.

The education crisis in the United States is not unique. In fact, it is rather typical. Shirley Brice Heath, a distinguished linguistic anthropologist and researcher, and Sir Ken Robinson, an internationally renowned expert on knowledge and creativity, have spent a great deal of time over the last two decades studying and working with youth arts programs in the United States and abroad. They remind us that global changes in western and developing nations have had detrimental and destabilizing affects on institutions that serve young people, and that children and young people are finding it necessary to quickly adapt, sometimes

without the benefit of stable adults. As if instinctually, young people in utterly desperate situations are turning to the arts as an adaptive strategy, and as an instrument of change. Heath and Robinson suggest that adults would do well to follow the intuition of young people struggling to develop new skills and knowledge, self-discipline, and other qualities broadly understood as essential to a democratic citizenry, a quality labor force, and a collaborative global community.

CLOSING THE GAP

In 1971, the average elementary school student received about two hours of art or music instruction a week. Thirty-one years later, the average elementary school student in Chicago received just 45 minutes of weekly instruction in the arts. Arts education has been comprehensively eroded in low-income districts, but is better established in affluent districts, and it is a core value in the country's most elite private schools. This suggests an enormous "arts gap" in American education. The 1990s saw vigorous efforts to reverse the long-term decline of arts education. Some of those efforts were quite ambitious and sensitive to the broad currents of school reform. Several of these supported serious assessment and evaluation components. Our final chapter begins with an exploration of the evaluation findings of six of these ambitious arts education programs. Three were expressly organized around the principles of arts integration. In three others, arts integration played a subordinate role in efforts to restore or introduce rigorous standards-based arts instruction to schools. While the methods and purposes of the studies varied widely, there is little doubt that the integrated programs had significantly greater affect on student achievement, teacher practice, and school culture than the standards-based programs. The implications of this finding are clear: schools, districts, and communities struggling to close the achievement gap are well served by arts integration, and arts education advocates who hope to close the arts gap would be wise to support arts integration as a strategy.

The resiliency of the education system's dysfunction has been one of its defining characteristics for a hundred years. Promising ideas about how to reform American education litter education history. Arts integration has yet to prove itself at a scale approaching the enormity of our education problems. There is a real danger that, like other promising reform strategies, it will be isolated in a few "special" locations, or its potency diminished as it spreads across schools and districts.

So, we conclude with hopeful ideas—building on actual practices of contemporary integrated arts projects—about how arts integration can become avail-

after school programs—can help

able to more students, more schools, more districts, and more communities, even in the current climate of high stakes testing and accountability. We begin by suggesting the development of integrated arts education initiatives, like those in Minneapolis, Chicago and elsewhere, in districts across the country. We see roles for charter schools and cultural organizations. We see a strategic role for private philanthropy, which has been essential to the development of integrated arts education thus far. We argue for the development of training, and professional development for teachers and teaching artists; we call for the development of networks that link them with researchers. We look toward the development of policies at the state and federal levels that will support and sustain arts integrated practices in schools; we suggest the potential of pre-service training for teachers through schools of education.

We harbor few illusions about the potential of the integrated arts. It cannot resolve all our educational woes. We know that high quality integrated arts education is a strategy that requires hard work and long commitments from educators and policymakers in a political culture that is demanding short-term results. In the end, arts integration will not make a very significant difference unless there are broader changes in the culture and politics of education and schooling in America.

Integrated arts education is a strategy that is within reach for many and perhaps most, schools, districts, and communities. It works because it keeps the focus of change on learning, which is where it belongs. Given the proper support, incentives, and time, it has profound benefits that a wide spectrum of reformers can agree on. It can contribute to the broader cultural changes necessary for deep improvement in American education. For those who know that there is no silver bullet, integrated arts represents a serious strategy for improvement and change. That is more than enough.

REFERENCES

Burton, J., Horowitz, R., & Abeles, H. (1999). Learning in and through the arts: Curriculum implications. In E. B. Fiske (Ed.), *Champions of change: The impact of the arts on learning*. (Available from the Arts Education Partnership, One Massachusetts Avenue, NW, Washington, DC 2001, http://www.aep-arts.org/PDF%20Files/ChampsReport.pdf.)

Bransford J. D., Brown, A. L., Cocking, R. R., Donovan, M. S., & Pellegrino, J. W (Eds.) (2000). *How people learn: Brain, mind, experience and school.* Washington, DC:National Academy Press.

Catterall, J. S., Capleau, R., & Iwanaga, J. (1999). Involvement in the arts and human development. In E. B. Fiske (Ed.), *Champions of change: The impact of the arts on learning*. (Available from the Arts Education Partnership, One Massachusetts Avenue, NW, Washington, DC 2001, http://www.aep-arts.org/PDF%20Files/ChampsReport.pdf)

Catterall, J., & Waldorf, L. (1999). Chicago Arts Partnerships in Education: Summary evaluation. In E. B. Fiske (Ed.), *Champions of change: The impact of the arts on learning*. (Available from the Arts Education Partnership, One Massachusetts Avenue, NW, Washington, DC 2001, http://www.aep-arts.org/PDF%20Files/ChampsReport.pdf)

Eisner, E. W. (1998). Does experience in the arts boost academic achievement? *The kind of schools we need* (p. 96). Portsmouth, NH: Heinemann.

Fauconnier, G., & Turner, M. (2002). *The way we think: Conceptual blending and the mind's hidden complexities.* New York, NY: Basic Books.

Fiske, E. B. (Ed.). (1999). *Champions of change: The impact of the arts on learning.* (Available from the Arts Education Partnership, One Massachusetts Avenue, NW, Washington, DC 2001, http://www.aep-arts.org/PDF%20Files/ChampsReport.pdf)

Gardner, H. (1983). *Frames of mind: The theory of multiple intelligence.* New York, NY: Basic Books.

Heath, S. B., with Roach, A. (1999). Imaginative actuality. In E. B. Fiske (Ed.), *Champions of change: The impact of the arts on learning*. (Available from the

Arts Education Partnership, One Massachusetts Avenue, NW, Washington, DC 2001, http://www.aep-arts.org/PDF%20Files/ChampsReport.pdf)

Perkins, D. (1992). *Smart schools: From training memories to educating minds.* New York, NY: The Free Press.

Seidel, S. (1999). Stand and unfold yourself. In E. B. Fiske (Ed.), *Champions of change: The impact of the arts on learning.* (Available from the Arts Education Partnership, One Massachusetts Avenue, NW, Washington, DC 2001, http://www.aep-arts.org/PDF%20Files/ChampsReport.pdf)

Root-Bernstein, R., & Root-Bernstein, M. (2001). *Sparks of genius: The 13 thinking tools of the world's most creative people.* New York, NY: Mariner Books.

1

You Can't Get Much
Better Than That

DAN WEISSMAN

At Mark Sheridan Elementary School in Chicago, Jennifer Gilbert's fifth-grade students are buzzing. "Hardy!" they murmur as they quickly take their seats. Tall and slim, with a slight stoop, Hardy Schlick stands at the front of the room wearing casual, practical clothes in shades of gray and beige that match the heavy blocks of clay he has brought with him. It's as if years of working with clay has caused him to blend in with it. His close-cropped hair, graying around the edges, completes the effect.

Schlick, a sculptor and teacher from the Hyde Park Art Center, speaks quietly, but the children hang on his words. "OK, what I'm doing is cutting up clay right now," he says. "It's going to take a couple of minutes." He recruits a few eager helpers to pass out newspaper to cover the school desks while he finishes his preparations.

Today's lesson will be one part art workshop, one part science demonstration. The students have been studying force, motion, and states of matter, and today they'll get a chance to put their knowledge to work, using clay and marbles. In the next 90 minutes, each student will build a small clay sculpture that can support at least one glass marble. When the pieces are fired, the marbles will melt—changing states from solid to liquid—at which point gravity will pull the melted glass down across the surfaces the clay presents to it. The aesthetic challenge is to design the

sculpture so that the melted marbled glass forms interesting patterns. The practical restriction is that the sculpture needs to form an effective container for all of the melted glass. If any of it spills, it could ruin the kiln. He checks in with the kids, asking if they have any questions. Just one, "Are you going to limit us to how much clay we can use?"

The kids have prepared designs on paper, and Schlick reminds them that the transition from a two-dimensional drawing to a three-dimensional sculpture will be a challenge. "Sometimes your ideas may change once you start working, and that's OK," he tells them as he distributes clay and a few tools—rollers, cloths, picks. "The drawing you made on the page is just something to get you started." As eager as the kids are, many of them find the project a challenge, and some very ambitious designs—like racing cars and mountainscapes—get scaled back, as the students struggle to work the clay into the shapes they want. In practice, the most popular designs resemble a playground slide, but with some help from Schlick, one girl does manage to pull off an impressive temple-like structure with a hole in the center of the ceiling, which is supported by eight clay columns rather than walls. Another manages a platform shoe. By 1:30 p.m., everyone has finished a sculpture and strategically placed their marbles. Next week they'll take a field trip to the Hyde Park Art Center to collect their fired pieces.

This elegant, seemingly self-contained lesson has deep roots. Hardy Schlick has been visiting Sheridan Elementary for almost ten years. When these students were in the first and third grades, Schlick led a longer series of workshop lessons with them, which explains why they were able to leap directly into sculpting their pieces with a minimum of coaching. This lesson reflects hours of planning time between Schlick and the Sheridan teachers, time spent carefully searching for ways that children's explorations of science and art making can enrich, deepen and extend each other.

Educators call the approach of arts and academics being taught together, with each reinforcing the other, "arts integration." Its advocates insist that it is not a replacement for traditional arts education, not just a way to squeeze the arts into time- and cash-strapped schools. Rather, arts integration presents itself as a strategy for engaging students more fully with the traditional academic curriculum, improving achievement without stinting aesthetics. In this case, students are testing their newly acquired scientific knowledge—about states of matter, gravity, and motion—by putting that knowledge to work in the service of creating sculpture.

The Chicago Arts Partnerships in Education (CAPE) has supported Hardy

 \
…ick's work at Sheridan for a decade. As the organization's executive director Arnold Aprill puts it, "Having an artist work in a classroom pushes teachers and the artists to tolerate the creative frustration of working together so they can both grow beyond their comfort zones." CAPE has emerged as a leader in arts integration, learning to find "the elegant fit" between the arts and academics, and developing lessons and units across the curriculum in which each set of practices adds to and deepens the other. Some of the resulting collaborations produce synergies so elegant that they seem like a simple application of common sense. The clay and marbles experiment at Sheridan is one example. Another is the case of a theater artist and a high school French teacher whose students perform improvisational comedy in French as part of their final exams.

Other teacher-artist teams come up with projects of dazzling complexity, like the archaeology project that teachers at Walsh Elementary School cooked up with artists from Pros Arts Studio. Sixth-graders studying the American Southwest visited a natural history museum to research art and social structures of the Anasazi Indian tribes. Back at the school, they used their sketches from the museum visit as a basis for dioramas reconstructing the village buildings, and they made pottery in the style of pieces they had seen at the museum. Then they smashed their pots, buried them in a specially created sandpit in a park field house, and commissioned a fourth-grade class to set up an archeological "dig" in the basement. The fourth-graders analyzed their finds and created their own archeological display.

CORPORATE MERGERS AND CURRICULAR ACQUISITIONS

CAPE owes its existence to corporate mergers and acquisitions, as the group's founding board president, Kassie Davis, tells the story. In 1990, the Minneapolis-based department-store chain Dayton-Hudson bought Chicago retailer Marshall Field's, and Davis found herself pushed out of her job as Vice President for special events and PR at Field's, a function her new employers already had covered at the home office in Minnesota. Davis was offered a job heading public affairs—a bailiwick that included corporate giving—so as one of her new tasks, she started a corporate contributions program, using the new parent company's guidelines. One of Dayton-Hudson's areas of interest was arts education for schoolchildren, and Davis went to work soliciting proposals.

She got 150 responses from arts organizations in Chicago, proving that there was an abundance of arts organizations that wanted to work in the schools. "Even as a novice, it was obvious to me that there was a lack of standards and quality

among the proposals," Davis recalls. Most were for "exposure" or "enrichment" experiences—in-school performances and field trips to matinee performances or museums—"kind of a one-shot deal," as Davis notes. "When you did a site visit and you asked the people at the organization, 'What are the students learning?' or 'How do you measure what the students are getting out of this?' They would say, 'It's the smiles on their faces after they leave the building,' or 'It's all the thank-you notes we get.' Maybe it was my background as a business person—I was used to measuring outcomes—but it seemed to me that there had to be a better way."

Davis started brainstorming with colleagues at other Chicago-area foundations, and she started looking for guidance. She noticed that two programs Dayton-Hudson funded in other cities "seemed light-years ahead" of the run of proposals, and that New York-based consultant Mitchell Korn was involved in both projects. She wound up commissioning Korn to do an extensive study of arts education in Chicago, including dozens of interviews at local schools and arts organizations over a 9-month period.

Korn found that exposure programs were all that was available in most of the system's 600 schools. They were generally popular—students and teachers enjoyed them—but they rarely had much relevance to what the students were studying in regular classes, because they were organized around the educational goals of the "providers," not the schools. Theaters did educational programs on the plays they produced and museums did educational programs on their exhibitions, but these were rarely connected with the curriculum the students were learning in class, and they were not designed to be sequential or comprehensive.

School leaders did not see how they could do more, though. Most art and music teachers had been laid off in the late 1970's in the wake of a deep financial crisis, so the schools lacked the human resources to teach the arts. And there was little flexibility in school days already over-scheduled with mandates and requirements. The arts didn't fit. "To me, the key challenge was changing the paradigm from pre-packaged exposure programs to programs designed to meet the needs and interests of the schools, programs that were sensitive to schools' limits and the pressures they were under," says Davis. "From a business point of view, I was interested in developing an approach that was driven by the needs of the customers, in this case the schools, not the needs of the producers."

Korn recommended that arts organizations become long-term partners with schools. They would help address the human resources issue by providing teaching artists to work with classroom teachers on a sustained basis. He recommended that

CAPE act as a matchmaker between schools and arts groups, a source of guidance and training for partnerships, and a clearinghouse for money to pay for the collaborations. What most distinguished CAPE from exposure programs, though, was that artists and teachers would integrate the arts into the regular academic curriculum as a strategy for fitting the arts into the school day. "CAPE broke ground by involving the classroom teacher from the beginning," says Davis. Teachers couldn't treat the artists' time as a break, and artists were called upon to help address the fundamental challenges in a big urban system where most schools are low-income and low-performing. The joint work would ensure real integration with the traditional academic curriculum, both during and after the artist's time in the classroom. "When the artist left," notes Davis, "the teacher had knowledge and skills to continue these kinds of lessons with their students." Ultimately, it was hoped, these partnerships would transform teaching across entire schools, which might lead the way to system-wide reforms. Chicago had begun a large-scale reform effort in 1987 based on the idea of bottom-up innovation from individual schools, and CAPE hoped to help lead the charge.

After a national search for an executive director, they chose Aprill, a talented director in the city's vibrant theater scene who had also worked for years as a teaching artist in area schools. By late 1992, Davis and a half-dozen other local funders had come up with the money for a six-year demonstration project and solicited proposals from teams of schools and arts organizations. Nearly a third of Chicago's public schools and nearly a hundred arts organizations submitted dozens of funding proposals for partnerships. The 14 that made the cut included schools from across the city and some of the city's top theaters, arts studios, and universities. Those partnerships spent the 1993-94 school year planning and developing their programs, which were rolled out in full the following year.

The founders' initial hope—that after six years of privately funded work, the Chicago Board of Education would adopt CAPE's program as its own, and expand it to serve more schools in need of innovative and effective improvement strategies—didn't come to pass. Those six years saw three superintendents and dramatic shifts in school policy, making it difficult to form lasting alliances with decision-makers. "You could try to achieve buy-in from whomever was there," says Davis, "and then six months later they'd be gone and you'd have to start over." Individual schools committed substantial amounts of funds under their discretionary control, but CAPE remains largely privately funded today.

Though CAPE was not adopted by the Board of Education, it has had broad

influence. Some arts organizations, like Free Street Programs, have adapted CAPE's approach in other schools. When the Board launched a program allowing some neighborhood elementary schools to become quasi-magnet schools—to select a thematic identity and orientation for their improvement efforts—more than fifty of the district's 500 elementary schools chose the arts as their focus. In 2003, the Board gave planning grants to 25 more schools that wanted to use arts integration as a strategy for academic improvement, and selected CAPE to provide professional development to teachers in all those schools. Reading in Motion, which uses a tightly focused approach that links skills in the performing arts to literacy skills in primary grades in dozens of schools. Columbia College Chicago, Chicago's largest arts college, is implementing sophisticated arts integration strategies to improve literacy at eight of the city's poorest performing elementary schools through its Arts Integration Mentorship Project (Project AIM). The Chicago Teachers Center of Northeastern Illinois University has been independently supporting the development of long-term arts integrated partnerships in schools across the city.

After a decade, arts integration has become a strategy for school improvement in close to a quarter of the elementary schools in the nation's third largest school district. These developments are the outcome of a steady string of successes and recognition for the work of CAPE and others. Some of these successes were artistic, in that students created works of genuine value. "I believe that a lot of our arts integrated work is just as challenging, brilliant, and formally beautiful as the hottest artists at the Museum of Contemporary Art right now," says CAPE's program director Scott Sikkema. The organization has backed up that belief by organizing public exhibitions and performances of student work—poetry and prose, visual art, music, theater, and video. CAPE schools and arts partners have displayed student work in major galleries and museums, including the MCA.

Some of CAPE's successes are the kinds that are measured by tests taken with a number-two pencil—the kind education policymakers take seriously. When UCLA professor James Catterall studied changes in academic achievement during CAPE's first six years, he found that CAPE schools tended to improve significantly faster than non-CAPE schools that served demographically comparable student populations (Catterall & Waldorf, 1999). Between 1993 and 1998, in one dramatic example, the number of sixth graders at CAPE schools with reading scores in the average-to-above-average range had grown six percentage points more than at comparable schools. CAPE schools had grown almost twice as quickly on this measure.

THE ARTS ADVANTAGE FOR DISADVANTAGED LEARNERS

One of the schools that shows the arts advantage most dramatically is Telpochcalli, a small public elementary school started in the early 1990s by a group of idealistic teachers. Telpochcalli serves a neighborhood called Little Village, which has one of the city's highest concentrations of Mexican-Americans. You can count the non-Latino kids at Telpochcalli on the fingers of one hand, and all but a few of the school's students qualify for free or reduced-price lunch programs, the standard index of poverty in schools. A large majority of Telpochcalli's students are still learning English.

Many schools serving low-income children choose a curriculum that emphasizes test-preparation and "basic skills," and see the arts as an unfortunate casualty of "realistic" necessities. Telpochcalli takes an opposite tack, building a curriculum around Mexican arts and culture, with art, music, and dance specialists on staff. In addition to a long-running CAPE partnership with the Mexican Fine Arts Center Museum, Telpochcalli seeks out other grants to support its arts curriculum, and the school invests much of its own discretionary budget in the arts. Teachers at Telpochcalli integrate the arts into academic classes, but students also study art on its own. For example, students analyze *corridos*—story-songs that have served for more than a century as what one writer calls Mexico's national "musical newspaper"—both as poetry and as part of the school's social studies curriculum. Telpochcalli's students can also learn to play *corridos*, since the school provides training on instruments used in traditional Mexican music—violin, mandolin, guitar, marimba, and bass—and provides the instruments as well. "Sure, it is worth studying art, music, and dance because it's good for lots of things academically," says the school's principal, Tamara Witzl, "but isn't it good to have kids who can visualize, and look at the world through the eyes of a visual artist? We do enough that it does both things. Kids do integrate the arts into reading and writing, but they also see themselves as musicians and artists."

The school's test scores show that the teachers' gamble has paid off. The percentage of Telpochacalli students scoring at or above national averages on standardized reading comprehension tests more than tripled between 1997 and 2002. Skeptics might point out that, due to the school's modest starting point, that percentage was still only 35 percent in 2002, but a closer look paints a more impressive picture. National figures show that students who are not modestly skilled readers by the end of third grade can generally be expected to fall farther behind and are unlikely to graduate from high school. Just 18 percent of the

school's third graders are proficient. But at Telpochcalli reading skills improve very substantially by the eighth grade. Fifty-five percent of the school's eighth graders score at or above that benchmark. The longer kids stayed at Telpochcalli, the better they did on the tests. Meanwhile, at a demographically similar school two blocks away, just 26 percent of eighth graders were proficient in reading, one percent less than the school's third grade.

Telpochcalli graduate Raphael Estrella is happy to spend an hour talking about his experiences at the school and the opportunities it gave him to explore art, music and dance. "I love art," he says. "Dance was a way to meditate, to be part of something, to be in a group." Music was his ticket into one of the city's top high schools. Even though his grades, he says, were "kind of low," he was able to audition for a place in Lincoln Park High School's music program because the school orchestra had an opening for a bass player. Lincoln Park initially slotted Estrella into remedial classes, but he found that his academic preparation at Telpochcalli allowed him to quickly master the high school curriculum and move up to higher-level classes. As a senior, his schedule is filled with challenging Advanced Placement courses, and next year he plans to attend Minnesota's highly regarded Carleton College.

Estrella says that the deep immersion in art and music he got at Telpochcalli gave him important tools for tackling academic challenges. "Music helps me think," he says. "When I'm playing music, I forget everything else, and that gives me a chance to relax and think about what I'm going to do later. I probably think more clearly after playing than before." Music also has taught him an attention to detail that he uses in other settings. "For music, you look at the little details that are really critical," he says. "You have to look at your positioning and every note that you play—or else you could mess everybody up. In math, a little detail might make the whole equation, and I'm wide open. I see little details that other people won't pay attention to." Similarly, he credits his art teacher's insistence on creating detailed visual works with his understanding of the importance of using detail to make his written work vivid.

CAPE director Arnold Aprill argues that this kind of perceptual shift—the way people's thinking changes when the arts become a serious pursuit, rather than a momentary diversion—is an important reason that arts belong in the schools. "People will often say, 'It's about creativity,' or 'It's about critical thinking,'" he says. "It's useful to look in some detail at what that means. The things that artists do all the time are things that kids need to be able to do—forming alternative solutions

to a problem, working with other people, being persistent, adjusting something after you've made a choice, taking responsibility for decisions, looking at options."

In 2001, a highly respected research group based at the University of Chicago published a paper (Newmann, Bryk, & Nagaoka) that indirectly backs up Aprill's point. The Consortium on Chicago School Research found that when students are engaged in "authentic intellectual work," they not only are more engaged with their schoolwork, they tend to gain more ground on standardized tests than do students who receive the kind of rote, skills-based instruction that is intended specifically to prepare them for such tests. The Consortium defines authentic intellectual work as activity that demands disciplined inquiry into a subject, requires students to digest knowledge thoroughly enough to apply it by themselves to new situations, and sets real-world standards for students' work products.

"The arts meet those criteria for authentic work in spades, and become an exemplar for the rest of the curriculum," Aprill notes with pride. "Making art requires students to develop deep understanding in order to represent their ideas to others through the art. Since real audiences will see the work, not just teachers, students are prompted to internalize high standards. And the work itself is an original application. You can't just copy the turkey, because that ain't art. It's just copying the turkey."

A recent study of CAPE documented how arts-based work changes student attitudes toward schoolwork and showed what a profound difference intellectual and aesthetic challenge can make. It didn't surprise researchers Karen DeMoss and Terry Morris (2002) when they found that students at CAPE schools reported enjoying learning more, paying closer attention, and remembering more when their teachers used an arts integrated curriculum.

A more revealing finding sneaks in toward the end of their report. Students described both traditional, lecture-worksheet-textbook instruction and arts integrated instruction as "hard," but they used the word to mean two very different things. "At no time during the general learning and non-arts interviews did students discuss what makes learning hard with anything other than a kind of resignation. Math is hard, tests are hard, remembering stuff is really hard," DeMoss and Morris (2002, p. 19) write. But when students described arts integrated work as hard, "the term 'hard' seemed to imply a challenge rather than a barrier." To illustrate their point, DeMoss and Morris quote an eighth grade student's description of one arts project: "The hard part was making it into a play," the student reports. "I thought that was hard because researching it took a lot of time and work. It was

hard to get the group to agree sometimes. We dealt with it by breaking into part-ners and that seemed to help us come together. We had to negotiate" (p. 19). Students went from thinking of themselves as hapless incompetents, beset by obsta-cles beyond their capacities, to seeing themselves as capable problem-solvers, with significant accomplishments under their belts. In other words, they found authen-tic intellectual work—disciplined inquiry, original application and real-world standards—to be a positive challenge.

Aprill says that teachers make the same shift, upgrading their estimates of what their students can do. "There's a very consistent positive impact on teaching that happens from this approach," he says. "The teacher always says, 'I couldn't believe that so-and-so was capable of such-and-such.' That's totally dependable. In every program, in every city I've ever been in, that always happens."

Aprill's observation—that integrated arts is a recipe for changing teacher per-ceptions about what their students can do—has profound implications. Decades of research on effective schools has shown that one of the most important differences between schools that work and schools that don't is teachers' beliefs in their stu-dents' ability to learn. Similarly, studies of effective versus ineffective teachers show a belief in student capacities as a key difference. Such conclusions seem obvious, and the underlying finding—that large numbers of teachers don't believe their stu-dents are capable of much—is depressing to contemplate. But study after study has documented that many teachers don't believe in their students' abilities. A typical response in the last decade has been for administrators to require teachers to sign loyalty-oath type "vision statements" declaring their belief that "all children can learn." Giving teachers a chance to work collaboratively with artists would be a refreshing alternative to such tactics.

ALEXANDER'S BLUES: HOW ARTS INTEGRATION MAKES BAD DAYS GOOD

At 11:30 a.m. on a Tuesday, near the end of the school year, a dozen or so adults stand in the hallway at Agassiz Elementary on Chicago's North Side, waiting outside the room that doubles as the gym and auditorium. We can hear a chorus of children accompanied by a blues guitar.

When we get in, a movie screen hides much of the stage. A wide aisle sepa-rates the two banks of folding chairs that make up the audience, and at the back of the aisle, three boys, about age 11, sit behind a folding table tending a laptop and a video projector. Next to them, one of their schoolmates operates a video camera.

Jim Kirk takes the stage. A thin man with light brown hair falling away from

his forehead, Kirk has a smile that's both conspiratorial and innocent. "We've spent the year studying the blues," he says by way of introduction. "It's kind of our take on the school-wide theme of migration." The performance we're about to see is based on work in social studies, language arts, and filmmaking. "Thank you *so* much for coming," says Kirk. "And now I'm gonna tell the class, places everyone."

The kids move into place, and one of the boys, an African-American kid maybe 10 years old, walks into a spotlight in front of the stage, wearing a straw hat and a yellow shirt. Accompanied by teacher Steve Lutz on guitar, (the familiar syncopated blues rhythm: ONE, and-*two*, and-*three* and-four-and-a) he introduces the four-bar theme that will be the show's chorus:

"It was a

TERRIBLE, *(and-three, and four-and-a)*

HORRIBLE *(and-three, and four-and-a)*

NO-GOOD, VERY BAD

DAYYYYY…" (and-two, and-three, and foooourr….)

And dances off cool as you like, while the last chord fades.

The play is an adaptation of Judith Viorst's classic children's book, *Alexander and the Terrible, Horrible, No Good, Very Bad Day*, in which the hero, a disgruntled everytyke, endures a day of disappointing food, irritating siblings, and classmates who don't let him in on their games. In a series of episodes, we see Alexander miss out on the prize in the cereal box, get crammed in the middle seat on the school bus (where he becomes sick to his stomach), and get yelled at for things that aren't his fault. From off-stage, a teacher reads the narration over the P.A., while, on the left side of the stage, the young actor playing Alexander—enthusiastic but, ever in character, unsmiling—acts out his day, with other actors coming and going as needed to torture him, armed with giant prop cereal boxes, bag lunches, and homework that is better-prepared than our hapless hero's dog-eared offering. Alexander has the blues, and each vignette is punctuated by the bluesy theme, with Alexander conducting from the stage a female chorus of five. Jim Kirk and Steve Lutz accompany the chorus on piano and guitar. The action is interrupted several times by the projection of 90-second video biographies of gospel and blues legends like Mahalia Jackson, Muddy Waters and Howlin' Wolf. Costumed students play the musical heroes, silently strumming prop guitars and clapping to inaudible beats, while the soundtrack features first-person voice-over narration read by students. ("I sang at the March on Washington," relates Mahalia Jackson, while a student playing Martin Luther King orates silently.)

When Alexander's miserable day comes to an end, as the last blues chorus fades and the kids take their bows, the crowd—maybe 40 adults and a half-dozen children—goes wild. It's worth examining why.

"Alexander's Blues" isn't exactly ready for Broadway, but it is entertaining. It has clearly been carefully planned and exuberantly executed, presented with love and care. It's a multi-media extravaganza—complete with choral accompaniment, props, and video interludes. It's a group effort. Everyone has a distinct part to play in telling the story. The level of complexity and involvement make "Alexander's Blues" a far cry from standard school-assembly fare, which tilts heavily toward hastily rehearsed choral singing, or group dance numbers with minimal choreography. Even at Agassiz, where the arts are integrated into the curriculum and the halls are full of student art, "Alexander's Blues" is a standout performance.

But there is more to this performance than it just being a better-than-average show with normally indulgent and enthusiastic parents. There is the intense progress that had to be made to stage this performance at all. The cast of Alexander's story was played by the students of Room 202, one of the school's two classes for autistic children.

Today's performance is a warm-up for a performance tomorrow before a downtown lunchtime crowd, and a show on Thursday for the toughest crowd, an all-school assembly at Agassiz. Last year, Jim Kirk's students won a school-wide award for best assembly, and they're hoping for a repeat.

Agassiz principal Bernadette Butler takes the microphone for a moment to offer tribute. "Every year these students have done this, I've cried," she says. "The second year, I was speechless. This year, I don't know what to do."

Kirk, Lutz, and Dave Rench are the school's teachers for kids with autism, and they had co-conspirators. One is Jacqueline Russell, executive director of the Lookingglass Theater Company, one of the city's leading ensembles. A few seasons ago, Lookingglass sent its adaptation of Ovid's *Metamorphoses* to Broadway, where it captured a Tony Award. A few weeks after "Alexander's Blues" finishes its run at Agassiz, Lookingglass will open a new theater in Chicago's historic Water Tower, with a show directed by the ensemble's most famous member, David Schwimmer, best known for playing Ross on the TV show "Friends." CAPE supports the partnership between Lookingglass and Agassiz, and the video interludes that were part of "Alexander's Blues" are the product, in part, of CAPE's video production and editing workshops, which Kirk and co-teacher Dave Rench attended.

Russell—who worked with Kirk, Rench and their students to develop the

show's concept, characters, script and props—has worked with Kirk's students for years. She says it is the highlight of her week. The project, she notes, addresses "the signature traits of autism." Focus, attention, and emotional expression are the most basic requirements of putting on a performance, and they are the things that autistic children find most difficult. Russell has seen victories that an outsider might have thought were small, or sudden, but were neither. One standard exercise has the group sitting in a circle, passing a classroom object from person to person—a pencil, for example. Each person, on accepting the object, is supposed to use it in a way that shows what he or she imagines it suggests. A gun ("Bang! Bang!"), a telephone ("Hello?"), a hammer ("Wham! Wham!"). In Room 202, that can be a challenging game. But the occasional breakthroughs inspire a giddy rush. "After a couple of years with this kid, Ramon, who never did anything but scream and cry, one day he picks it up and goes, 'Yee-haw!'—gesturing as if twirling a cowboy's lasso. Jim and I were like laughing…and crying."

All of the students have a role in "Alexander's Blues," although not everybody can be a star. For some, just placing a prop onto the right spot on the stage at the right moment is a triumph. "Eli did a very good phone," says Steve Lutz, remarking on one student's performance as a prop. "And for Eli to hold it together as long as he did, starting with the run-through, that's huge!"

Kirk thinks back to when he first met Isaac, the animated, overjoyed, and very connected actor who played Alexander today. "Isaac has been my student for five years," he says, "and when I first met him, he was real shy and had a hard time trying anything new, like zipping up his coat, say." He notes that for a kid like Isaac performing "plays to his strength of being able to memorize a script. Dave and I prepared that script, but he knows it better than either of us. If someone misses a bit, he'll cue them. A few of the kids have that strength, and this is an excellent way to use it."

One of Kirk's favorite things about the production is that it provides a powerful experience for his entire class. "When they go to bed tonight, every one of them is going to feel like they accomplished something," he says. "It's very unusual to reach *all* the kids like that. Except with this."

Another part of what makes Jim Kirk's eyes light up about "Alexander's Blues" is what's called "reverse-inclusion." The support roles—the chorus, the videographer, and a crew of assistant stage managers—were played by members of Debbie Brown's 5th-grade class, none of whom are autistic. In a role-reversal, the autistic kids were in the spotlight, utterly defying expectations, while the main-

stream kids were behind the scenes. The first person whose perceptions were changed and challenged was, it turns out, Kirk himself. "Jacqui had a lot to do with planting that seed. All the games—here we're handing around a duck and pretending the duck is in different modes—here, it's scary duck, and this is the baby duck. We had one where it was a stinky duck. But what was happening was, Jacqui was able to come in and get these kids to use a whole part of their mind that I was rarely able to tap into, and that was the imagination. These guys are so grounded in the literal and the functional. I am too. I have to be. My whole outlook is, where are these guys gonna be when they grow up? I'm constantly on 'em. 'Tie your shoes.' Because I know, you're gonna have to tie your own shoes. And then here's Jacqui, handing around the duck. It was a real eye-opener for me. And OK, all right, let's do a play. Maybe we can."

"The play has been a vehicle to change perceptions," he says. "We took the art and the creativity, and the energy that happens in here, and we used that to help these guys be cool in the whole school. Before last year, nobody viewed kids like Isaac or Jeremiah as what they are, which is excellent performers. I can't tell you how many other teachers came up and said, 'I didn't know they could do that.'"

The play has also been a vehicle for learning and integrating significant academic content in several subjects with the arts. The study of the Great Black Migration "has been our social studies curriculum," says Kirk. "We've been through all the different states where Mahalia [Jackson] was born and raised. The science, the technology of moviemaking, language arts…Wow, it's super cool to see these kids taking a text and making it their own. Those are storyboards over there, that's how the kids thought we should make the Mahalia Jackson movie. We'd spent the previous week studying close-ups and long-shots and stuff like that."

"We'd been studying all year long about the different blues singers," says Rench. "And I asked the kids, 'What do you think we should include in our movie?' And we pulled the facts together. And Jim and I said, 'OK, so first she's gonna be talking to the camera, what kind of shot should that be?' They said, 'Medium shot.' 'And then we have to show her moving—what'll we use?' And the kids said, 'How about a map?'"

The most important part of the project was getting the students to confront their fears and overcome their weaknesses. Autistic children, Jim Kirk tells me, tend to view the world as threatening and unpredictable. Kirk sees his job as preparing students for the messy world in which they'll have to live. Performing does that by forcing them to connect with others and to adapt to changing circumstances. It

also provides an activity that pulls together a disparate and disconnected group around one curricular focus. "Autism is a sensory processing disorder," he says. "What that means is, for some reason the part of the brain, the cells responsible for the relatedness of our senses, doesn't quite happen. It must be so anxiety provoking, and that's what leads to withdrawal."

This kind of story, of holistic change for students and the adults who work with them, is dear to Arnold Aprill's heart. "For me, the purpose of art is to change consciousness," he says. That belief was the reason he took on the job of running CAPE more than ten years ago. CAPE has shifted its focus in recent years, from trying to get its program adopted by the city, to in-depth documentation of the work produced and the lessons learned by the students, teachers, and artists in its partnerships. Engaging the help of prominent researchers, the group aims to help practitioners use portfolios to capture the scope, substance, and nuance of learning that comes out of successful partnerships.

In creating artful documentation, teachers and teaching artists gain new insights and raise new questions about the creative and learning processes. It is, itself, a form of disciplined inquiry that makes arts integrated teaching authentic intellectual work for adults.

THE ARTS AND ACADEMIC ACHIEVEMENT

As CAPE focuses on deepening its work with the 25 or so schools in its network, and helping another 75 schools get started with arts integration, the question remains: What if a big-city school district did buy into a program like CAPE? Can efforts like this be scaled up? What might the quantitative results show? One place to look for answers is Minneapolis, where a similar effort has been running for several years, reaching about a third of the city's public schools.

In the early 1990s, media magnate Walter Annenberg, the creator of *TV Guide* and other national publications, pledged $50 million of his fortune to a series of challenge grants intended to spur school reform efforts across the country. Most of the money was spoken for in the first few years, but in 1997, the Annenberg Foundation had some money left over for "smaller" grants, and in the summer of that year, one went to the Minneapolis Public Schools—$3.2 million for a 4-year effort called Arts for Academic Achievement (AAA). To get the grant, the district would have to pledge an identical amount of its own money and raise another $3.2 million from other private sources. The district agreed to the terms and hired Judy Hornbacher, a veteran administrator and teacher (and a former professional actress),

to run the new program. Hornbacher immediately started meeting with the district's program design team, began doing outreach to schools and arts organizations that might participate, and started raising private matching funds. By fall of 1998, the program was in full swing, with the district distributing grants to 29 schools, adding more over time.

Since one of the project's goals was building teacher leadership, teachers and artists were responsible for developing their own proposals. At AAA schools, groups of teachers got together, found an artist to work with as a partner, and designed a program that involved using the arts to teach the regular curriculum. With their principal's approval, they submitted their application to the district themselves. Hornbacher describes the application as, "You collaborate on your goals for students, both academic and aesthetic goals, and identify the data you've used to set your goals. Not just because it's cool to do—it may be really cool to do, but why are they doing it? What are the educational objectives?"

The AAA budgeted a healthy amount for evaluation, and researchers from the University of Minnesota helped AAA select criteria for which proposals they would fund. "We would make sure there was a rubric that was clear and measurable," says Debra Ingram, one of the researchers who led the evaluation effort.

Thanks to that careful planning, the final summary report Ingram and colleague Karen Seashore (2003) published was able to show some very clear results. It also helped that Minnesota collects lots of data on students and keeps it, as Seashore says, "so clean you can eat off it." Ingram and Seashore were able to look at students' "gain scores"—the degree individual student test scores changed from one year to the next—a more meaningful and fine-grained measure than the usual comparisons between, say, two different second grades over two years. The researchers conducted surveys to supplement the state's data, using the results to zero in on the program's effects. For students in AAA schools, the evaluators looked at not only whether teachers used arts integration, but also how much they used those techniques.

The results were striking. Arts integration boosted student achievement, and the more it was used, the more difference it made. For third-grade girls living in poverty, for instance, having a teacher who used the arts "very little" as opposed to "not at all" meant a gain of more than a month's extra progress in a year. A teacher who used the arts "a lot" added three more months of progress. The most encouraging finding was that AAA often produced even better results for poor kids than for others. "In some cases," Ingram and Seashore write, "the relationship between

arts integration and student achievement was more powerful for disadvantaged learners, the group of students that teachers must reach to close the achievement gap" (2003, p. 3—4).

There were limits to what they could measure, of course. At the outset of AAA, the design team had decided not to add to the considerable battery of tests that Minneapolis students take already. Only students in grades three through five took tests that produced clean enough data to suggest conclusive results, but the trends were impressive.

AAA was also intended to improve teaching, and the researchers report a strong showing there as well. "This is one of the most powerful professional development experiences that we have seen for large numbers of teachers," says Seashore. Teachers had to work in groups with arts partners, and they had to learn new skills and take on new roles. "They became designers of the program, they became collaborators, and they took responsibility for school-wide improvement," says Seashore. And of course, teachers also consistently upgraded their estimates of what their students were capable of. Or, as Ingram and Seashore's study has it, "Arts integration allowed teachers to see strengths in students they had not expected" (2003, p. 7).

Ingram says that programs as effective as AAA don't come around very often, and Seashore concurs. "Increased student achievement, teachers thinking so carefully about their work, teachers developing as leaders," says Seashore, "You just can't get much better than that."

The program's success has won it a firm place in the district, even though the Annenberg funds ran out over two years ago. In January 2002, Superintendent Carol Johnson turned down a $30,000 raise, citing the district's tight finances, and asked that the money go instead to AAA. Hornbacher was floored. "What can you say?" she marvels. "Wow." The district cut its budget by $85 million over the past three years, eliminating 550 teacher positions in 2002-2003 alone. But it has maintained funding for AAA at $500,000, and it has raised another $350,000 privately.

Although the evaluations of student achievement focus mostly on elementary schools, AAA has taken hold in many of the city's high schools, and Judy Hornbacher arranged for a tour of Southwest High School where an English teacher named Chris Fisher would be my guide. Pretty much every kid at Southwest seems to know Fisher, who started teaching at the school twenty years ago, after promising his wife that he would give up show business to make an honest living. When they make the movie about Southwest High School, Fisher is the

guy Robin Williams will play, popping up everywhere, coffee cup in one hand, cell phone sometimes in the other, his improbably big and pointy eyebrows poking out from his long face, which tends to be set in a deadpan.

Southwest sits in one of the city's wealthiest areas, serving a mix of the upper-crust kids from the neighborhood and at-risk students who come from all over town. In the mid-1990s, Fisher and some colleagues started putting together an "arts-infused curriculum," primarily intended as a way to prevent those at-risk kids from dropping out. Over time, funding from AAA helped the program cohere, but it retains an impromptu, ad-hoc character. The main competition to the arts track at Southwest is a program called International Baccalaureate (IB), which prepares students for a series of rigorous examinations. There are currently about 400 IB programs in the United States, all monitored and certified by a governing body in Sweden. Based on a curriculum developed for the children of diplomats, IB programs are widely considered an academic gold standard for high schools. Some kids come to Southwest specifically for the IB program, a by-application-only affair. Most of the rest wind up in the arts track, either because they've sought it out, or by default.

The morning's classes provide clues to what Fisher and his colleagues are trying to do. Social studies teacher Carolyn Hooper and art teacher Cecily Spano team-teach a 10th-grade class. Today their students are de-briefing performances they gave last week before the whole school, based on ideas they had studied in Hooper's class. The multimedia performances included dance, puppetry, singing, painting, movement, and spoken-word elements. It's hard to judge what the content was like from the discussion, but it's clear that the experience was important to the students. "I seriously thought it wasn't gonna turn out good," says a girl named Kyra. "I almost threw up, too." But all came out fine, she says, "since nobody wanted to look stupid in front of a whole bunch of people."

Providing an authentic audience—people in front of whom students do not want to look stupid—is a key difference the arts make, says social-studies teacher Kristen Borges, who has helped lead arts related work at Southwest for more than a half-dozen years. An arts integrated curriculum gives students "an audience for their work beyond just, 'The teacher's going to read my paper,'" Borges says. "Having poetry readings, having their poetry published…it's more a validation of their work than just a grade." Even in projects where aesthetic concerns don't seem quite as front-and-center, the principle of raising the stakes by providing an audience has a powerful effect. This month, Borges's ninth-grade social studies students

are preparing to enact a mock Supreme Court case, assuming the roles of justices and attorneys. They're arguing and deciding for themselves a case the Court decided in 2000, about whether students could legally lead a prayer service before a football game. "They're looking at some really tough documents," she says, "stuff that would bore them to tears if I just asked them to read it." But the end result is a performance. Students realize it requires a deep understanding of the material to project the confidence that a successful performer needs.

LEARNING THROUGH THE ARTS OUTSIDE THE CLASSROOM

If performances in front of authentic audiences are important to the dynamic of learning in schools, they are the center of some after-school programs in the arts. In the spirit of full disclosure, this is the time to note that I have a personal stake in the work that gets done outside of school. Close friends of mine run an organization in Chicago where local teenagers create exceptional original theater out of real-life stories from their working-class, multi-cultural community, Chicago's Albany Park neighborhood. I sit on the board of the Albany Park Theater Project (APTP), and I'm one of the cheerleaders-in-chief.

I'm not a lonely voice. Since the organization's founding in 1997, APTP has grown into one of the city's finest theater companies, and the many dozens of people I've brought to APTP's performances over the years have become part of a legion of fans. The company's work is regularly featured in local media, and APTP shows have more than once been named "Critic's Choice" by the Chicago *Reader*, a weekly newspaper that takes its arts coverage seriously. When the company added two extra nights to the run of its most recent show, *Aquí Estoy*, tickets sold out in less than ten hours. Days later, the *New York Times* ran a laudatory article (Wilgoren, 2003) about the show and the company, published on the day of *Aquí Estoy's* final performance.

APTP's young performers are notable for their courage. They extend full commitment to the characters they play, even those who are repulsive or pathetic: a husband who brutally beats his wife; a date who nearly becomes a rapist; an alcoholic father who molests his daughters; brothers lost to gang life, drugs and despair; sisters who submit to abuse from their husbands; new parents who suffer from schizophrenia. They draw on a variety of styles. Recent pieces have featured a post-modern Greek chorus, a four-piece rock band, a puppet made from three pieces of crumpled newspaper, and a world-class human beatbox. Dance and original music have been staples of the company's work for several years, and over time,

they have become smoothly integrated, so that movement, music and storytelling are often woven together in a single story.

The teen members of APTP's company take full ownership of their performances because they are responsible for developing them. Many of the stories the group chooses to dramatize come from the company members' own lives and family histories, but it is a rule that no company member may play the part of him- or herself on stage. The idea is that the company takes collective responsibility for doing justice to the story, no matter whose it is. Company members gather oral histories, often meeting with sources as a group that includes the adult directors, but sometimes conducting interviews on their own. The interviews are transcribed, and the transcripts become the basis for a long workshop process, in which company members try out different approaches to each story, evaluating and refining as they go. The workshop sessions are videotaped, and the final scripts are based directly on the workshop material. Company members write or co-write the music and songs, and they take a hand in directing and choreographing many of the finished performances. At the end of each performance, the actors engage the audience in a question-and-answer session, explaining the company's purposes and processes.

After one performance, someone in the audience asked how a haunting lament about company member Michael Nguyen and his mother came to be written. It is a model of how the company works. "We had twenty minutes to create 'a piece about my mother,' and I wrote a song," Michael told the audience. "It was short—a lot shorter than what you heard today—and when the company heard it, they were like, 'Oh, my God, there's a story there.' So, we all decided that we should get in the circle and tell the story, and I did that. And when we got into the rehearsal process, Marisa [Ramirez, another company member] and Colby [Beserra, one of the adult directors] and myself put the song together. We crafted it into what it is today." Michael wrote a snippet of a song, the company sniffed out a story worth telling, and with the help of the adult directors, they fleshed out the story and turned it into a powerful performance.

There are no auditions. Any teenager in the community who stops by is pretty much immediately part of the family, which is how APTP company members frequently refer to each other. The company is an ongoing ensemble, with most members maintaining their affiliation until they go away to college. One result of the no-audition, instant-family policy is that APTP's members reflect the neighborhood's mix of Latino, Asian, Eastern European, Middle Eastern, and other cultures. APTP pieces have found their beginnings in countries from around the

world, including Mexico, Cuba, Colombia, Nicaragua, Vietnam, Bosnia, Bulgaria, Poland, and Palestine.

Aquí Estoy explored immigration stories, an appropriate theme in a neighborhood where more than half of the population is foreign-born. Company members researched archival material to reconstruct the story of a new landowner, recently arrived from Germany, surveying his farm in 1853. They interviewed current and former neighborhood residents to gather stories about Albany Park in the 1930s and Sarajevo in the 1990s. High school seniors Elizabeth Cobacho and Marta Popadiak went out to a street corner a few blocks from the theater to interview the *jornaleros*, day laborers who gather to wait for contractors to come by. The result became "Amor de Lejos," a moving, entertaining ensemble piece that formed, what the *New York Times* called "the spine of Aquí Estoy" (Wilgoren, 2003, p. A10). When the audience enters, one of the *jornalero* characters, dressed in shabby clothes, seems to be sleeping on the stage. In between other stories, his companions gather, wake him, console each other with world-weary ribbing and tender advice, and stand aside to watch from the wings, waiting for work as the show unfolds. Over the course of the show, the performers playing the *jornaleros* use movement, dance, and song to show us their world, with the characters interrupting their labors to tell us their stories and troubles. The man whose story became the central narrative of "Amor de Lejos," Eliceo Zamora Caballero, attended many of the performances, and when he did, the company invited him to stand for a bow during the post-show Q and A.

The most courageous performance of the evening is the show-closer, "Nine Digits," based on the experiences of an APTP company member who is an undocumented immigrant, his name hidden by the pseudonym "Julio Alvarez." Unable to get a driver's license, receive financial aid for college, or take the internship he desperately craves with a nationally-known dance company, Julio lives with the fear that he'll be deported and sent back to Colombia, where young men his age are taken straight into army service, fodder for the country's ongoing civil wars. Eventually he confides in a fellow company member and the company's directors. "And now," Julio says, looking right at the audience, "I've told a roomful of people!" The piece climaxes with a confrontation between Julio and his foil, "J. Wilbur Worker," a living symbol, in whiteface, of the Social Security Administration, which dispenses the nine-digit number Julio needs. The clash between the two men takes the form of a highly charged tango, with the white-suited Worker teasing Julio with his seductions: "Say you want it," he says, caressing Julio's face, their lips almost

touching. "Tell me you want the nine digits!"

APTP company members also became standouts for what they do outside the ensemble. Just 42 percent of the freshman who entered the neighborhood high school in the fall of 1997 had graduated five years later (Consortium on Chicago Public School Research, 2003). Most students at the school consider passing grades to be a lofty goal, and many APTP company members held the same view when they joined the company. But the high standards and expectations that are the norm for the company's work infect other dimensions of their lives, thanks, in part, to encouragement and coaching from the company's directors. Only a handful of the dozens of teenagers who have performed with APTP have failed to finish high school.

Even more striking, of 33 kids who have graduated high school while part of APTP in the last three years, 30 have gone to college, and two of the others have plans to start within the year. Now an increasing number are being recruited to top-ranked liberal arts schools—including Carleton, Pomona, Connecticut College, and Beloit—on healthy scholarships, thanks to intensive support from APTP's directors, Laura Wiley and David Feiner.

Like the company's artistic work, the college counseling efforts developed gradually over time. Laura and David worked hard to help an early APTP alum get into the University of Illinois' flagship campus at Urbana, figuring the state school would be a stretch, but a bargain. Experience proved the school to be no bargain. A giant, impersonal campus where many of the large lecture classes are "weed out courses," designed to flunk large numbers of kids, the U of I was a disaster. Subsequent research uncovered a happy reality that small, highly regarded liberal arts colleges would be a better match. Many of these intimate, nurturing schools were looking for smart, interesting, diverse, and engaged urban kids and have been willing to lend a helping hand with financial aid. APTP alums have received over $1 million in financial aid over the last several years, a sum that is several times greater than the company's annual budget.

APTP's official mission statement makes no mention of academics, college, or even "youth development." Yet those are key outcomes of the program, ones in which the directors take justifiable pride. "In six years, we have never explicitly designed a workshop around the educational benefit that will be derived from it," says David Feiner. "You don't come in and say, 'This is the week we're doing theater stuff to help you learn to read.' [But] we're proud that company members become more serious about their dreams for themselves, especially their educations

and what they want to do with their lives."

In fact, the company's explicit mission to produce the best possible theater and its implicit mission to produce the strongest possible people are simply two sides of a coin. Producing great theater requires the participation of fully actualized people—people who understand trust and accountability, people who are ready to learn whatever it takes to make a performance work, people who know themselves and have a vision for their lives. APTP members become fully actualized by rising to the occasion of doing the company's artistic work, not because the company fills some internal lack in them. Their intelligence, drive, resilience, and compassion are innate. APTP simply creates a context in which those qualities are given a forum and a reason for emerging.

In 1999, MacArthur Fellow Shirley Brice Heath published a 10-year study (Heath with Roach), of 124 after-school programs for teenagers. Although APTP was just starting out as Heath was concluding her study, her summary results sound like a description of the company. "Through their involvement in effective youth-based arts organizations," Heath wrote, "young people cultivate talents and dispositions they bring into their voluntary association with such high-demand, high-risk places. Once there, the intensity of these groups builds and sustains a host of skills and capacities rooted in their personal recognition of themselves as competent, creative and productive individuals" (p. 29).

Heath (1999) found that arts-based organizations were exceptionally good—even better than excellent sports or community service programs—at what she called the "new three R's." They offer young people diverse "roles," establish clear "rules" and norms, and provide meaningful "risks" or challenges to young people. They gave young people opportunities to express their own ideas, take planning and leadership roles, consider multiple perspectives and solutions to complex problems, and reflect on the results of their efforts. A linguistic anthropologist, Heath was particularly interested in the ways "at-risk" youth developed and used language. In arts organizations, she found a "dramatic increase in syntactic complexity, hypothetical reasoning, and questioning approaches taken up by young people within four-to-six weeks of their entry into the arts organization"(p. 27). Participants became much more likely to ask "What if?" and describe possible answers, to use verbs like "consider" or "understand" that deal with cognition itself, and to use what she calls *modal verbs* like "might" and "could," which imply a consideration of multiple possible outcomes. "These linguistic skills enable planning, demonstrate young people's ability to show they are thinking, and also help them have the language to

work together with firm resolution and a respectful manner" (p. 27). APTP company members have many times confirmed Heath's observations.

A key idea in Heath's (1999) description of effective arts organizations is "risk," and the way that these organizations use it to young people's advantage. "While public rhetoric laments the fate of 'at-risk youth,' our research reveals how youth depend on certain kinds of risk for development," she writes (p. 27). Organizations like APTP give kids an opportunity to grow by facing the risk of performing for authentic audiences—and knowing that the organization's viability depends on their ability to communicate effectively with those audiences.

One organization that exposes young people to a different sort of productive risk, literally giving them a financial stake in the success of their work, is Boston's Artists for Humanity. Founded in 1991 by visual artist Susan Rodgerson, Artists for Humanity now employs several dozen young people as painters, muralists, photographers, junior architects, graphic designers, silkscreen artists, web developers, and fashion designers. Participants who successfully complete a 72-hour apprenticeship earn an hourly wage and receive commissions when their work is sold. "We're not a school, we're a business," says Rodgerson. "These kids are very aware that if we don't produce good work, we don't have a project," Rodgerson says. And that awareness, that sense of ownership and risk, makes the work more satisfying. "Kids want the respect of adulthood," she says. "School doesn't give them that sense. I think bagging groceries can do it, but think about being an owner in a business like Artists for Humanity. I couldn't do this at a school—we couldn't do what we do."

Heath (1999) studied dozens of youth arts organizations in urban and rural locations across the country. Few of them are well known, but APTP and Artists for Humanity are not rarities. There are organizations like them in most cities, wherever artists marry their talents to a broader social agenda. They operate quietly and independently for the most part, often without solid financial support, but driven by deeply committed adult leaders and youth prepared to take all the roles and risks necessary to make the art excellent and the organization persist.

SEVEN IS HIGHER THAN THREE: THE POWER OF PARALLEL PROCESSES

Heath's (1999) exhaustive research begins to uncover what it is that makes the arts such a powerful force for development in young people. Ingram and Seashore have some other ideas. After school, on the day of my first visit to Southwest High School, Chris Fisher and I went to a Minneapolis Board of Education meeting, where the University of Minnesota researchers presented their final report on AAA,

practically garnering an ovation from the board. A board member, after gushing about the program, asked the question: "Why did the arts make such a difference?"

"We've talked a lot about it," said Seashore. "Partly, it may be that the arts use different intelligences, or that they are easier to integrate than other kinds of work." In the end, she said, the arts seem to have reinvigorated teachers. "We saw teachers who giggled and laughed as they learned to do this. They knew they weren't supposed to be experts, so it was very easy for them to say, OK, what *can* I learn? It's not like professional development for reading, where teachers think, I'm supposed to know how to teach reading already. There's no implicit message here that there's something wrong with them."

In a later conversation, Ingram mentions several other provocative hypotheses: the arts are inherently interdisciplinary; they offer immediate connections to real world, hands-on problem solving; they force teachers to pay attention to individual students and their ideas. She admits it may also be that teacher-driven initiatives like AAA simply draw some of the most energetic, motivated teachers. The number of possible explanations indicates the poverty of evidence for any one of them. For all its rigor, Ingram and Seashore's research only points to the fact that, as a group, teachers using an arts integrated approach in Minneapolis got better student results than other teachers working with similar students. It doesn't say much about how those results are achieved, perhaps because of the scale of the study— thousands of students, scores of teachers, dozens of schools, many different art forms, and so many varied approaches to arts integration itself. What's more, Ingram and Seashore are education researchers. They brought no personal inclination to the arts into the study, and while that is part of what makes their findings so credible, it also leaves a gap. They focused on academic outcomes, not on understanding how the content of learning in the arts might be cognitively related to learning in other subjects.

Enter the Conservatory Lab Charter School in Boston, a small elementary school started by the Research Center of the New England Conservatory of Music. The Lab Charter School is dedicated to exploring how a single art form can be most thoroughly and productively integrated with other disciplines, especially the basics of literacy and numeracy. And enter founding co-director, Larry Scripp, a musician, teacher, and researcher with longstanding ties to both the Conservatory and Harvard University's Project Zero, where he worked with the likes of Howard Gardner, who developed the theory of multiple intelligences, and David Perkins, who has done breakthrough work on how knowledge and understanding "trans-

fers" from one domain to others. Scripp describes the Lab Charter School as "theoretically based," and although his official title is research director, he can also be described as the school's theoretician-in-chief.

Among the first things a visitor to the Lab Charter School notices after walking through the door are the big plastic tubs in the hallway near the entrance, filled with violin cases. Starting in first grade, every student at the school is issued a violin. Every week for the rest of their tenure, students get a half-hour semi-private lesson as well as a half-hour group lesson with nine other children. In addition to the two full-time violin teachers, the school employs two full-time music teachers, and each class gets an hour with one of them every day, learning recorder as early as kindergarten. The violins and recorders are only the most visible symbols of the way the Lab Charter School applies the theoretical model called Learning Through Music, which is summed up in a mantra that Scripp repeats several times as he talks about the school. "Music is employed as a medium and a model for learning."

Examples of music as a medium for learning abound and are easy to spot. Kindergartners learn the names of dinosaurs by making up quick songs about them to the tune of "Mary Had a Little Lamb,"—as in "Brontosaurus has a long, long, neck, a long, long neck, a long, long neck…" Fifth-graders write and perform an opera to sum up what they've learned about historical characters they've studied in social studies. Music as a model for learning involves a little more theory, which comes in two parts, the *Five Processes* and *Shared Fundamental Concepts*.

The Five Processes—*Listening, Questioning, Creation, Performing and Reflecting*—describe ways students engage with curricular material, whether the material in question is a piece of music, a short story, or a math problem, and Scripp defines each word expansively and evocatively. When applied consistently, these processes are internalized as learning strategies that become the basis for meaningful assessments.

Listening, he says, "is the power to discern, the power to discriminate, the power to notice, the power to observe." A description in a recent journal article (Scripp, 2003) adds two other provocative definitions—to focus and to remember.

Questioning, for Scripp, "means investigation. And it means holding significant questions over time, questions you return to. What is narrative? What is proportion? What is harmony?" It also encompasses a great deal of the analytic realm, Scripp says, including "discovery, hypothesis-testing, scientific method."

Creation encompasses "invention, transformation, choices, composing, improvising," Scripp says, pointing out that creation can take many forms when defined

this way. Everyday speech, for instance, is a form of improvisation, an example that brings creativity into the realm of the commonplace.

Performance "means demonstration," says Scripp. "It doesn't just mean getting on stage. It means being ready to show what you know." Performance offers a very concrete example of music serving as a model for other forms of learning, since the experience of rehearsing a performance on the violin, as Scripp says, "becomes a model for demonstrating what you know: practicing, and honing, and rehearsing. There's a loud tradition in academics that you're not supposed to rehearse things: Question? Get it right. New question? Get it right. But in music, it's very much the opposite. Rehearse, rehearse, rehearse. It's so deep, it's worth rehearsing."

Reflection includes "making connections, self-assessment, goal-setting" in Scripp's schema. The process of revision, too, falls under reflection. A video on the school's web site shows Scripp talking with a group of students who have just finished an exercise where they used sounds to portray various animals, "OK, why did you do that?" he asks them. "What was the purpose?" Theoretically, every lesson, in every subject, should engage students in each of the Five Processes.

If the Five Processes describe the school's approach to how to teach, then the idea of Shared Fundamental Concepts describes the school's approach to content. The premise is that music, language, and math are all systems of symbolic representation. By drawing students' attention to the underlying structures that they share, Scripp hopes the school will make the study of these systems mutually reinforcing, so students develop a deep and rich understanding of each system and the connections among them. For example, the idea of beginning, middle and end applies equally well to a story or a song. Some other examples require more intellectual stretch, with a correspondingly richer payoff. "A musical staff is a matrix that is as mathematical as a graph," Scripp points out. "Time is the X axis and pitch is the Y axis." Musical time, too, quickly translates into mathematical propositions or "if-then" statements. For example, the value of a 'whole note' depends on the designated duration of the 'quarter note'. So Scripp asks, "If a quarter note is assigned one, two, or four beats, then the duration of the whole note is...?" Among music, math, and reading, "Which is more synthetic of the other two?" Scripp asks rhetorically. "Music is more like math than language is, and music is more like language than math is."

The Lab Charter School is a "learning through music" school, but other art forms employ variants of the Five Processes, which Scripp thinks of as a design standard that can be used in any school, with any art form to promote student engage-

ment in learning. "You have a strategy and a design standard," he says, "and you choose an art form that's appropriate."

All art forms share fundamental concepts with other thinking and symbol systems. In visual art, for example, framing and perspective are used to pay and call attention to salient details, an approach well understood by the students at Agassiz School who chose to use a medium shot when they introduced their blues artists on video. Perspective and framing are close analogues to voice and point of view in writing or history. A student might consider how the system of slavery differs from the point of view of the slave, the slave trader, the slaveholder, or the abolitionist.

As important as the shared concepts are, Scripp insists that music also be taught discretely, not only in integrated contexts or as a tool for making reading and math instruction more effective. "The premise of the school is that music is the equal of the other two things," he says. "Some people ask, 'Well, they don't really have to be good at music do they? Isn't the point of the school that they're good academically?' And I say, 'The way that students learn musical concepts is through the development of musical skills. Reading musical notation. Playing an instrument. Singing. They demonstrate their understanding of musical concepts by performing these skills, just as they would demonstrate their understanding of math concepts by solving mathematical problems. Of course, they have to be good at music!'"

That's the theory. Here is how it works in practice in a first grade classroom: Having listened to a short melody, students are given the notes on the staff to read. They count up the number of times each note occurred, using hash marks in sets of five to make their tallies on a separate sheet. Adding up the number of hash marks for each note, they take another sheet out and make a bar graph of the results, showing how many times each pitch showed up in the melody. Students listen to music and note which instruments they heard, tally their totals and make a bar graph to show which played the most and least. Listening again, students draw faces in response to musical pieces to indicate if they are "happy," "sad," or "angry." They sort musical instruments according to size, the material they are made from, and how they are played (blown, struck, shaken, plucked, or bowed). Students write a simple melody and play it for the class on the xylophone. The class listens and tries to repeat the rhythmic pattern of the piece verbally.

A second-grade teacher and a music teacher team-teach a lesson about birds, with students learning to play the songs of the phoebe and the red-winged black-

bird on the recorder. The phoebe's song requires them to play a new and challenging note, the high E. "There's always a tension in this school about how much integration is good," says Scripp. "When do you over-integrate? Is it possible to over-integrate?" His first response to that last question tends to be "probably not," but he has occasionally been convinced otherwise.

Frequently, those tensions require compromise and creative solutions. Should the school take time away from music instruction to give extra tutoring in reading to kids who struggle with basic literacy? So far, the answer has been no, based on a gamble that music skills will provide a solid foundation for language skills. Scripp thinks his research is starting to show that this gamble is paying off. Learning to clap out rhythms, for example, gives teachers a tool to use in teaching kids to break words into syllables. For students still learning English, a solid ability to match pitch gives teachers a way to train their ears to a new language. Compromise works both ways, with music teachers pushing for less integration sometimes. "The violin teacher would prefer that students start on the upper strings—easier to play," Scripp says, "but harder to sing." Those higher notes, out of the kids' vocal registers, offer fewer bridges both to spoken language and to musical literacy. Singing the tune lets students learn the notation by singing out the names of notes as they play them, or the intervals between each pitch in a series, or the number of beats given to each pitch. Scripp's preferred compromise is to have the students play a tune on the high strings, then sing it in a lower key. The violin teacher would prefer to spend the entire lesson on, well, violin.

The payoff for those negotiations is that kids learn more deeply, as well as more broadly, in the arts and across the curriculum. "Number awareness taught with music can combine five or six aspects of mathematical awareness all at once," Scripp (2003, p. 137) writes in a recent journal article. At a parent conference, for example, "the teacher can say…'Well, your child is doing wonderfully. She really understands that seven is larger than three. This is an understanding that is essential for a first grader.' However, at our lab school…the child understands through…notation of musical melodies that seven is also higher than three [on the scale]. It also lasts longer than three. It's also true that a note on the seventh beat comes in later than a note on the third beat. Through music, numbers mean all these things at once."

Test scores have risen significantly at the Lab Charter School. Scripp says that grade level performance on the Stanford Tests of Math and Reading improved an average of 10 percentile points in reading and nearly 20 points in math by the third

year. And substantially more third graders at the school were highly proficient in reading than the district average, 79% to 38%. Scripp reports that analysis by NEC colleague Martin Gardiner shows that the correlation between musical skills and test scores increases over time as the test scores rise.

These tests scores, like those in CAPE schools and AAA schools, are very exciting. But, Scripp and the other arts integrators are after something far more profound. They are trying to learn how a school can leverage learning by making an art form an integrated element of the school's pedagogical approach and its core curriculum. Scripp's fine-grained research is returning findings that he thinks justify the school's experiments, and showing how they can do it better.

One finding is that musical ability alone—the capacity to match pitch, or sing back a melody in tune—doesn't correlate with math and reading achievement. But the ability to use musical notation does match up with math and reading. "We haven't yet found a kid who can read music well, but can't read well or do some math problems," says Scripp. In more recent testing, the converse has also been shown to be true, suggesting that the connection works in both directions. "In the third year, no one who was doing well in academics was doing poorly in music."

Another recent finding is that notating pitch correlates more closely with higher math scores, and notating rhythms correlates more closely with higher reading scores. Scripp isn't sure yet what this means. It could be a sign of separate forms of intelligence at work, or it could be a result of the way the school matches up concepts in practice, with kids clapping out rhythms to help them break words into syllables, a skill measured in the reading tests. Either way, Scripp thinks that results like these justify the school's approach. They show that Learning Through Music is an effective teaching strategy, and they open new questions for further research.

Scripp is looking beyond the Lab Charter School as he plans that research. "There's so much to be done, it's going to be hard to do it all in one place," he says. Since early 2002, he has teamed up with Aprill and other practitioners across the country to create a national consortium for exploring the role of music in education. The arrangement, he thinks, promises to bring together the best of all worlds. Thanks to the work of CAPE and other organizations, Chicago has a large number of schools with plenty of experience in arts integration, making it a great place to test out some Learning Through Music practices on a larger scale. In Boston, where the policy climate isn't receptive and there is no equivalent to CAPE, "we'd have to wait till the weather system changes," to expand in this way, Scripp says. "But with the consortium, we can do it right now."

While Scripp criss-crossed the country developing and testing further applications for his Five Processes and Shared Fundamental Concepts, his former colleagues at Project Zero, the Harvard research center that explores questions of learning and cognition, were struggling with a more theoretical issue—one that speaks to the question of why programs like CAPE, AAA, APTP and Learning Through Music might be so successful. They had labored for many months over a monograph about what they call "the aesthetic dimension of learning," and by late spring of 2003, they had written two versions, only to throw them out and begin again. Project Zero's director, Steve Seidel, said at that time, "I feel it's been the hardest piece, in my 15 years here, that we've ever struggled with."

On at least one thing, the researchers agreed. "We're quite convinced that the aesthetic dimension of learning is extremely powerful," said Seidel. "Far more powerful than, in this culture, we tend to acknowledge." But they couldn't agree just how important. Among the Project Zero researchers, "Some people feel that the aesthetic dimension is really the engine of learning. It sort of pulls the rest of the train along," Seidel said. "Others feel that it's—I'll sort of leave the train metaphor—it's an element that, like chemical elements, has to be there to get the proper fizz, but it's not the only driver. That it's not the only essential element, it's just one of the elements."

At this writing, the monograph still had not been released, and the question of the importance of the aesthetic dimension was awaiting resolution. But either way, Project Zero's work suggests that the role of the arts in learning has so far been badly underestimated. We are accustomed to asking, "Do the arts add something to learning?" The real question might be, "Could there be anything that adds more?"

REFERENCES

Consortium on Chicago Public School Research. (2003). *How do students perform in high school?* Retrieved November 10, 2004, from http://www.consortium-chicago.org/littlepeople/hs2003/1520/1520.html#table1

Catterall, J., & Waldorf, L. (1999). Chicago Arts Partnerships in Education: Summary evaluation. In E. B. Fiske (Ed.), Champions of change: *The impact of the arts on learning.* (Available from the Arts Education Partnership, One Massachusetts Avenue, NW, Washington, DC 2001, http://www.aep-arts.org/PDF%20Files/ChampsReport.pdf)

DeMoss, K., & Morris, T. (2002). How arts integration supports student learning: *Students shed light on the connections*, p. 19. Unpublished manuscript.

Heath, S. B., with Roach, A. (1999). Imaginative actuality: Learning in the arts during the nonschool hours. In E. B. Fiske (Ed.), *Champions of change: The impact of the arts on learning* (pp. 26-29). (Available from the Arts Education Partnership, One Massachusetts Avenue, NW, Washington, DC 2001, http://www.aep-arts.org/PDF%20Files/ChampsReport.pdf)

Ingram, D., & Seashore K. R. (2003). *Arts for academic achievement: Summative evaluation report.* Unpublished manuscript, Center for Applied Research and Educational Improvement, College of Education, and Human Development, University of Minnesota.

Newmann, F. M., Bryk, A.S., & Nagaoka, J.K. (2001). Authentic intellectual work and standardized tests: Conflict or coexistence? *Improving Chicago's schools.* (Available from Consortium on Chicago School Research, 1313 East 60th Street, IL, 60637, http://www.consortium-chicago.org/publications/p0a02.html)

Scripp, L. (2003, Summer). Critical links, next steps: An evolving conception of music and learning in public education. *Journal for Learning Through Music*, 2, p. 137.

Wilgoren, J. (2003, June 14). Gritty Chicago memories come to life on stage. *The New York Times*, p. A10.

2

No One Learns Alone

MADELEINE GRUMET

Few of us can resist the joy that jumps off the page in Dan Weissmann's description of Isaac's performance, or his rendering of the creative friendship of Jim Kirk and Dave Rench. These stories provoke vivid memories of our own educational experience when learning something new was fused with excitement and emotion, and shared with other people: the intense engagement James Pellegrino has called hot *cognition*[1].

In the arts integration work described here, the arts and the interest, immediacy, and feeling that accompany them, are extended throughout the curriculum. Math becomes part of making music as the children in the Lab Charter School work to make the song of the cardinal or the blackbird. Histories of the Great Black Migration become part of making theater in Chicago's Agassiz School as children create and perform a play based on a wonderful children's book for their families and schoolmates.

It is important to distinguish these arts integration processes from arts experiences that are inserted into the school day without deep connections to the core curriculum of the classroom. You will find animation and engagement as kids make pilgrim hats at Thanksgiving. You will find interest and attention as they gather around the dancer who is visiting their school for a three-week residency. But their interest in making things is too often contained within these experiences and not

intertwined with their academic subjects. In contrast, these integrated arts programs have rescued the arts from educational cul-de-sacs where they have been sequestered: arts for the talented and gifted, arts for precocious professionals, arts as therapy. And they have rescued the academic disciplines from their dead ends in the flat, dull routines of schooling that leave students intellectually unchallenged and emotionally disengaged.

This book aims to lift these moments of hot cognition out of anecdote, without losing their incandescence, to show that they are now embedded in educational programs that sustain and augment them. This book aims to show that these moments are not simply the products of exceptionally gifted teachers. They are the results of an approach to teaching and learning that is accessible to virtually all schools and all teachers, given sufficient support and time for development.

This chapter aims to explain why and how arts integration leads to hot cognition, heightens student engagement, improves the culture and climate of schools, leads to deeper learning, and inspires the professional development of teachers. It aims to explain why and how arts integration works. It aims to demystify the remarkable transformations that are often the hallmarks of arts integration and to make clear that there is an understandable logic to its practice. It may be marvelous, but it is not a mystery.

EDUCATIONAL INTEGRITY

This word we are using, "integration", comes from the Latin word *integrare*, which means to make something whole, just as we call whole numbers "integers". When we speak of arts integration, we are speaking of a process of curriculum development and instruction that enriches relationships among students, teachers, and parents, as well as relationships within each of these groups. Arts integration is an approach to teaching and learning that lives in lessons and curriculum. When a teaching community embraces arts integration, and children meet it in different classes and experience it with various teachers over time, arts integration is a process that profoundly changes schools embracing its approaches to instruction, and assessment, to individualization and differentiation, to values, community relations, and ultimately, to spirit.

The arts integration programs of the Chicago Arts Partnerships in Education (CAPE), Arts for Academic Achievement (AAA) in Minneapolis, the Conservatory Lab Charter School in Boston, North Carolina's A+ Schools and Curriculum, Music, and Community project (CMC), and the Lincoln Center Institute in New

York grow from the conviction that the strong emotions which inform both art and academic work cannot be isolated from the relationships of students to each other, to their teachers, and to their communities. Arts integration planners understand that each child's development is contingent on the support, resources, relationships, and interest of his or her community. This assertion would not be surprising if we were talking about character development or civics, curricula that we immediately associate with the category of human relations. What is new is our conviction that the processes and quality of relationships surrounding the making of art influence not only the cultural and moral tenor of the school, but also cognitive achievement in mathematics, science, foreign languages, and literature.

Evaluation studies of arts integration programs indicate that through this work teachers see their students in a new light. In integration programs, students reveal enthusiasms and hidden capacities, and express ideas, feelings, and new dimensions of their intelligence. Teachers marvel at what their students can accomplish. This light, too often hidden in the routines and flatness of traditional curricula, takes time to shine. Jim Kirk and Dave Rench learned to trust their students' growing abilities to sustain attention, collaborate, and take responsibility, and over time their students learned to trust and respect each other's efforts and ideas. Persistence characterizes their collaboration and Hardy Schlick's ten years of visiting the Sheriden Elementary School in Chicago. And those programs that have been operating for a number of years have evaluation data to show that achievement grows as the schools participate, and as their students mature in these integrated arts programs[2].

INTEGRATED ARTS AND INTELLIGENCE

Academic achievement and intelligence have been linked in popular and scientific worldviews for nearly a century. It is assumed that "smart" students do well in school; low achieving students are not smart. Critics of the "born scholar" theory of intelligence have argued that it is a tautology, a self-fulfilling prophesy that has been the ideological foundation for prolonging some of the worst practices in American education—from *de jure* and *de facto* segregation to tracking children at an early age. They offer broader conceptions of intelligence as implied in phrases like "street smarts," "emotional intelligence," "horse sense," and "common sense." They urge a more dimensional understanding of intelligence and its indicators, and claim that one can be "smart" without getting good grades. It would be foolish, of course, to assert that intelligence does not depend, in some measure and way, on the

speed, precision, and efficiency of the neurological system. But it would be equally foolish to argue that neural function is the only basis of intelligence, just as preposterous as claiming that academic performance is its only indicator.

Our own life experiences persuade us that as we make meaning of the world around us, we utilize all of our diverse skills and sensibilities. Howard Gardner (1990) has worked to convince us that making meaning of our experience requires a pluralistic view of intelligence, for it involves many processes: linguistic, logical-mathematical, musical, spatial, kinesthetic, interpersonal, and intrapersonal. In *The Intelligent Eye*, David Perkins (1994) has made a case for a three-dimensional understanding of intelligence: neural, experiential, and reflective.

Neural intelligence is the capacity of the neurological system to process information and contribute to intelligent behavior. The development of neural circuitry is largely inherited, but it is also influenced by our experience. Donald Hebb's (1949) theory of learning and brain plasticity is now widely accepted by neuroscientists. It suggests that a growth process and metabolic change occurs in brain cells when neurons and synapses that are close together are activated simultaneously and/or frequently. Connections or pathways are formed among neurons and their synapses, and among areas of the brain that specialize in specific functions, among cognition, emotion, and motivation, and are coordinated in yet other areas of the brain where language and the executive function reside. In other words, experience contributes to neural development and intelligence. And as particular neural pathways are developed, they make possible certain forms of intelligent behavior. The pianist's capacity to play a difficult piece is developed through rigorous practice (experience) to the point that the music comes to virtually inhabit his or her mind and hands (neural).

Experiential intelligence is the accumulation of context-specific knowledge that contributes to intelligent behavior. Experiential intelligence is learned over time. It is threaded through the subjectivity and activity of individual persons. Connected to our lived worlds, experiential intelligence is situated in time and place, often associated with strong sensations, emotions, and powerful human relationships. And experiential intelligence is also attached to the society that surrounds each individual with history and culture. A core purpose of schooling is to develop experiential intelligence through the study of academic subjects that reflect the accumulated wisdom of centuries, what we call human culture. From culture we inherit an understanding of the organization of the world that tells us what is important and deserving of notice, and what is merely background and not worthy

of our attention. Without these conventions of value and emphasis, we would be immersed in a colorful but always shifting and confusing landscape.

Reflective intelligence is the capacity and inclination to think about our own thought, and apply strategies and different approaches to complex problems. It is a kind of control system for the other two dimensions of intelligence. As the pianist plays, he or she also listens and adjusts touch, pace, and color to better approximate the "right" feeling in the music. Reflection relies on our experience, blends with it, and revises it, for experience is not what happens to us; it is the sense we make of what happens to us. It was reflective intelligence that enabled Copernicus and Galileo to upset Ptolemy's geocentric universe, and it is reflective intelligence that leads us sometimes to see beyond the sedimentations of past experience, culture, and perceptions that we know as reality, to the contradictions and inconsistencies of our own beliefs and understanding. Eric Booth (1999) reminds us that the arts interrupt what he calls the "gestalt default," our tendency to "grab something we notice and snap it onto a previously placed guideline. Artists learn to delay the mind's snap to a previous guideline long enough to perceive the specific feature of what is really there. They can intentionally disrupt, postpone, surprise, and challenge the matching process to allow for new understandings" (p. 79). Cynthia Weiss, a teaching artist in Chicago, gives small cardboard frames to children in a CAPE school to peer through as they look around the room. This simple act of identifying a scene for study interrupts the "gestalt default," inviting children to notice and engage a piece of their everyday world that has receded into the background. They are surprised by what they see.

The three dimensions of intelligence complement and transform each other. If we were to use a crescendo in music, a geometric progression of numbers, contrasting images of small and huge proportions, poetry that moved from spare, brief phrases to dense prose—all to express an idea of menacing growth—we would be mirroring the parallel processes that go on in our brains as auditory, visual, tactile, emotional, and language systems all respond synchronously to a physical threat. Le Doux (2002) tells us that working memory is involved in all aspects of thinking and problem solving, and cites Marvin Minsky's comparison of the functions of working memory to the aesthetic judgments engaged in rearranging a room of furniture: "You shift your attentions back and forth between locations. Different ideas and images come into focus, and some interrupt others. You compare and contrast alternate arrangements. You may concentrate your entire mind on a small detail one moment, and on the whole room the next" (Le Doux, p. 175). The visual, aural,

tactile, vocal, and kinesthetic experiences of art stimulate, exercise, and enhance our embodied and our cognitive ways of knowing our world. What is most important about Perkins' three-dimensional model is that it recognizes that intelligence, and reflective intelligence in particular, can be developed and learned.

These three resources—neural, experiential and reflective intelligence—are clearly implicated in Hardy Schlick's melting marble lesson. Neural intelligence is displayed as clay is pressed and pinched and rolled by the sticky fingers of these ten year olds. How thick must the wall be to hold the weight of the marble, of the molten glass? This kind of question stretches the body knowledge that walks us up hills and stairs and finds the light switch in the dark with our fingertips. Experiential intelligence operates as the kids remember water slides and pictures of molten lava. Maybe they have sat on the edge of the ocean letting wet sand drip between their fingers to make castles, maybe they have helped to paint the house, remembering the errant drip that escaped the roller, snaking its way down to the baseboard. Reflective intelligence is provoked by the terror of destroying the kiln. No opportunity for unbridled expression here, just so much, just so far.

CURRICULUM

Conversations about learning always address the question of how the subject that is to be learned should be presented to children. Should a topic be broken down to its smallest elements and built up from there? Should topics be nested in contexts that are important to the learner? These positions have been coded over time as part-whole, traditional-progressive, mimetic-transformative, basic-holistic (Jackson, 1986).

In this era of accountability and high stakes testing, student scores on standardized tests have become the dominant measures of learning and achievement. It is tempting for school superintendents, principals, and teachers, threatened with the loss of their jobs and their schools, to concentrate only on those subjects to be tested. They rush to the first term in these learning dichotomies, isolating content, employing traditional pedagogies of drill and repetition. They encourage mimetic versions of right answers, but drain variety, relevance, and interest from the curriculum as they push the basics. They reduce content to the world of the classroom, rather than using the classroom to make sense of the content of the world.

But integrated arts programs refuse to dichotomize learning and achievement. The evaluation studies of CAPE, AAA and other arts integration programs provide evidence that when arts experiences are connected to academic instruction,

achievement is sustained and increased, not diminished by this enriched curriculum. So, while we expect students in an integrated arts curriculum to improve on tests of reading and mathematics, we also expect them to participate in powerful learning experiences where they make sense of the curriculum just as they need to make sense of their experiences in the world. That is a high standard.

In an arts integrated curriculum we ask students to find order and form for their ideas and their feelings, as we hope that they will find order and form for their lives. We ask them to work together and find pleasure and interest in each other's ideas, as we hope they will when they form friendships, families, and civic associations. We invite them to bring their imaginations and feelings to their studies, as we hope they will connect their temperaments and abilities to enterprise that sustains them and promotes their interests. All these processes of making a life rely on our capacity to find life meaningful.

Contemporary theories of cognition also emphasize the construction of meaning. The research and theories of Levi-Strauss (1972), Piaget (1977), Jerome Bruner (1960), and Howard Gardner (1990) have dissuaded us from thinking of learning merely as the acquisition of discrete pieces of information. Contemporary cognitive theory is persuaded that learning involves developing webs of concepts and categories we need to interpret and order our experience. Concept formation requires analysis—pulling things apart to know and name them—and synthesis—bringing things together. The complementary processes of noting differences and similarities, of separation and connection, are rhythms that pulse through our identities, our politics, and our cognition.

We bring the arts into the curriculum of academic subjects because to experience or to construct a work of art requires careful interest in the parts of the piece and the ways they are combined to make the painting, the dance, or the play. Because any art work—Mona Lisa, or the first grader's self-portrait—marks the world as seen by a particular artist, at a particular time and place, the arts require the lively presence of the learner. The arts require choices that rely on our attention and the specificity of our own thoughts, feelings, and understanding.

In contrast, early theories of instruction assumed that the best way to learn something was to break a topic down to its smallest elements, learn them, and then add them together. In reading instruction we would start by teaching letters, and after they are learned, combine them into words for reading. But why would any child want to learn letters by themselves? They mean nothing. Combined into simple words like mama, apple, dog, they refer to a world of love, appetite, and

excitement. And so the teaching of reading uses sight vocabulary from the start to let children know that reading is full of meanings they care about.

THINKING AND LEARNING

The conventional patterns of schooling, David Perkins (1992) wisely observes, are precisely backwards. In most schools, most of the time, students are expected to acquire knowledge—from texts or teachers' lectures—and then think with and about that knowledge. But "learning," Perkins reminds us, "is a consequence of thinking. Retention, understanding, and the active use of knowledge can be brought about only by learning experiences in which learners think about and think with what they are learning" (1992, p. 8). For Perkins thinking comes first, and knowledge is its consequence.

But, what is thinking? Robert and Michele Root-Bernstein (1999) have studied reports by eminent thinkers on how they think in many disciplines. From these reports, they have identified a set of thirteen mental operations they call "thinking tools". These operations are used consistently across divergent fields— science, mathematics, history, philosophy, theater, painting, writing, and music. Thinking almost always begins with non-logical, non-verbal operations—feelings, intuitions, and senses. Recall Larry Scripp's description of the relationship of music and mathematical processes in the learning of the children in the Lab Charter School. In finding pitch one must sense the interval, feel the relationship between the note and its key, the note and its triad, the note and its precursor. When children sing, they are feeling and thinking intervals before they represent them with notation or read them on a staff. They are feeling the beat that gives coherence and unity to the piece before they can count. Their tapping feet or clapping hands measure the time between downbeats. Quarter notes and half notes have value only in relationship to measure, the whole of which these fractions are a part. The same is true for music and language. When children learn to sing songs like "Pop, Goes the Weasel" or "Three Blind Mice" the musicality of the words provides contextual clues to their meaning before they can read or write them.

The logical, verbal, mathematical, and scientific dimensions of thinking, symbolization, and communication rest on this pre-logical foundation. The Root-Bernsteins (1999) offer a rich menu of examples of these tools in action, constantly emphasizing that the foundation of thinking is in the embodied human nervous system. Thinking is not something that we do with our brains alone. It is something that engages our brains with the world through our bodies. These operations

are the constituent parts of thinking. They are also intertwined with subject matter in the curriculum:

Observing: patient, detailed, sustained perception

Imaging: forming mental representations of the world when we do not actively perceive it

Abstracting: paring down complicated things to simple principles

Recognizing patterns: discovery of repeated structures in nature, mathematics, rhythm, music, movement, language

Forming patterns: combining and repeating structural elements or operations

Analogizing: identifying shared properties in two or more different things

Body thinking: drawing preverbal and preconceptual intuitions from our bodily sensations and responses

Empathizing: sensing the lived experience of another person or organism, or thing

Dimensional thinking: imagining an object in another domain, from two to three spatial dimensions, or from present to future time

Modeling: creating a virtual, mental, imaginary, or physical representation of a concept, idea, object, or set of conditions

Playing: irreverent and imaginative reordering of conventions and rules

Transforming: serial or simultaneous use of multiple mental operations

Synthesizing: bringing together many of these operations in understanding the world (Root-Bernstein & Root-Bernstein, 1999, pp. 25-27)

These are the thinking operations we use to construct a new energy policy, direct a play, choreograph a dance, or vote. They are the actions going on in our minds when we shift from decimals to fractions, speculate on transmission of SARS across the world's population, or transform a Virginia Woolf novel into a play. These are the cognitive processes we employ as we make sense of our experience. They are operations of deeply immersed and engaged thinking. It is important to remember that when we talk about learning the curriculum, that curriculum is not just content. It is the processes we design to help students think about these topics' content by using these tools.

For example, when we study history, we expand our perceptions as we seek and identify pertinent data. We note distinctions between what we have found, checking veracity, sources, and consistency. We interpret the significance of this information by considering the context that surrounds it, weaving those associations into our understanding; and we make connections among the pieces of information that we have discovered, designing the logic and meaning of the story we call history.

When we join the arts to learning in the academic disciplines, most often verbal and discursive, we introduce other forms of expression and communication that are embodied and engage our senses through imagery, gesture, texture, color, sound, and movement. We also bring processes of exploration, expression, and interpretation that are deeply felt and intensely experienced into the classroom.

That is why the art teacher and the social studies teacher at Agassiz School work together as they teach the American Revolution to their fifth graders. The students have read the history text and studied Tom Paine, the Boston Tea Party, and Paul Revere. On the day I visit their classroom, the children are working intently at their desks, designing posters that urge the colonists to join the war for independence. The art teacher has taught them techniques to make their message visible: the use of borders, lettering, and contrast. The students have looked up World War II posters on the web and talked about the visual imagery of that era compared to colonial times. They have discussed our impending war in Iraq and imagined the posters that might be developed today. As they draw their posters, they reclaim the Revolutionary War as an argument, a persuasion and a decision. When learning relies only on text for its representation, moving from textbook to homework to classroom discussion, children have difficulty finding a way to connect to curriculum. But these children own their ideas.

The capacity to think about your own thought, often called metacognition, is a characteristic of school success and accomplished learners. When diverse and interpretive practices join the text-centered curriculum, students have many more opportunities to catch themselves in the act of thinking. Because the arts invite originality and idiosyncrasy, they reveal authorship, and each artwork, poem, or painting reflects the ways that the artist, da Vinci or our first grader, has thought about the world. Because art produces things that other people can see, hear, and feel, it brings evidence of an individual's thought into social and cultural spaces where other people can pay attention to it, argue with it, and care about it.

In an era yearning for the simplicity and control of bottom lines, high stakes

tests, scripted instruction, and basic skills, the thinking processes described above may seem too elaborate for fifth grade history or high school chemistry. Nevertheless, the distinction that Davis, Luce-Kapler, and Sumara (2000) draw between complicated and complex systems supports our contention that learning through the arts belongs in schools at all grade levels. Complicated systems such as airplanes or watches "are predictable sums of their parts. Their behaviors are planned, directed, and determined by their architectures" (p. 55). In contrast complex systems, like weather, economies, or the human brain "exceed their components. They are more spontaneous, unpredictable and volatile—that is, alive— than complicated systems. [They] are self-organizing, self-maintaining, dynamic and adaptive" (p. 55). Human learning depends on the complex interactions of several complex systems. To imagine that education could be reduced to the predictable mechanics of a complicated system is a denial of the fundamental nature of learning. When learning communities are recognized and organized as complex systems, they fit and support the vitality, adaptability, and creativity of the human beings who teach and learn within them.

The meaning we seek in the world is not only a complicated set of recognizable patterns and structures, as proposed in cognitive theory, but also a complex system whose structures provide a home for our deepest hopes and grandest adventures. And the arts, mixing material with fantasy, hope with memory, form with possibility, and individuality with community, are powerful processes of making meaning.

ARTISTIC TEACHING AND LEARNING

Because art making allows idiosyncrasy, mining individual experiences and memories, it invites a sense of ownership and responsibility for the forms it produces. It is easier to think about our own thinking when we can recognize it as our own, and the engagement and individuality of art making invites this ownership. Elliot Eisner (2002) celebrates the independence and responsibility of thinking that flourishes in arts education: judgments that must be formed in the absence of rule; goals that can shift and evolve in the process of art making; recognition of the unity of form and content; thinking within the possibilities and constraints of a particular medium. We all have experienced the excitement and anguish in art making when we try to bring an intuition to form for the first time. Now and then what emerges is "just right." But more often the writer or painter feels a slight or cavernous gap between what the artist is trying to communicate and what actually

appears on the page or the canvas. This journey from inspiration to production invites the recapitulations of reflective intelligence, the modifications of organization, emphasis, and the new approaches and recombinations of metacognition, all coordinated and related in the process of making something.

Peter Abbs (1982) reminds us that our words for poetry are derived from the Greek word *poieen*, meaning "to make." The Anglo-Saxons actually called the poet, "maker". The word "art" also holds a history of fabrication. It derives from the Latin *ar*, meaning "join," "fix," "put together" (p. 108). When the arts are integrated with the academic curriculum, students make things that express their understanding of the phenomenon being studied. Even when students perform a dramatic text word for word, they are not performing the text; they are performing their understanding and interpretation of it. We know that when we want to test students' understanding of instruction, we often ask them to describe the content they are learning in their own words. That work of translation from one code to another, anchors their understanding. When students have the opportunity to encode their understandings in something they make—a play, a mural, a sculpture, a dance—they bring their thoughts and feelings together in a cultural object that they and their classmates can think about, for thought, translated into art, provides experience. In arts integration classes, students experience each other's ideas.

Suzanne Langer's (1957) work has helped us understand how the arts contribute to the shared and codified ideas about the world that we call knowledge. She defines a work of art as an expression of knowledge about feeling and teaches us that each art form emphasizes a domain of human experience by creating a virtual experience of the world where we can play with its properties, test its limits, and encode our experience (Langer, p. 8). Music, for example, makes time perceptible by giving form and expression to elements of duration, interruption, extension, and repetition. Painting makes space visible by giving form and expression to elements of presence and distance, continuity and separation, enclosure and expansion. Space and time are where we live. "Our lives", Daniel Barenboim and Edward Said (2002) tell us, "move like music, from silence to silence" (p. 29). When music expresses duration it is not only measuring time in minutes and periods, it is also filling time with languor, or impatience. When painting expresses enclosure or expansion, it is not only ordering objects according to scale and perspective, it is placing a frame around the scene that the painter has decided is worthy of notice, giving size and light to thought and feeling. Despite centuries of anxiety about emotion that have separated thinking from feeling in schools, programs integrating

the arts with the rest of the academic curriculum show that we learn what thrills us with risk, what warms us with applause, what beckons to us to lean just over the edge of the familiar, what comforts us with harmony and resolution.

WE LEARN WHAT WE CARE ABOUT.

Here is one example: In Rochester, New York, Paula Salvio and I brought theater work to a class of young ESL children taught by Chojy Shroeder. Hoping to engage her children in reading and writing, Chojy had been asking children to read, edit, and make suggestions to each other for improved drafts. Sweet and compliant, the children followed her instructions, but their suggestions were repetitive and empty, for they had no particular stake in each other's narratives. We asked the children, instead, to perform each other's stories. After enacting one little boy's description of a trip to the zoo, children gathered around the table. This time they had wonderful language for the world of his story, for they had inhabited it with their bodies, memories, and imaginations as they played the parts of the boy, his friends, and family, the polar bear, tiger, and giraffe. Through performance they had participated in his world and that enactment brought language both to them and to him. They had lived for a little while in the world of his story, and now their suggestions were grounded in a shared desire that the story's language convey the fun, furious beauty, and rambunctiousness that they had performed.

The creation of this art of understanding justifies our habit of bringing children together to learn reading and writing, mathematics, and social studies. Why do we read books with other people? It cannot be just to keep our eyes on our own pages. As we join others to make sense of a common experience, we are learning the skills of democracy, the capacity to appreciate what is different within what we share. The creation and presentation of art objects that express ideas and feelings move classroom discussions from debate to the conversations that take place in the theater and the museum, and permit students to empathize with opinions they oppose.

If learning is a complex system that grows and changes from the interaction of its parts, then it makes sense that bringing the parts of education together will facilitate learning. The arts and the academic disciplines differ in their forms and codes, their social histories, rules, and roles, but they all address the world we care about. History addresses the shaping of our lived world, helps us understand ourselves as we study the stories of those who have come before us, and helps us learn which stories are reliable. Literature and poetry regale us with images of human

possibility and permit us to feel the range of our own wishes and ideas, as well as those of others. The sciences help us understand the natural and physical world, how to protect ourselves and extend the boundaries of our perception. Mathematics makes it possible for us to think about patterns and relationships so that we can understand and predict the behavior of things we cannot touch or see.

If the academic disciplines seem abstract, text-bound and irrelevant, it is only because we have allowed the forms that they take in our children's classrooms to become abstract, text-bound, and irrelevant. When we blend academic disciplines and the arts, we restore the worldliness and cogency of the disciplines.

One might be tempted to consider the variety of contexts that appear in these curriculum integrations as distractions, akin to the "keep it moving, keep 'em busy" rationale of video games, action movies, and much of children's television. But this diversity and integration are powerful contexts for cognitive development. They represent what David Elkind (1976) calls horizontal elaboration:

> A child who has learned geometric forms, such as circle and square, can elaborate these skills by looking for circles and squares in all spheres of his experience. He can discover that coins, wheels, and doughnuts all are circles. Through this elaboration of his experience he arrives at a general concept of circles that, combined with general concepts of squares and triangles, will lead naturally to the more general concept of geometrical forms. The horizontal elaboration of experience multiplies the variety of the child's encounters with a concept and renders it at once more general and more susceptible to vertical integration within a broader more abstract conceptualization. (p. 122)

In the 1980s, I worked with preservice teachers at Hobart and William Smith Colleges, and asked students to identify the assumptions and convictions they brought to teaching. I received this narrative from Mary Lavin:

> I remember sitting in Sister Marie Therese's kindergarten class sometime in November when I was five years old. I was sitting at a brand new blonde wood table with a shiny Formica top, cold to the touch. The table was near the window, the glare of which reflected all around my workbook. My book was open and the assignment was to do rows and rows of letters. This day was for the letter V.
>
> I was about halfway down the page of V's when something reflecting on the table caught my eye. It looked like lots of flying V's. I looked around and saw in the sky migrating geese, and they did look like

V's. They even flew together forming one big V. I was amazed. I never saw anything like this before. Those geese flew away and as I looked around for more, I saw the upside down skinny V the church steeple made against the sky, and the fatter also inverted V's of every roof of every house. Every branch of every tree seemed to make V's. The street corner, where Mr. Strang the crossing guard stood, was the bottom point of the biggest V in the whole world.

I laughed out loud to think what Mr. Strang would say if I told him he worked on the world's biggest V. Sister heard me laughing and called me up to her desk. She wanted to know what was funny. I told her, everything. About my page of V's, the geese, Mr. Strang, and how everything seemed to have a V in it. She smiled, said I was being silly, patted my head and told me to go sit back down and finish my work.

I was feeling so happy, so accomplished that her disinterest didn't faze me. I was boldly confident in my discovery, and actually felt she was missing out on a biggy. For my last row of V's on the page I made them flying away geese with little feet hanging down. This was my first recollection of drawing from real life. It, drawing, was and still is an important part of my life. (Grumet, 1992, pp. 28-29)

The junctions crossed in this narrative link text, community, nature, and school. The operations of observing, imaging, noticing patterns, forming new patterns, abstracting, transforming, analogizing, and synthesizing are all present in Mary's epiphany. What is formal and abstract, the letter V, becomes intertwined with a system of meanings tied to this child's world. Sister Marie Therese smiles and pats Mary's head, but she doesn't celebrate her discovery of relation, expressed in her insight and drawing. I don't know if Mary ever told Mr. Strang, the crossing guard, but I do know that after twenty years, Mary told the story again, this time to me, when she was studying to be a teacher. That was years ago, and I am still celebrating.

Rogoff and Gardner (1984) argue that "generalization from one problem to another is a function of the individual searching for similarities between new problems and old, guided by previous experience with similar problems and by instruction in how to interpret and solve such problems" (p. 96). But Rogoff and Gardner cite research by Glick and Holyoak, showing that people often do not recognize the link between subject matters nested in different contexts until the underlying similarities are pointed out to them. As teachers work with each other and with teach-

ing artists to bring the arts into the curriculum, they find that the process of constructing an integrated curriculum requires them to make the similarities between the elements they wish to blend together explicit. As they work to articulate the themes, processes, and content that they are bringing to the table, each offering is specified as it is presented for integration. These conversations are essential to teaching. They are fueled by the rich associations of experience and emotion that teachers bring to the curriculum. If art integration animates students, it profoundly engages their teachers as well, for in these conversations their own construction of curriculum becomes artful.

These conversations are essential to children's learning, because, as Vygotsky (1978) has pointed out, children cannot develop an internal understanding or capacity that does not first exist in the relationships and operations of the society that surrounds them (p. 57). David Perkins (1994) invites art into the curriculum because it encourages thinking that is "broad and adventurous, clear and organized"(p. 4). That means that teachers need to work and think in broad and adventurous, clear and organized ways. Just as we cannot teach participatory democracy in authoritarian classrooms, we cannot teach deep thinking in classrooms drenched in routine and cynicism. We learn what we care about—and we learn what the people we love care about. This is a form of transfer, of mimesis, as children adopt attitudes and dispositions of the people who surround them in their homes and schools.

These processes of art—abstraction, recognizing and forming patterns, analogy, and modeling—support another form of transfer, essential if learning is to be meaningful to us outside of the classroom and the laboratory. How are citizens to make sense of our ever-surprising society, of our constantly changing jobs, partners, children, or ozone layer, if we cannot extrapolate from past and similar experience? Now this is not a formula that slaps the past over the present expecting endless replication. Recognizing specificity and noting distinctions are part of this process of analogy. The presence of art experience in this process accentuates a commitment to detail, because art does not communicate its message in generalities. Even the creation and reception of visual art is an event, placed in time and space, responding to a specific version of our common world. Nevertheless, as multiple, highly specific representations of a single problem or phenomenon are constructed, an abstraction that indicates what they all share, or how they vary emerges. Such abstractions, constructions built from the varied materials of everyday practice, offer us intellectual flexibility and fluidity as we approach our worlds. (Bransford, Brown

& Cocking, 2000). The Schlick sculptures take many forms, from a temple to a platform shoe, but the principles of motion, force, and gravity operate in all of them. The street corner, the church steeple, and the flying birds are all specific perceptions for Mary. They sustain her concept of V without collapsing into it. The capacity to tolerate the tension between the specificity of an individual instance and the generality of the group of instances is also the tolerance that supports a democratic and multicultural school and society.

"Conceptual blending" is the name that Giles Fauconnier and Mark Turner (2002) give to these processes. Their portrayal incorporates the transfer of information from past experience, but also emphasizes the new ideas and understandings that can emerge when material from more than one domain are brought together. They designate four spaces:

Input space I

Input space II

Generic Space

Blended Space

Fauconnier and Turner (2002) work through many variations to show how we blend what we already know with new and unfamiliar experiences to learn something new. This is the work that I observed in CAPE classrooms: not only complicated combinations of arts and academics, but complex events bringing together relationships, processes, disciplines, and media. The Fauconnier–Turner model is a powerful heuristic for the descriptions of classroom practices of integrated arts programs that follow.

THE THIRD SPACE: INTEGRATED ARTS IN CLASSROOM PRACTICE CHEMISTRY IN SILK

In *Renaissance in the Classroom: Arts Integration and Meaningful Learning* Gail Burnaford, Arnold Aprill, and Cynthia Weiss (2001) provide vivid descriptions of the ways that art making and study in the disciplines inform and augment each other. High school chemistry instruction is usually extended into laboratories where students get the opportunity to mix solutions, although these are rarely solutions for which students have a use. Sophomores at Lakeview High School create designs for pieces of silk. Chemistry teacher Pat Riley and textile artist, Eleanor Skydell work with students studying acids and bases to make the dyes that will create the colors and patterns they have envisioned. This approach does not sacrifice a study of chemical molarity in solutions to creativity. The concept of acids and bases is one of the oldest in chemistry, dating back to the 17th century when acids

were used to change the colors of dyes extracted from leaves or plants. While Pat Riley's students work through the process of hypothesis and experimentation, they are also pulling colors from nature that capture the vivid kaleidoscope in their minds.

Notice how this integration of chemistry and textile art provides a new space that invites the students' interpretations and resymbolization of the disciplines. Many of these successful projects rely on this generic space, an unmarked field—in a world crowded with media, messages, words, and distraction—that can elicit, hold, and display the sense that students make of what they study. The generic space becomes the blended space, or new knowledge.

LITERATURE AND HISTORY IN A CODEX

A codex provides this generic space in the collaboration of art teacher Amy Vecchioni and English teacher Linda Garcia at Waters School in Chicago. Mayan and Aztec texts were inscribed in picture language composed of designs called glyphs, and assembled in an accordion style book, called a codex, that held their stories, history, and the passage of time. Continuity is literal as the codex unfolds into an unbroken stream of images. The English curriculum requires the eighth graders to read *The Pearl*, Steinbeck's novel about a poor fisherman in southern California. Throughout the novel, Kino, the main character, sings his life, creating songs of family, evil, the enemy, and the sea. It is a tale that moves from happiness to despair, as Kino finds a pearl that promises prosperity, but ultimately separates him from the joys that animated his life and relationships. Vecchioni works with her students to recover the artwork of Mesoamerica and to use its images for their readings of *The Pearl*. She shows the children pre-Columbian designs and has them choose a design to represent each of Kino's seven songs.

These 8th graders empathize with his desire for prosperity, his love for his family, and his fears and losses. Many of them have emigrated from Mexico and, like Kino, share a hidden cultural history. The art project requires the students to interrogate their own responses to the book, for they are held to a minimalist representation of those feelings and thoughts as they select the design and the colors that seem to best capture them. Here again are the moments of judgment and consideration that Eisner has identified as significant artistic and educational processes.

In groups of six, the students print their glyphs on codex paper they have washed in watercolors. Note that in this project where literature and social studies point to loss, Vecchioni teaches the children a printing process that ameliorates

the erosion of culture by providing multiple copies of their ideas and images. The groups select a glyph that best represents each of Kino's songs and choose the order of colors to best represent the moods of the narrative as it moves from its beginning to its sad end when "the music of the pearl drifted to a whisper and disappeared" (Steinbeck, 2000, p. 90).

Interpreting text is a challenging process in many literature or arts classrooms. Teachers struggle to find a path to meaning hospitable to the individual student's understandings and the group's discussion and judgment. How do you encourage children to invest in reading and in the ideas they draw from it, and then ask them to acknowledge other interpretations? The protocol for criticism and interpretation that emerges in this project provides a structure and process for inquiry and judgment from their readings of the text and their creation of forms to represent those understandings. Sharing their various interpretations of the text, the children select the interpretation they can agree on as well as the glyph which best represents it for their group codex. Vecchioni and Garcia intertwine individual and group processes as children bring their images together to create a codex of their collective reading. This is how culture moves and grows, as one generation reads the work of another and answers it with new work that represents their lived understandings.

When children understand literature as something meaningful and complex, they sense its capacity to inform their lives. This is the kind of literacy that influences reading scores in middle school and high school, when we often see the gains of intensive reading instruction diminish in national assessments. In contrast, it is worth noting that James Catterall and Lynn Waldorf (2001) found some improvement in 3rd grade reading scores in CAPE schools, but significantly greater improvement in 6th grade reading scores, a distinct sign that reading gains persisted past 3rd grade in that arts integrated program.

This enriched literacy curriculum challenges a 21st century reality of Latino children who live through emigration, assimilation to a new situation, and a media culture that has buried their cultural history. Vecchioni and Garcia recuperate the forms of their Aztec and Mayan ancestors to provide a visual vocabulary for their grasp of the Steinbeck text, and resist Kino's despair and the loss of a brilliant pre-Columbian culture. What is the point of showing immigrant children the richness of their eclipsed cultural history as they struggle to make their way through the poor neighborhoods of Chicago? Vecchioni and Garcia have turned loss into creation, interruption into continuity. In the making of the codices they have pulled

the past into and beyond the Steinbeck text, showing these children how they can use the making of art to recover and recreate a rich life. In this way they enact the transformative processes of art and literature, not as esoteric experiences granted to the gifted, but as everyday possibilities. They also provide a multicultural curriculum that acknowledges the struggles and losses of cultural politics without reducing that history to nostalgia, split off from the agency and energy of these children's vivid everyday lives.

SCIENCE IN A CD: BEYOND CRITICAL THINKING

The generic space Nick Jaffe offers his students to mediate the curriculum and their experience is a blank compact disc. Jaffe integrates music and science in a charter school organized by the Chicago Children's Choir.[3] Music provides the arts focus for classes across the curriculum. I watch Jaffe teach a lesson on sound waves, distinguishing between rarefaction and compression and showing the students how waves can cancel each other out when they cross. The lesson is fairly conventional, with Jaffe presenting some information, asking students to speculate on hypothetical situations, and to draw diagrams of the widely spaced or compressed molecules.

But then the beat changes. "Move around the room as I throw some sound at you," Jaffe says, as he works the oscillator, and they note where the volume is louder and softer, where the chairs are vibrating, where they are still. Feeling this knowledge with their bodies, hearing it as they move, these students are enjoying a solid activity based curriculum. In the land of science demonstrations, of baking soda volcanoes, magnets and iron filings, this is pretty sophisticated. But after Jaffe has taught them to identify the node, the place where sound waves cancel each other out, and the anti-node, where they reinforce each other, he asks them to use this information in placing the mikes for their recording session.

The students listen to a recording they have made. They comment on what they like and want to retain, and what they would like to change. There are three vocal tracks, echoes on top of echoes. They wonder about intelligibility. Jaffe teaches them the word, "ambiguity". They like the variety of moods that the three tracks contain, but some think that some of the vocals are too prominent. Then there is discussion about the purpose and range of their critique. Are they being too negative or positive? When one student worries whether they are being too critical, one girl parodies what usually passes for classroom critique: "OK," she declares, "I liked it. It was wonderful!" And Jaffe, supporting her irony reminds them

that they must listen as engineers.

Educators trying to transform the passivity that characterizes students in many classrooms, often encourage their activity under the rubric of "critical thinking," seeking strategies and assignments to provoke students to bring reasoned, independent judgment to topics in the curriculum. Students are asked to develop arguments that express diverse points of view in discussions, debates, or simulations. The problem with this approach is that it overstates students' interest in these topics. Kids like games and will respond to an adversarial debate process, but the contest becomes the point, and because the content is not connected with their own experiences, their learning remains largely rhetorical. The discussion and critique that Jaffe's students use to argue for the sounds they want to make and hear are generated by their investment in the music and the necessity to work together to make their own CD. We learn what we care about.

After their critique, the students move to their places on the new ground. Some are typing out the lyrics on a computer: "We started out high school sweethearts…" Others are practicing the percussion and guitar accompaniments, working to get the rhythm down right. Some are measuring the distance from the instruments to the mikes. One smiley fellow works the console, coached by Jaffe, earphones and all, moving to the beat of the percussion that he is recording. A boy and girl work together at another computer, learning how to use a program that provides various rhythms. In e-mail correspondence, Jaffe reflects on the lesson I observed:

> While I feel the hard science and craft elements of our work is essential, the affect and context that we (me and the students) experience in that studio is typified more by the production work. When the students think of "recording class," I think they think of that sort of noisy buzz of activity and argument that culminates in a few silent minutes of tracking, followed by playback, critiques, rethinking, and more activity, etc. At the center is the palpable, and usually exciting idea that very soon there will be a finished recorded work that lots of people are going to hear. It's very hard to get them out of the studio at the end of class, and there are always a huge number of students who want to spend their study hall there. I think it's because they feel that it is their workspace where their natural work style is encouraged. I think that the loose atmosphere actually makes it possible for me to be a more provocative and active critic without inhibiting the students creatively or intellectu-

ally. They know they can tell me to go to hell if they don't agree with my critique. And often they do!

When the students are in production mode I try to make a habit of "going on break" and leaving the room from time to time. I will do this sometimes even when they aren't working that well together. As long as I don't feel that there's a risk of an actual fistfight breaking out, I'll leave, sometimes for twenty minutes at a time. (I'm nearby, of course, in the hallway.) They work very differently, both as individuals and as a group when I'm not there. I know because I used to watch surreptitiously through a window in our old room and I've had kids video-taping more recently. They are often more focused, purposeful and exacting of themselves and each other. Sometimes students who do not integrate easily are left aside as I am not there to help them find a place or way to work. But sometimes the other students will take over my role in helping these kids find a place. In any case, I think the experience of "doing it on your own," even if episodically, is really important in learning for children, just as for adults. When the emotional, technical, and intellectual safety nets of teacher authority are absent, it feels like one's brain just seems to ratchet up to a higher level of intensity and receptivity.

These are middle schoolers. Their song is called "Sweethearts."

So, what is science about if not discovery of how to predict and control the forces that surround us and affect our lives? Here science is about learning how to control volume and sound in a song about the joy and pain that can be predicted but cannot be controlled. Jaffe makes it clear that his integrated music and science curriculum is about making music and making community, and about controlling waves of feeling and impulse that are both external and internal.

STRUCTURE IN DANCE, ARCHITECTURE, AND CITY PLANNING

The generic space in the Hawthorne School's Structure Project is laid out as students in groups of six create city plans. This is an extensive 3rd grade unit, planned and accomplished by social studies teacher Aric Arnold, visual artist and teacher Lauri Malee, dancer Angie Phiefer, biology teacher Tricia Rowland, and architect Andy Wang. The instructors collaborate to intertwine the children's studies of structure—the relationships of parts that make a whole—as it occurs in dance, the human body, architecture, city planning, and government. Students understand

the interrelationship of forms kinesthetically as they find the body postures that represent arches, columns, cantilevers, domes, posts and beams, vaults and trusses. They study a building as a system through architecture. They analyze Burnham's plan for the City of Chicago, design their own street grids, and arrange the placement of buildings that will supply essential civic functions. This physical system of the city is also compared to the interaction of the physical systems of the body, and the representative and administrative systems that govern the city.

If the project stopped here, it would comfortably inhabit the conceptual space of horizontal elaboration, making analogies among the parts and whole structures of complicated systems. But the students also join each other in groups to create their own city plans. They need to organize their city into wards, as Chicago is organized, but then they have to determine what buildings and functions they will require for life in their ward to flourish. In this process, they encounter the demand that the allocations of space and the investments of location and design serve the needs of people. The process becomes political, and the students are learning not only what is involved in the replication of structure, but also, what is required to transform it.

BLENDING SYSTEMS OF REPRESENTATION

In the three preceding vignettes, the blended space, where students encode their understanding of the academic and the arts curricula, holds symbolic representations drawn from more than one symbol system. Riley and Skydell use textile art and chemistry. Vecchioni invites students to draw on literature, history, painting, and printing. Jaffe invites students to draw together the vocabulary and diagrams of science with music and technology. And the Hawthorne team moves the children back and forth between architecture, dance, diagrams, model building, biology, and civics.

Patrick Mitchell, a music teacher at Cameron Park Elementary School in North Carolina, and Phillip Hochreiter, whose focus is literacy, offer another version of this movement among symbol systems. Their school is a participant in the arts integration project of the Research Triangle Schools Partnership, a consortium of public schools and the School of Education at the University of North Carolina at Chapel Hill. Mitchell and Hochreiter are working with first graders, children developing foundational attitudes toward literacy, reading, writing, and the use of symbol systems to communicate. Notice the shifts that take place as the children switch codes from speaking, to hearing inflection, to graphing, to composing, to

painting, to writing, to movement and performance.

Children start with a short sentence describing a teacher. "Miss Hale is very intelligent," for example. The children speak their sentences into a recorder and then represent them visually in a graph that traces their voice inflection syllable by syllable. The graph is converted to musical notation, and the notes are played on a synthesizer and recorded. The children order the musical phrases and link them together in a longer piece of music. They experiment with organizing the sentences so that they fit together as a narrative. They experiment with rhythms and sounds, using music to imitate the narrative order of exposition, conflict, climax, and resolution. They arrange their graphs to make a long visual picture, and then translate the graphs back into musical phrases played as one composition.

The children choose one version of their collective melodies as their musical theme. They interview the teachers upon whom their characters are based, and write poems about them—haikus, acrostics, and natural rhymes. They adapt the main melody with rounds and harmonies to suit the poem. They develop ideas for sets and movement. And finally, they perform their poetry and music in a theatrical production.

The virtuosity of these teachers is breathtaking, as is the capacity of first graders to move through this series of transformations. Significantly, the students are also developing some of the word "attack" skills (breaking words and sentences down to their syllables for spelling, narrative structure for writing) required for end of grade tests. These literacy strategies are emphasized in every elementary school in North Carolina, but when they become part of a child's expressive repertoire, and part of that child's performance with peers for parents and friends, literacy is not merely a strategy for scoring well on the test. It is the power to communicate what you think, and to thread your thoughts into the fabric of your community.

We can think of the curriculum areas in the academic disciplines and the art disciplines (molarity and textile design; literature and visual art; science and music; social studies, biology, dance, architecture, and visual art; reading, music, mathematics and visual art) as the inputs in the Fauconnier-Turner (2002) model. That third space (the blank codex, the new CD, the theater) marked out for the children's sense-making is the generic space, and it becomes the blended space once they have encoded through painting, writing, performing, and building their old and new understandings.

To this space we bring what we have. In bringing our math and history, our physics and dance, our painting and readings together, we make something new.

This was, in Dewey's (1899) vision, the space of the school. Students learn the semiotics of democracy in these integrated arts programs that blend symbolic representations. They learn that there are differences in people's experiences, interests, and cultures. They learn there are different ways of expressing similar things. They learn that powerful ideas can be apprehended through multiple and diverse representations.

INTEGRATION AND DIVERSITY

A brief comparison of an urban and a rural arts integration program may illustrate the cross-cultural participation these curricula encourage. The Curriculum, Music and Community (CMC) project of the School of Education at the University of North Carolina at Chapel Hill brings indigenous music into classrooms across the state. Local blues, old-time, jazz and gospel musicians are teamed with classroom teachers to bring music to the study of literacy, social studies, science and mathematics. This music may be new to some children who do not hear its echoes in rock, hip-hop, or rap. But to others, it is the music they hear in church, on their front porch, or at their grandmother's house. Because the culture of schooling is so often bland and standardized, we create a cross-cultural curriculum when we bring the sweet and poignant sounds of this regional music into school lessons. CMC teachers may connect the music to oral history, writing, a study of bow length and sound, or the mathematical values in the beat. As they make these connections they are building a bridge between many of these children and their families and schools. Parents come to the school to perform this music, and parents come to the school to share what their children have learned.

This music also speaks to the children in the New York City schools that work with the Lincoln Center Institute for the Arts in Education. The Institute brings arts repertory to schools, escorted by teaching artists who work with classroom teachers to make connections between those art works and their classroom curriculum. That arts repertory may include a dance by Merce Cunningham, a Bach prelude, or in this case, *Fire on the Mountain*, a roots-music band that plays Appalachian music, derived from a blend of Irish, English, Scottish, Afro-American and Native American music. Their song, "Dream of a Miner's Child," presents a father's plaintive request to his son not to go down to the mines as he has done. When the Institute brings *Fire on the Mountain* to Allyce Fucigna's P.S.191 second grade social studies class, she ties it to their study of urban and rural communities. Old time music provides experiences that evoke identification with places and peo-

ple these students have never seen, yet city kids find parallels in their own families to this struggle of generations, and use the music to tell their own stories.

For some time we have been working to acknowledge the diversity of the population of our country by diversifying the curriculum so that it represents the literatures and worldviews of nationalities, ethnicities, social classes, and genders. Despite the efforts and resources devoted to this worthy project, the time and space of the curriculum will never expand to include all these materials for each of its topics. Choices must always be made. Arts integration processes augment multicultural curricula by providing a broad repertoire for interpretation and expression of focal texts and disciplines. If children are provided with the opportunity to resymbolize the content of the curriculum and to present this resymbolization to the people who form their class, school, and neighborhood, multiculturalism flourishes in the display of diverse responses to common material. Furthermore, because the arts blend imagination with experience, the expression of specific cultural practices becomes figurative, not merely literal. We are where we came from, and we are where we are going. We are who our parents are, and we are who they are not. If we hope to invite cultural specificity into the classroom without dividing classroom and communities into defensive enclaves of identity politics, we need the flexibility and openness of the arts to provide for the expression of evolving and dynamic identities. We are complex students and teachers, from complex cultures, in complex schools, sharing a complex world.

THE POWER OF LEARNING COMMUNITIES

The tension educators encounter as we work to address the interests of individual children and the interests of the whole community of children is deeply connected to other issues that surround learning in the 21st century. We struggle to address the ancient tension between knowing and feeling inherited from centuries of celebrating the triumph of rational thought over fantasy and superstition. We are haunted by the ambition to escape working class immersion in manual labor, an aspiration that idealizes and dissociates thought from the sensuous, physical act of making things. As we struggled to make learning a thing apart, a meditation, we also generated a politic that removed schools from their communities, from families, and from politics. Finally, we burdened the people who teach our children with the weight of all these abstentions: Don't feel. Don't move. Don't talk. Don't act. Work alone. In arts integration schools teachers do not work alone. They work with arts specialists and teaching artists instead of leaving to grade papers or get a

coffee during the arts class. Together they plan an educational process that intertwines art and academic curricula. And the teachers go with their students to museums and theaters, parks and concerts in their communities. They work with parents, grandparents, and community members who come to perform, share their skills, or just help out. And teachers in arts integration schools work with each other.

Arnold Aprill (2003) points out that these collaborations don't happen by accident and lists these CAPE commitments to learning communities:

1. Long-term professional development of teachers and artists, rather than the short-term provision of services to students;

2. Committed time for planning and investigating meaningful connections between arts learning and the rest of the curriculum;

3. Long-term relationships among schools, arts organizations, and community organizations to form a professional community that reflects upon and deepens the quality of instruction over time;

4. Connecting intellectual and aesthetic assets of the community in generative relationships with each other. (p. 57)

Arts integration lessons offer the same opportunities to teachers that they offer to children: the opportunity to make a connection among the discourses of mathematics, science, history and literature, and life experience, imagination, and creativity. Good teaching shares many of the properties of good art: presence, communication, intellectual provocation, and emotional resonance. Just as artists pursue their creative visions in their studios and show that work to their communities in art galleries, arts integration programs call teachers to the studio of their own lesson design and invention and to the community gallery where they share their work and their students' work with others in their learning communities (Grumet, 1988). Peter Abbs' (1982) definition of art making is useful: "The art-making process is preeminently concerned with the development of consciousness through the creation and recreation of symbolism within a critical and responsive community"(p. 33).

Evaluation studies of the A+ Schools, AAA, and CAPE record and celebrate the depth and breadth of teacher interest, participation, and curriculum development in these programs. Nevertheless, given the funding, distribution of time, and reward structure of American schools, we recognize that when collaborative work like this flourishes, it is going against the conventions of traditional schooling. When collaboration flourishes, its success is a testament to the value that teachers

have placed on it. They value the integration of the arts because they realize how it deepens their student's learning, and they value it because arts integration programs invite teachers as well as students to be part of something bigger than themselves. The learning groups of children, teachers, and parents in the Reggio Emilia schools studied by Project Zero, have been described as "a collection of persons who are emotionally, intellectually, and aesthetically engaged in solving problems, creating products, and making meaning—an assemblage in which each person learns autonomously and through the ways of learning of others," (Krechevsky & Mardell, 2004, p. 285), or as Steve Seidel (2004) puts it," the group holds the individual in its arms" (p. 313).

NO ONE LEARNS ALONE

It has taken western civilization a very long time to admit that human relationships are absolutely necessary to the development of cognition. But after centuries enthralled with learning theories focused only on individual students, our current educational leaders have recently declared this nation's belated acknowledgement that no one knows alone. From "it takes a village to raise a child," to "no child left behind," we now acknowledge that every community is responsible for the achievement of even its most vulnerable children. These slogans are admirable as they express a communitarian ethic, but they also mask the complex tensions between the interests of the generation and the self-interest of its individuals. They raise issues, particularly in times of fiscal stress, about the need to support excellence and creativity as well as basic literacy and numeracy. They raise issues that have always challenged public education as we struggle to develop the individual interests and strengths of every student in a participatory democracy striving for equity.

Curriculum that can contain these tensions must be broad and deep. It must have room for imagination as well as information. It must offer opportunities for expression as well as attention. It must acknowledge individual creativity as well as group achievements. Arts integration meets these challenges as it brings powerful ways of learning to our nation's schools.

[1]

James Pellegrino contributor to the 2002 National Research Council Publication, *How people learn*. Washington, DC: National Academy Press, made this comment at the Power of the Arts, a meeting convened by the Chicago Center for Arts Policy, July, 2003.

[2]

In the summary evaluation of the Chicago Arts Partnerships in Education, published in *Champions of Change*, James Catterall and Lynn Waldorf report (1999) data drawn from a 1998-99 comparison of CAPE and non-CAPE Chicago public schools test data in grades 3, 6, 8, 9, 10, and 11. In none of the 52 separate comparisons run by the researchers did they find non-CAPE schools out-performing CAPE schools. While a moderate case could be made for CAPE program effects in reading and mathematics at the third grade level, Catterall and Waldorf concluded that a very strong case could be made at the 6th grade level and that middle and high school data showed significant improvement of scores in CAPE schools between the planning years and the years when the project was implemented (p.54). Catterall and Waldorf reported these CAPE gains in 6th grade mathematics:

> Prior to CAPE, CPS schools averaged about 28 percent at or above grade level:
> CAPE schools averaged about 40 percent. By 1998, more than 60 percent of CAPE
> sixth graders were performing at grade level on the ITBS, while the remainder of the
> CPS schools averaged just over 40 percent (p.55)

In the 6th grade reading tests they reported an eight percentage point differential in favor of CAPE schools in 1993 that grew to 14 percentage points by 1998. In their evaluation of the North Carolina A+ Schools, Bruce Wilson, Dickson Corbet, and George Noblit (2001) observe that while at the beginning of the pilot project in 1995 of the 24 schools only 9 had achieved test scores on the state-wide accountability ABCs testing system that met norms for expected growth. At the end of the pilot project in 1999 all 24 schools had met that criteria. Finally, Debra Ingram and Karen Seashore (2003), evaluating the Arts for Academic Achievement project in Minneapolis, compared student achievement scores in third grade reading and mathematics to the degree of their teachers' use of arts integration, finding a student gain score increase of 1.02 for every unit increase in the teacher's use of arts integration. In mathematics, the gain score was 1.08 points per unit increase in integrated arts instruction. Significantly, the researchers found even larger gains for students in the free and reduced lunch programs: in reading, these girls' scores increased 1.75 per unit increase; in mathematics, these boys scores increased 1.28 points per unit increase. In the fourth grade tests, these gains were even higher.

[3]

While the school attracts children with some interest in choral performance, musical ability or training are not prerequisites for admission.

[4]

The evaluation of the A+ Schools Program in North Carolina lauds arts integration as a process of school reform that engages schools as well as their communities. The evaluation of the Arts for Academic Achievement program in Minnesota declared it "truly a teacher-led initiative," showing that even where there was weak support from the principal, teachers and artists could collaborate to plan excellent units and partnerships. Catteral's and Waldorf's (1999) evaluation of CAPE reported positive changes in school climate including principal leadership, focus on instruction, positive colleagueship, and widespread participation in important decisions.

REFERENCES

Abbs, P. (1982). *English within the arts: A radical alternative for English and the arts in the curriculum.* London: Hodder and Stoughton.

Aprill, A. (2003, Summer). Developing organizational structures that support ongoing collaborative professional development. *Journal for Learning Through Music*, 2, 57.

Barenboim, D., & Said, E.W. (2002). *Parallels and paradoxes: Explorations in music and society.* New York: Pantheon.

Booth, E. (1999). *The everyday work of art.* Naperville, IL: Sourcebooks.

Bransford, J.D., Brown, A.L., & Cocking, R.R. (Eds.) (2000). *How people learn: Brain, mind, experience, and school* (pp. 51-78). Washington, D.C.: National Research Council.

Bruner, J. (1960). *The process of education.* New York: Vantage.

Burnaford, G., Aprill, A., & Weiss, C. (2001). *Renaissance in the classroom: Arts integration and meaningful learning.* Mahwah, NJ, Lawrence Erlbaum Associates.

Compact edition of the Oxford english dictionary. (1982). Oxford: Oxford University Press, 1, p.1455

Catterall, J.S., & Waldorf, L. (1999). Chicago arts partnerships in education: Summary evaluation. In E. B. Fiske (Ed.), *Champions of change: The impact of the arts on learning.* (Available from the Arts Education Partnership, One Massachusetts Avenue, NW, Washington, D.C.2001, http://www.aep-arts.org/PDF%Files/ChampsReport.pdf)

Davis, B, Luce-Kapler, R., & Sumara, D. (2000). *Engaging minds: Learning and teaching in a complex world.* New Jersey: Lawrence Erlbaum.

Dewey, J. (1899). *The school and society.* Chicago, IL: University of Chicago Press.

Eisner, E. W. (2002). What can education learn from the arts about the practice of education? *Journal of Curriculum and Supervision*, 18 (1), 4-16.

Elkind, D. (1976). *Child development and education: A piagetian perspective.* New York: Oxford University Press.

Fauconnier, G., & Turner, M. (2002). *The way we think: Conceptual blending and the mind's hidden complexities.* New York: Basic Books

Gardner, H. (1990). Multiple intelligences. In W. Moody (Ed.), *Artistic intelligences: implications for education.* New York: Teachers College Press.

Grumet, M. (1988). The line is drawn. *In Bitter milk: Women and teaching.* Amherst, MA: University of Massachusetts Press.

Grumet, M. (1992). The Curriculum: what are the basics and are we teaching them? In J. L. Kincheloe, & S. R. Steinberg (Eds.), *Thirteen questions, reframing education's conversation* (pp. 28-29). New York: Peter Lang.

Hebb, D.O. (1949). *The organisation of behaviour: A neuropsychological theory.* New York: Wiley.

Ingram D., & Seashore, K. (2003). *Arts for Academic Achievement: Summative evaluative report.* Unpublished manuscript, Center for Applied Research and Educational Improvement, College of Education and Human Development, University of Minnesota.

Jackson, P. (1986). *The practice of teaching.* New York: Teachers College Press.

Krechevsky, M., & Mardell, B. (2004). Four features of learning in groups. *In Making learning visible: Children as individual and group learners* (p. 285). Reggio Emilia, Italy: Project Zero & Reggio Children, SRL.

LeDoux, J. (2002). *Synaptic self: How our brains become who we are.* New York: Penguin.

Langer, S. (1957). *Problems of art.* New York: Charles Scribner's Sons.

Levi-Strauss, C. (1972). *Structural anthropology* (C. Jacobson & B. Schoepf, Trans.). Hammondsworth, England: Penguin. (Original work published 1958)

Perkins, D. N. (1992). *Smart schools: From training memories to educating mind.* New York: The Free Press.

Perkins, D. N. (1994). *The intelligent eye: Learning to think by looking at art* (p. 4). Los Angeles: The J. Paul Getty Trust.

Piaget, J. (1977). *The development of thought: Equilibration of cognitive structures.* (A. Rosin, Trans.). New York: Viking.

Rogoff, B., & Gardner, W. (1984). Adult guidance of cognitive development. In B. Rogoff & J. Lave (Eds.), *Everyday cognition: Its development in social context*. Cambridge, MA: Harvard University Press.

Root-Bernstein, R., & Root-Bernstein, M. (1999). *Sparks of genius: The 13 thinking tools of the world's most creative people*. New York: Houghton Mifflin.

Seidel, S. (1999). "Stand and unfold yourself": A monograph on the Shakespeare & Company research study. In E. B. Fiske (Ed.), *Champions of change: The impact of the arts on learning*. (Available from the Arts Education Partnership, One Massachusetts Avenue, NW, Washington D.C., 2001, http://www.aep-arts.org/PDF%Files/ChampsReport.pdf)

Seidel, S. (2004). To be part of something bigger than oneself. In *Making learning visible: Children as individual and group learners* (p. 313). Reggio Emilia, Italy: Project Zero & Reggio Children, SRL.

Steinbeck, J. (2000). *The pearl* (p. 90). New York: Penguin Books.

Vygotsky, L.S. (1978). *Mind in society*. Cambridge, MA: Harvard University Press.

Wilson, B., Corbet D., & Noblit, G. (2001). *The arts and education reform: Lessons from a four-year evaluation of the A+ Schools Program*, 1995-1999. Winston Salem, NC: North Carolina A+ Schools.

3

A Short Look at a Long Past

MICHAEL WAKEFORD

Just what separates "the arts" from other types of knowledge and intellectual practice has long drawn attention from American intellectuals and educators. As one eminent historian (Hollinger, 1987) has put it, while the figure of the scientist has held claim to the mantel of empirical inquiry, reason, and cognition, the artist has stood as the embodiment of subjectivity, spontaneity, and imagination. To be sure, some significant voices have cast doubt on just how real this divorce is, arguing that science and art, as modes of knowledge and inquiry, share common ground. Nonetheless, it is clear that the arts in American life have, unfolded particularly in popular perception, as a realm apart, a venue that privileges emotion over reason, impulse over deliberation, and expression over cognition. Distinctions of this order have advanced the cause of the arts as a repository of ideals vital to the good life, but they have also given root to claims that the arts are less than essential to the project of educating young Americans and preparing them for the practical challenges of the world of work.

Over much of the past two centuries, this tension has confronted advocates of arts education with a dilemma. After all, they have been not only evangels of the arts, but also keepers of education's broader commitment to foster students' capacities to think and to learn in productive and meaningful ways. Defenders of the arts' place in education have drawn from an expansive palette to establish their cur-

ricular worth, however, and reconciling the two has been difficult. As Donald Arnstine (1995) has stated, the arts "have traditionally been justified on the grounds that they provided wholesome recreation, salutary therapy, the cultivation of taste, or vocational preparation." "These are not bad reasons for teaching the arts," he continues, "but they are not compelling enough to keep them from being among the first school studies to suffer when budgets are cut" (p. 86). The seeming lack of connective tissue binding the arts to schools' fundamental charge to help students attain knowledge and think in increasingly sophisticated ways has historically left the arts vulnerable when the tides of education reform cyclically turn back to "the basics."

Against this backdrop, it is tempting to frame the history of the arts and education as one of slow and steady convergence. This retelling would pose its historical trajectory as one that began with the arts residing squarely outside the core mission of schools, as an outlier to the overarching process of learning, and leading to recent years in which the arts have gained increased attention—at least among those sympathetic to such claims—as a contributor to effective learning across the disciplines.

In general terms, this is a reasonable enough way of looking at things. We should note, however, that the guiding mission and goals of American schools have been no less varied than the curricular and pedagogical strategies with which they have been pursued. It would be wrong to suggest that education in the United States has rested wholly on the ideal that the school's purpose is to foster intellectual, higher order thinking skills among the masses. From the very genesis of the common school movement such goals shared the stage with more socially-oriented goals of Americanizing an immigrant population, preparing an industrial labor force with necessary skills and inclinations, and promoting moral or political order (Spring, 1976). Insofar as the inclusion of arts instruction pursued these types of ends, the arts have been an integral part of what schools have tried to teach.

THE ARTS AS LEARNING

Nonetheless, the current conversation about just how the arts relate to learning does pursue something new and ambitious. It moves beyond claims that the arts deserve a place in American education either for their own intrinsic values of self-expression or aesthetic cultivation, or as a socializing force, and instead makes the more radical assertion that the arts, deployed most effectively, are of a piece with the higher order types of learning from which they have traditionally been deemed

separate. It sets aside conventional notions of education in the arts as an end in itself in favor of the belief that arts experience and artistic knowledge equip students with competencies and habits of mind that embody learning more generally.

Such ideas build upon a complex, and at times internally contentious, foundation. In recent years, for example, advocates of a "discipline based" approach to arts education have insisted upon the cognitive, academic character of the arts. For their part, they have argued that the arts be taught as a stand-alone discipline, which, though affirming the arts' historical claims to particularity, initiated a bold counter to the critique of the arts as a soft, and therefore dispensable, curriculum. Alternatively, champions of an "integrated" approach to arts education have departed from the disciplinary strategy of curricular segregation, and framed the arts as facilitators of the cognitive learning process. Emboldened by the lessons of promising new research, the integrationists underscore how the emotional and affective dimensions of artistic experience can be a key part of what makes authentic learning happen in the classroom.

This said, the continued struggle to maintain support for the arts in education testifies to one basic fact: the absence of a widely understood and accepted connection between artistic activity and the constituent activities of learning—between the arts and cognition—remains the field's dominant challenge. To center arts education from the curricular margins and solidify its place in schools, its proponents must emphasize the centrality of arts experience to the learning process and the capacity of the arts to promote a frame of mind conducive to learning.

The arts integration paradigm rightly boasts of newness. That the arts are not merely learned, but that they help constitute learning, is a fresh formulation being advanced in powerful new ways. But the paradigm also emerges from a longer history of educational thought and reform. This essay explores how this basic assertion about the value of the arts to education has endured and evolved. In doing so, it finds itself navigating between two distinct, but overlapping pasts. There is the more recent, shallower past, the temporal bounds of which is marked by the emergence of several key critiques of the state of arts education between the 1980s and today. The last twenty-five years gave witness to both the pedagogical virtue and curricular-political imperative of fortifying the links between arts experience and the general tasks of learning, between the value of the arts on the one hand, and the core mission of schools on the other. What this recent past crystallized, however, were claims and debates that have circulated through arts education discourse from its genesis—questions about the goals of arts education, the relationship (if any)

between artistic activity and conventional notions of "intelligence," and a ubiquitous tension between the stand-alone and integrative approaches to arts curricula. Thus, it moves us to widen the lens, to look back into a deeper but more dispersed past, and to consider how more contemporary inquiries echo and advance much older ones.

ART AND THE EARLY CURRICULUM

Critics of arts education, in an effort to forward their own reform agendas, have often overdrawn the polarization between the motivating ideals of arts curricula and the generally accepted goals of schools. Further, arts educators have frequently defended the arts in terms of their capacity to elevate the spirit and as a source of cultural refinement, obscuring more recent cognitive claims. Yet, alongside "cultural" defenses of the arts, and despite the caricatured divide drawn by critics between the arts and learning, there has persisted an alternative strain of argument more focused on the integral connections between the arts and cognition.

Throughout most of its history, proponents of arts education have imagined the arts' virtue in close relationship with the goals of other elements in the curriculum. In the early to middle decades of the nineteenth century, for example, as support grew for common schooling in the United States, advocates of mass education thought art should occupy a significant, embedded place in schools. American popularizers of the kindergarten movement drew upon the pioneering ideas of Heinrich Pestalozzi and Friedrich Froebel, which emphasized the broad benefits of drawing lessons. Though their philosophies diverged in significant ways, Pestalozzi and Froebel's pedagogies both espoused the role of drawing in cultivating a sense of perception. Through "the use of something tangible to enhance the understanding of something conceptual," kindergarten historian Norman Brosterman (1997) explains, the kindergarten movement, "recognized children's ability to see analogies and draw conclusions by comparison" (p. 34). Pestalozzi conceived of drawing as a language of form, an activity through which students could discover and communicate the structure of the object world. Early instructional methods relied on workbooks that guided students through various exercises of geometrical line drawings and simple copying of artist sketches and details of craft or architectural design (Efland, 1990; Wygant, 1993).

In the United States, antebellum pioneers of the common school movement, most notably Horace Mann, were deeply influenced by Pestalozzian thought, and supported the inclusion of drawing in the common curriculum as a means of cul-

tivating accurate perception and honing practical design skills, while also developing a more affective appreciation of artistic beauty and its capacity for moral uplift. Further, advocates of drawing highlighted the crossover benefits that drawing lessons could have for handwriting skills, effective communication skills, and the ability to use language (Efland, 1990).

As with the visual arts, early flirtations with these principles included curiosities about the benefits of a music curriculum. Consistent with the philosophy of developing children's innate abilities through carefully-managed experience with "sense-impressions," early advocates of music education espoused methods that aimed to lead pupils through a progression of increasingly complex musical exercises. Rather than teaching music through rote memorization of songs, they reoriented music instruction around lessons in which the teacher would sing musical exercises, and then ask students to distinguish higher from lower tones, and identify changes in rhythm and tonal duration. Musical sound, in this way, offered a site for students to understand aspects of measurement and the relationship of component parts to a larger product. Geared ostensibly toward the improvement of vocal musical technique, the musical exercises were also designed to shepherd the student toward more sophisticated, even abstract, types of competencies (Keene, 1982). There was, in this sense, an early glimmer of the idea that, through the arts, a broader set of learning skills would be advanced.

The philosophical origins of mass arts education, therefore, were imbued with a belief that the arts were not mere ends in themselves, but rather, that they were implicated in the development of sophisticated mental faculties with both academic and practical applications. Nonetheless, the democratizing calls of the common school movement, driven by a populist belief in education's mandate to provide marketable skills and knowledge to all, held the arts in a hesitant half-embrace. During most of this era the primary rationale for arts curricula circulated around ideals of cultural and moral refinement, based on the notion that appreciation of artistic form, or recitation and memorization of moral texts through song, could foster a sense of beauty, harmony, and social order (Keene, 1982; Wygant, 1993). Thus, as the common school movement advanced, deeper links between the arts and learning remained attenuated.

If the arts struggled in this era to find a secure and permanent place in the common school curriculum, it was nonetheless a vital period for development of some founding principles for arts education's future. Most important was the emergent view that artistic competency was something all students could achieve. In

other words, the arts were learnable disciplines. The intensity with which early disciples of arts education promoted drawing or singing as universally accessible skills laid an essential foundation on which later generations of educators depended. It undercut conventional notions that artistic ability belonged to the few, that it was innate rather than learned (Efland, 1992). This pivotal recognition undergirded all future efforts to install arts into the education of the masses.

As art instruction made inroads into school curricula during the post-Civil War decades, its guiding goals were multiple. While both music and the visual arts saw their causes advanced in the post-bellum years, they did so haltingly and on somewhat divergent terms. For example, the late 1880s and 1890s witnessed a rapid increase in the number of schools offering music classes to students (Keene, 1982). Vocal music continued to dominate in this era, heralded as a source of mental discipline and moral development. Its advocates defended music for both its intrinsic and extrinsic values: Through the artistic power of song, students' character could be strengthened and their emotional sensibility enlivened. But, also, it could aid their skills of pronunciation of the English language, and develop their memory (Keene).

As the new century approached, the child-study movement began to challenge the predominance of faculty psychology and its categorical division of the intellect from action and emotion. In its place, thinkers like psychologist G. Stanley Hall and a young John Dewey advanced new educational ideals, rooted in sensitivity to the developmental nature of the child, which insisted upon the interconnectedness of intellectual development with bodily and emotional engagement. Such discoveries laid the groundwork for an active approach to knowledge acquisition—in stark contrast to a system of rote memorization and instructional drill—that would inform arguments for arts education for the better part of a century (Keene, 1982). Alongside these philosophical developments, however, school music curricula were dedicated primarily to music appreciation through the first decades of the twentieth century. Music appreciation curricula methodically introduced students to historical and formal understanding of the art, emphasizing discernment and memorization rather than performance (Keene).

Alternatively, the case for the visual arts in mass education was made on the intensely practical grounds of preparing a labor pool to fit the needs of a modernizing economy. American industrialists returned from the Paris Exposition of 1867 intent on promoting superior manufactures that would compete in the world market with those of other industrializing nations. Best exemplifying this impulse was

Massachusetts' passage of the Drawing Act of 1870, and the importation of Walter Smith from Great Britain's South Kensington Museum, the foremost institutional model of industrial art education, to lead its implementation. The act was unprecedented in its mandate for drawing instruction throughout many of the state's common schools, and by the early 1880s, the National Education Association created an Art Department dedicated to creating a uniform curriculum in industrial drawing. More than thirty schools prepared instructors to teach it. Industrial drawing curricula provided for instruction at both the grammar school and high school level. Young students began with freehand exercises before moving to representational drawing from models. In later grades, students were introduced to factors of visual perspective and composition, with increasing attention paid to the ability to draw from memory (Efland, 1990).

Though the industrial drawing movement is often cast in opposition to later, less vocationally oriented modes of arts pedagogy, Smith was adamant that drawing offered intellectual benefits well beyond rote, skill-based training. In language that anticipated later "integrated" educational philosophy, Smith suggested that drawing was an interdisciplinary medium, a potentially useful exercise in teaching math, science, or history, and further, insisted that drawing lessons were meant to foster perception and skillful imagination (Efland, 1990).

In the final decades of the nineteenth century, the virtue of visual art instruction found a different articulation in British radical John Ruskin's critique of industrial labor and in the separate, but closely related, manual training movement. A contemporary of Marx, and equally disenchanted with the industrial organization of labor, Ruskin's philosophy of arts education was part of an attack on the way modern production purged art and craftsmanship from the process of work. His ideology called for the reunification of art with labor in order to restore dignity to work and worker alike. In pedagogical terms, such views challenged the industrial emphasis of contemporary arts education, and redirected attention to the idea that art should be taught first as an encounter with beauty, with the divine, not with the rules of design. Accordingly, it espoused instruction that encouraged spontaneous artistic activity and drawing from nature, activities to which they ascribed moral import.

PROGRESSIVISM, REFORM, AND THE ARTS

The effort to rend art from the utilitarian alignment with manufacturing led in varied directions. The critique of industrial drawing had intended to argue that

the aesthetic and moral dimension of art brought it into common purpose with liberal education. And to a certain extent, these claims carried the day. The manual arts movement that began in the late 1870s and shaped American school art programs through the First World War, for example, departed from the functionality of industrial drawing, and was of a piece with liberal education's primary goal of developing the "whole" person. Its proponents squared manual training with the liberal ideal, arguing that direct experience with aesthetic design and handicraft, the stuff of the workaday world, would offer students the spiritual benefits of artistic experience and teach the character of production (Cremin, 1961). Progressive social reformers, such as Dewey and settlement house pioneer Jane Addams, advocated the manual arts as an exemplar of experiential education that heightened students' understanding of production and could spur industrial reform through demand for more artfully produced goods. Moreover, they introduced notions of "correlation" between artistic creation and the effective learning of other school subjects. Early experiments in progressive education used artistic activities such as weaving, ceramics, or metalwork to enhance the study of other cultures, for example. Here, the distinction between "doing" and learning began to erode, which portended pedagogical developments to come later in the 20th century (Wygant, 1993).

Still, the new century saw art education increasingly bifurcated between the goals of preparing skilled laborers, and alternatively, promoting an art-for-art's-sake approach. The wartime Smith-Hughes Act of 1917, designating federal funding for vocational training including industrial design, marked an apex for the manual training movement. As manual training evolved increasingly back into the service of vocational preparation, it was opposed by arts curricula that featured picture-study and composition lessons. The latter aligned with genteel cultural ideals, which carried forward the notion that art should not be subservient to practical concerns and underwrote the separation of art from other aspects of school learning. It heralded the stand-alone value of creating beautiful things, and therefore promoted the copying of masterpieces or drawing from nature. The vocational and cultural rationales of manual training and picture study, though clear in their intents to develop practical skills or to pursue the late-Victorian ethic of self-cultivation through aesthetic sensibility, respectively, seemed to sequester the arts from the general curriculum.

With the interwar rise of progressive educational philosophy, however, reformist educators forged a new bond between the arts and their sense of the central goals of education. Animated by postwar avant-garde interest in the

arts, Freudian psychology, and a growing interest in child-centered pedagogy, "progressive" educators rebelled against the relegation of the arts to the cause of industrial-technological civilization, and opposed as well picture study and composition's reduction of the arts to an exercise in passive appreciation or rote imitation. Dedicated to the idea that education's primary goal should be self-realization of each individual student, progressives turned to the arts not as a decorative addendum to the school day, but as the very embodiment of education.

Under the mantra of "creative self-expression," progressive educators brought all of the associated arts into a shared purpose. Within this context, meaningful distinctions between the various arts dissolved. Visual art, music, dance, drama, poetry, puppetry, and sculpture were all heralded as active, creative outlets through which students could realize their creative potentials (Hartman & Shumaker, 1939). Unified by this expressionist ethic, the progressive approach to the arts stood as a revolt against earlier formalist approaches, which reformers argued privileged classical aesthetic standards and fixed notions of technique over an emphasis on self-realization. Leading music educators of this era, for example, veered away from the formalism of earlier pedagogy. Reducing music lessons to skill acquisition, technique, or the ability to read a score, they insisted, effectively gave primacy to what they conceived, in educational terms, to be art's secondary attributes. In the context of general education, they reasoned, providing students with musical "experience" should be the fundamental goal. In the post-WWI era, then, public schools began to regularly incorporate instrumental music and school bands into their curricula (Keene, 1982). Likewise, visual arts leaders challenged imitative and technical instruction (Hilpert, 1941). Instead, they argued that children should function as artists, free to make their own decisions regarding content and style. Expressive drawing drew comparisons to dance, and students were encouraged to explore media that allowed for greater bodily and emotional engagement—larger pieces of paper, chalk and crayon, brilliant color, or finger painting. Further, in the 1930s educators embraced a broader set of arts techniques such as printmaking, mural projects, and three-dimensional sculpture (Wygant, 1993). This anti-formalism and experimentalism was the pedagogical analog to modernist currents in the avant-garde art world, which were assaulting the art historical canon with a new commitment to artistic subjectivism.

As the "new education" gained its greatest prominence in the 1930s and 1940s, it brought into fuller relief the key issues and debates that still define dialogue about arts education. A perceived divide between the arts as a mode of "doing" and

the arts as realm of knowledge acquisition and learning was of central concern to observers inside and outside the progressive fold. Critics cautioned that the classroom must remain an arena of active instruction, and that the teacher, as the custodian of standards, intellectual discipline, and evaluation, had to maintain the central role. Even one as closely associated with the progressive movement as Dewey, voiced concern about focusing too heavily on individual expression as a self-justifying ideal. This, he suggested in works such as his 1934 book, *Art As Experience*, could only further sequester the category of art from a more rounded view of experience that his generation of thinkers were bringing to educational reform.

MAKING AND APPRECIATING

At issue then, as today, was how to square participatory arts activity and the development of individual personality with the central goal of fostering learning. To this end, defenders of the creative arts disputed too narrow an understanding of creative expression, which placed it in unnecessarily stark opposition to art appreciation or more academic understandings of the arts. "Is creative expression so narrow a term after all?" queried one educator, "Is it confined to inventive activity either of mind or hands?" (Surette, 1939, pp. 70-71). "No," answered advocates of the creative arts. Listening, looking, and studied concentration—better understood as conventional modes of learning—were just as key to creative pedagogy as the original production of art. But they insisted that arts curricula that called for direct participation—in pen or paint, in individual or group song, or on stage—transformed all modes of artistic activity into more effective learning moments. The arts, so taught, would foster both expressive freedom and recognition of the need for intellectual and sensory discipline. Understood in this way, "creative expression" referred not solely to the creation of artistic output, but rather, the pursuit of knowledge and self-knowledge through active engagement with the arts in school.

Such sentiments responded to a particular notion of knowledge rooted in an objectivist worldview. "There is the error of treating *knowledge about, rather than experience with*, music as the chief aim of music education in the schools," wrote James Mursell (1936, p. 5), a leading scholar of music education at Columbia Teachers College. Another prominent progressive offered that through the arts "character emerges . . . and with it knowledge, a kind of wisdom, so sure in its judgments as to make us listen and attend rather than command and instruct" (Mearns, 1939, p. 18). Importantly, though, they did not challenge the premise that music education was a cognitive enterprise of knowledge acquisition and thought. They embraced it. In

dispute, however, was whether art was to be conceived of only as a body of knowledge or skills to be gained, or as a medium of experience through which knowledge could be created or attained through imaginative and emotional involvement.

In historical terms, we can see that this generation of interwar arts educators were struggling to narrate the historical transition to which their field would become absolutely central: the shift from a positivist to an experience-based notion of knowledge, and the emergence of a refashioned understanding of cognition expansive enough to recognize subjective modes of perception and expression as a sophisticated type of thinking. In the interwar period, the view that scientific modes of inquiry were more intellectually demanding, and involved a higher order of cognitive skills, than the type of thought involved in artistic perception and creation, still prevailed (Efland, 2002). Yet, with the experiential and expressive emphases of progressive education, arts educators were beginning to claim a share of the cognitive mantel. Learning and thinking, this era's pedagogues suggested, could happen in concert with activities heretofore identified as merely affective or emotive.

COGNITION AND CREATIVITY

Through their clarifying defense of "creative expression" mid-century arts educators began to assert, albeit subtly, the field's cognitive dimension, and to align it with other components of the curriculum. Even more concretely, so did arts educators' calls to "integrate" or "correlate" the arts by incorporating arts activities into the teaching of other subjects. The arts were not to be forced unduly into school instruction, proponents of "integration" reasoned, but if used properly could "break down artificial boundaries between the different school 'subjects'" (Hilpert, 1941, pp. 448-451). As prescriptions for "integration" ascribed new relevance to the arts by fusing them more meaningfully with the general curriculum, they sought both to emphasize the arts as an essential mode of experiencing the world as well as to collapse the disciplinary divisions that relegated the arts to a secondary status. If the curriculum's intent was, as progressive educators insisted, to "contribute to effective living," (Winslow, 1941, p. 482) then art instruction, too, needed to pursue this end by emphasizing art's applications in realms such as consumer habits, home decoration, and landscaping. But further, the integration perspective insisted that the arts could strengthen the teaching of history, literature, music, and physical education. The aim was twofold: first, to teach the arts in what advocates of integration thought a more useful manner, and secondly, to bolster learning in other sub-

jects through the appropriate use of art.

The "integration" ideal applied to music, too. In the architecture of music, educators suggested, lay the bases of "correlation" with numerous other disciplines. They pointed to elements of form, rhythm, melody, harmony, tonal color, and emotional tenor as offering opportunities to draw meaningful connections between music and students' notions of historical progress, the mathematical and physical foundations of sound production, as well as physical education and dance (Dykema, 1936). This early integrationist approach reflected a nascent understanding of the integral relationship between the arts and the general culture of learning. Proponents of "integration" also pointed to the arts' ability to hold students attention more effectively. The "integration" approach, music educator Peter Dykema explained in 1936, "is based upon the conception that effective learning takes place only when there is interest."

The alignment of the arts with learning required not only their continual negotiation into the life of schools, but a deeper re-thinking about the arts as an arena of intelligent action. Throughout the last century, for example, scholars of education grappled with the notion of "intelligence" as a discernible, quantifiable realm. In the first three decades of the century, European and American researchers—Alfred Binet, Lewis Terman, and Edward Thorndike key among them— strove to measure various capacities for abstract reasoning that correlated with educational achievement, leading to the development of the "intelligence quotient," or IQ (Zunz, 1998). The vogue of intelligence testing presented arts educators with a problem and an opportunity. The challenge, not surprisingly, lay in the way that early conceptions of intelligence disregarded the arts as a way of thinking or reasoning. This reflected the enduring view of the arts as a mysterious and deeply subjective domain, impossible to measure and disconnected from the intellectual basis of student performance. Yet, the currency that intelligence held among educational reformers provided a powerful discourse to which arts education sought to attach itself.

Indeed, in the years following the rise of intelligence testing, interest intensified in bringing the arts into the conversation. In the 1930s, a spate of research took place, most notably through Norman C. Meier's studies at the University of Iowa, which queried the category of artistic intelligence. Arguing, for example, that "the creative artistic individual . . . is destined to be of incalculable importance in a world visually minded and so largely responsive to graphic stimuli," Meier and his contemporaries (Meier & McLoy, 1936, p. 164) pointed to the importance of explor-

ing the arts more systematically. They initiated a broad set of psychological studies into the nature of the artistic process and the potential of measuring it using the tools of intelligence testing. In music, too, researchers of musical ability differentiated between the general intelligence quotient and "musical intelligence" (Kwalwasser, 1936). While such studies drew distinctions between categories of artistic or creative intelligence, and the types of intellectual capacity that the testing movement had previously sought to capture, this emergent recognition of the arts' relationship to intelligence provided further traction to the field's association with cognition. These efforts, emerging from the scientific worldview that often stood in tension with the arts, represented a significant step toward bringing the arts into mainstream educational conversation.

It also encouraged arts educators themselves to articulate more stridently that their field's goal was as much about teaching how to think as it was about art. As leading museum educator and aesthetic philosopher Thomas Munro (1941) observed, "Too often we teach art without asking how we can best develop the power to think and imagine artistically" (pp. 308-309). Views like Munro's, increasingly influential in the interwar era, suggested a broadening understanding of the arts as a realm ripe for psychological investigation. Munro echoed many others in challenging monolithic and simplistic conceptions of the "artistic" type. The types of action associated with the arts—"perceiving, imagining, desiring, reasoning, [or] experiencing emotions"—were, insisted Munro (1941), mental functions better understood through a broader frame (p. 308-309). This anticipated, of course, what would later become an increasingly urgent call among advocates of arts education. In the 1960s, for example, critics continued to take aim at the enduring limitations of intelligence testing that measured a narrow band of "cognitive functions," and emphasized "convergent" rather than "divergent" thinking. "To do well on the typical intelligence test, the subject must be able to recall and to recognize . . .he need not necessarily be able to invent or innovate" (Getzels & Jackson, 1962, pp. 2-3).

It was something of an irony, then, that in the very time when some began to see the arts as an exercise in intelligence and cognition, the day to day practice of arts education weathered withering assaults as a poster child of anti-intellectualism. The dominance of the expressionist strain of arts education, and what many saw as its detachment from cognitive claims in favor of therapeutic goals, provided the seedbed for criticism of much of progressive pedagogy. School art reflected the influence of Bauhaus arts ideology and abstract expressionism, with their shared interest in nonobjective modes of representation (Wygant, 1993). Children's art, in

this context, stood as a therapeutic medium of individual growth, an avenue toward mental health (Efland, 2002). The most influential voice in the field during this period, Viktor Lowenfeld, pointed to art education and creative expression as a process through which students' emotional development takes place in identifiable stages.

PROGRESSIVISM AND THE NEED FOR STANDARDS

Spurred by Cold War anxieties about the nation's educational lag, which intensified in the wake of the Soviet Union's successful launch of their Sputnik satellite in 1957, critics caricatured progressive education as a laissez-faire pedagogy that fetishized individual creativity and self-expression at the expense of educational standards and the appropriate prioritization of math and science curricula (Cremin, 1961). Progressive methods were derided as exemplars of the insidious anti-intellectualism of postwar American culture (Hofstadter, 1963).

In the shadow of Sputnik-induced anxiety about educational lag, much arts educational thought pressed toward articulating the field's emphasis on "creativity" as contiguous with a broader concern about spurring innovation and scientific discovery. Consistent with the impulse to bring the field into line with the academic structure of other school subjects, others turned to a "disciplines" approach to curriculum development (Efland, 1990). Though embracing the value of artistic expression as part of the arts curricula, proponents of disciplinary organization argued that art, no less than any subject, should be organized as an academic discipline in full. Emergent from this were the first rumblings of terms such as "aesthetic education" and "disciplinary" art education, which carried with them ideas of shaping arts education according to the model of scientific inquiry. In the case of arts education, this meant contextualizing artistic expression within an instructional model that included art history and a critical understanding of aesthetics (Efland, 1990).

Critics of the disciplines movement noted that much of what these reformers pursued were the very things that early architects of progressive education had idealized. As Charles Silberman (1970) observed in the wake of 1960s reforms, Dewey and others had parted ways with other progressives over what they saw as a one-sided application of new education principles. They had called for a balance between subject-centered approaches to education and methods that took account of the individual student's intellectual needs and capacities. Though postwar education might have grown too permissive at the expense of content and academic

rigor, critics allowed, the new reforms threatened to reduce curricula, in this case the arts, to static bodies of knowledge without sufficient attention to fundamental questions about how students would most effectively learn in the classroom.

Additionally, dissenters from the disciplinary structure suggested that remaking the arts in the image of science was too costly. It wrongly de-emphasized the affective, emotional aspects of art, and moreover, it disregarded the ways in which scientific discovery itself took place through the imaginative and intuitive processes often ascribed to art. This backlash against the disciplines movement inspired programs aimed at providing more direct experience with the artistic process. In one sense, this was an expression of the social and cultural politics of the era, as skepticism about top-down, academy-driven curricular formation led some arts advocates to opt for programs that brought professional artists and performers into schools and integrated arts and culture into the general curriculum. One example of such a program was the University City Project, sponsored by the John D. Rockefeller 3rd Fund (JDR 3rd), which in the late 1960s offered a model of how the arts might be more fully fused with the teaching of other subjects. The project pursued universal provision of arts education to all students at every grade level (Efland, 2002).

PHILANTHROPY AND ARTS EDUCATION

The JDR 3rd's entry into arts education also points to a significant development: the increasing role of major philanthropy in bringing the arts into American education in a new and purposeful manner. It was not an unprecedented philanthropic commitment. In the 1920s and 1930s, for example, the Carnegie Corporation of New York, the Carnegie Foundation for the Advancement of Teaching, and the Russell Sage Foundation, had been instrumental in forwarding inquiries into the nature of the artistic process and creative thinking, as well as funding programs to prepare teachers of the arts. But in the 1960s, following a postwar lull in philanthropic attention to the arts, foundations entered upon the cause of arts education with new vigor, this time in response to the sense that the curricular politics that so strongly favored the hard sciences had left the arts and humanities dangerously under attended. In the 1960s, for example, the Ford Foundation's Program in Humanities and the Arts collaborated with the Music Educators National Conference, to expand the Contemporary Music Project for Creativity in Music Education. The project, which had originated as a program dedicated to placing young composers-in-residence in schools, expanded its scope under Ford's funding

to pursue a broader reform of music instruction and teacher preparation (Mark & Gary, 1992). The American philanthropic community also offered its collective support to the long-term planning and publication of the watershed 1977 report (Rockerfeller), *Coming to Our Senses: The Significance of the Arts in American Education*, which argued for the inclusion of artistic literacy in a refashioned understanding of basic education, as well as a recognition of the arts' contributions to learning across the curriculum.

More than a century after arts instruction had begun to make its way into American schools, a constellation of approaches was in place that, aided by a developing philanthropic support structure, would energize the arts education debate over the ensuing decades. Disciplinary and integrated reform ideals, informed by a rapidly maturing research agenda concerning the relationship of the arts and cognition, would continue to be key reference points as arts reformers advanced new claims to the arts' place in education.

The history of arts education in the United States has been inseparable from its perpetual need to justify the arts' inclusion in the common curriculum. Its entire past has been an exercise in persuasion and self-legitimation, but never more than in recent years. The past two decades, in particular, have brought intense focus to the question of exactly how the arts constitute learning. That the arts can be taught and learned, of course, is not really in dispute. The pressing questions are of a different sort. Do arts curricula, whether taught in isolation or integration, pay dividends for learning in other subjects? Are those benefits unique? That is, do the arts foster thinking skills, or offer types of knowledge, unrealized through other channels? And equally important, can learning in or through the arts be assessed in any meaningful way? Arts educators, of course, have answered affirmatively to all these questions. In recent years, however, they have come to these questions with varied goals, multiple instructional strategies, and new research with which to bolster their assertions.

The maturation and persuasiveness of this line of thought has built upon the research and advocacy efforts of Project Zero at Harvard University's Graduate School of Education. Founded in the late 1960s by philosopher Nelson Goodman, Project Zero dedicated itself to improving understanding of the character of artistic knowledge and how it might best be cultivated. From its start, Project Zero's research circulated around a linguistic approach to the arts as systems of symbols, and its empirical work echoed an older ideal of bridging the gap between the arts and other disciplines. Most importantly, Project Zero approached the arts as a sys-

tem of knowledge akin to the sciences, with a part to play in the active processes of discovery and production of new knowledge (Gardner, 2000). Work of this order offered a decisive shift of the ground on which arts education's merits could be debated. Its dogged pursuit of the "cognitive model" both struck at what arts education's advocates had long criticized—the marginalization of arts from other fields of knowledge—and also called for an integrated understanding of the various art forms as part of a unity. The very notion that the arts were a mode of cognition, a way of "knowing," was key, resting on the view that theories of knowledge had to embrace the dynamic and active nature of perception and expression (Prekins & Leondar, 1977).

Most famously Project Zero's co-founder, Howard Gardner, continued the push against the historically narrow definition of intelligence, offering his theory of "multiple intelligences"—which identified seven distinct modes including "musical", "spatial," and "bodily-kinesthetic" —as an alternative (Gardner, 1983). Such theories were not without critics, of course. Detractors suggested that in its effort to combat exclusion of certain types of learning from the embrace of "intelligence" by identifying categorical divisions of intelligent activity, such theories reinscribed a historical view of the arts as distinct or separate. Efforts to frame artistic activity as the site of a particular brand of "intelligence," like those that define it as a discrete "discipline" of knowledge, existed in tension with the integrated approach to curricular reform. Still, the ideas authored under Project Zero's auspices, and the retheorization of cognition of which they were a part, were influential in placing the arts in the domain of cognition.

THE ARTS AT RISK

This proved essential as the reformist mood of the 1980s sharpened its sights on elements of the curriculum that it deemed dispensable. The publication of *A Nation at Risk* in 1983, for example, in which arts education received scarce mention, evidenced the enduring marginalization of the arts from mainstream conversation about how to improve educational performance. Commissioned by Ronald Reagan's Secretary of Education, Terrel Bell, the intentionally provocative report decried the fraying of American education and assigned schools blame for a perceived lag in the nation's economic competitiveness. The problem, it suggested, was a softening of the general curriculum at the expense of basic skills, an appropriate focus on math and science, and a decline in academic standards (Bracey, 2003). Considering the report's assertion that "knowledge, learning, information and

skilled intelligence are the new raw materials of international commerce" (National Commission on Excellence in Education, 1983, p. 7) its conspicuous omission of any discussion of arts education was resounding.

Few disagreed, of course, with the premise that American schools merited rigorous examination and vigilant reform. For arts educators, however, the implication that the arts fell outside this rubric of "knowledge," "learning," and "intelligence," and the apparent ease with which these terms excluded the arts, brought the field's historical problems to the fore. It was a political imperative, not just a pedagogical one, that the arts be understood as a site of learning—either as an acquirable sphere of knowledge, a broadly applicable and transferable practice of mind, or, ideally, both. Here, in a way that has sometimes confounded arts proponents, "learning" was inflected in opposition to pedagogy that revolved around "doing." The sometimes-unforgiving character of curricular politics demanded that the arts frame themselves in reference to prevailing reform ideals.

In this way, *A Nation at Risk* helped shape what we now see as a watershed era for arts education. Though controversial—it was criticized widely for unfairly scape-goating American schools and overstating the nation's educational decline—the report shifted public attention to the complex intersection of pedagogical and cultural politics with which art educators had to engage. It energized debates regarding both the relative importance of the arts in education as a whole, but also served as an important backdrop for tensions long internal to the arts education movement itself.

Contemporary with the government report was a nascent vision for reform more specific to arts education. In the early 1980s, advocates of the arts in schooling cohered around the view that the arts did and should take an important place in American education. They differed, however, on precisely what shape an arts curriculum should take, and how it might be best delivered. A key intervention into the debate came in 1984 from the newly formed Getty Center for Education in the Arts, under the auspices of the J. Paul Getty Trust. Known by the moniker DBAE, for "discipline-based-art-education," the Getty's initiative criticized prevailing trends in visual art education for overemphasizing the importance of artistic production to the exclusion of art history, criticism, and aesthetics. Getty's inaugural study, titled *Beyond Creating: The Place for Art in America's Schools*, made explicit what was only inferred in *A Nation at Risk* (Hechinger, 1985; Getty Center, 1985). It stated that art education should cultivate itself as a discipline of knowledge analogous to other school subjects, and therefore as a curriculum demanding of think-

ing and learning rather than mere "doing."

Importantly, the disciplinary perspective was a sympathetic critique of arts education. It embraced the value of the arts, and suggested that the arts deserved equal rather than secondary status in the curriculum. Even those who sided more with the creative approach to arts education credited advocates of "discipline-based" pedagogy with bringing vital public focus to the field as a whole (Daniels, 1989). The discipline-based perspective underscored the sense that arts education, if it was to strengthen its claims for inclusion as an equal partner in students' education, had to assert itself in larger educational policy issues regarding "knowledge acquisition and the development of reasoning skills" (p. B6). Echoing earlier proponents of "aesthetic education," this generation of reformers warned that arts education had too long taken shelter under the banner of "creative expression," and thus had opened itself to the charge that the arts were "tangential" to schools' central purpose." (Kaagan, 1990) The disciplinary approach, in encouraging students to encounter art not just as creative producers, but also as critics and historians with a basic aesthetic vocabulary, claimed to involve art education more directly in the goals of constructing students' bases of knowledge and critical thinking skills (Kaagan). The Getty initiative gave new currency to core ideas that would drive the arts education agenda over the next two decades. It served as the foundation for programmatic reform and as a foil against which detractors' shaped alternative approaches.

In 1988, the National Endowment for the Arts, at the direction of the U.S. Congress, published the first federal audit of arts education in over a century and offered its own recommendations. *Toward Civilization: A Report on Arts Education* (Hodsoll, 1988) represented an official embrace of the disciplinary approach, though it diverged from Getty's version significantly. It called for universal provision of a "basic arts education," which broadened Getty's view to include the performing and media arts and literature, as well as the visual arts. Though it joined in DBAE's call for a more rigorous, academic approach to arts instruction, *Toward Civilization* was more explicitly inscribed with the cultural politics of the Reagan era, advancing arts education as an agent of "cultural literacy" and as a means by which schools could better foster students' attachment to American "civilization" (Honan, 1988).

Yet, emerging out of the same generation of educational soul-searching were calls for reform that warned against deploying the arts as a means to a cultural end. One such initiative developed from the Rockefeller Foundation's 1980 study, *The Humanities in American Life*, the grim conclusions of which led the foundation to

establish Collaboratives for Humanities and Arts Teaching (CHART). CHART programs were dedicated to preparing teachers to bring humanities and arts, through intensive summer institutes, into their classrooms, as well as collaborating with local school districts on experimental liberal arts programming. In particular, Rockefeller sought to redirect instruction in the arts and humanities toward the goal of intellectual development rather than the social and cultural goals to which the liberal arts had often been directed. CHART's leaders suggested that instruction in the liberal arts, including the visual and performing arts, could be strengthened if curricula were organized to foster thinking skills. Too often, they explained, arts curricula were subservient to "predetermined" worldviews authored within the social sciences, such as the promotion of "patriotism" or "multiculturalism," which led inevitably to narrow, static forms of instruction and underwrote an educational culture of rote teaching and standardized testing. CHART found greater democratic potential in the arts themselves as venues for the exercise of students' intellects and imaginations (Renyi, 1994).

Also counterpoised to the disciplinary structure were calls for the "arts-integrated" school. Advocates of "arts integration" saw promise in the arts' capacity to enhance learning generally through a hands-on approach to knowledge acquisition. In contrasting it to Getty's stand-alone arts curriculum, integration's proponents did not necessarily part with the former's view that the arts merited more rounded treatment. Instead they suggested that art's benefits might multiply if they opened up creative and imaginative forms of engagement not just with art-specific content, but by being deployed in math, science, or reading instruction as well. Just as Getty's proposals had antecedents in the 1960s, the integrated approach had been in circulation for the better part of a century. But in the 1990s, the case for integration drew new strength from research that established, at least cautiously, a correlation between arts-rich school environments and assessable academic achievement (Sautter, 1994).

One notable program initiated under CHART was Arts Propel, a collaboration between Project Zero, the Educational Testing Service, and the Pittsburgh Public Schools. For Project Zero, the program offered an opportunity to bring its research and theory concerning the arts' cognitive character into the realm of classroom practice, but more, it also wrestled with the enduring question of how to reconcile the need for student assessment with the subjective particularities of artistic production (Gardner, 1989).

While Arts Propel endorsed Getty's insistence that arts education needed to

move beyond its traditional emphasis on original "production," it argued that the cognitive character of the arts could be best realized by encouraging perceptive and reflective competencies in dynamic relation to students' own artistic work in the fields of music, visual art, and creative writing. Artistic production could no longer be the sole focus of arts education, but it should be the fulcrum around which broadened arts pedagogy should be structured. The arts curricula it brought to the Pittsburgh schools was structured around long-term projects that challenged students to apply art history and method to their own work, reflect critically on both their work and that of their peers, and engage in on-going revision that would result in the gradual assembly of a "portfolio" of work that itself invited further reflection on artistic creation as a process of learning.

THINKING, LEARNING, ASSESSMENT, AND THE ARTS

The program embodied the cognitive approach to arts education, emphasizing the need to teach students to "think" artistically. Equally, it was committed to sculpting a curriculum that could be meaningfully assessed in a way that both acknowledged the art's subjective character, and underwrote the teacher's responsibility to evaluate the individual student's progress and intellectual development. Part of what made Arts Propel significant was that it presented itself not just as a vehicle for bringing the arts into school curricula, but as part of a broader reform of student assessment. Critical of the shortcomings of standardized tests, but cognizant of the need for assessment tools, the program proposed the arts, well-taught, as an assessment model that could account for different types of student cognition.

The assessment model tried to account for the range of competencies students exercised in the artistic process. Attempting to broaden the scope of assessment from narrow teacher evaluation of a student's finished product—a model always dogged by the troublesome search for appropriate standards—the Arts Propel model emphasized the student's own role in the evaluative process through "peer interviews" and reflective "dialogues" with the teacher (Magee & Price, 1992). Such a model, the program's architects suggested, usefully blurred the line between the learning process and assessment. As students were evaluated not just on the end product—the "best" example of their work—but on the basis of a "portfolio," assessment could be better tied to individual development of a student's work as well as her capacity to reflect critically on it. This system of assessment offered an alternative to what arts educators had long seen as an intrusive, and often arbitrary, application of aesthetic standards to student artwork. Further, by explicitly including

historically and methodologically informed perception, and verbal and written exercises in critical reflection, into the artistic process, Arts Propel strove to establish a wider range of competencies as assessable components of an arts curriculum.

Foregrounding the arts as a medium of cognitive learning, while holding strongly to the unique and indispensable character of arts experience in relation to other subject areas, Arts Propel anticipated some of the identifying characteristics of the arts integration paradigm to which educators have turned their sights in the past decade. The focus on assessment, of course, is central. Debates about the culture of educational testing aside, the imperative of making arts education accountable in a manner comparable to other subjects has demanded innovative thought about how learning in and through the arts can be assessed.

But more, arts integration continues to hold appeal as a productive path around the field's long-standing and oft-reappearing divisions between academic and expressive approaches. In its purest form, we might suggest, the arts integration formulation takes no sides in such debates. They become secondary issues. There should be no mistake—its intent is integrative. But "integration," in this regard, refers to the goal of bringing the arts wholly and multidimensionally into the service of the learning mind. It leads toward interdisciplinarity, not via an inflexible commitment to cross-subject teaching, but because of the growing recognition that exposure to the arts enhances a student's prospect of learning and achieving in general. As a recent study (Burton, Horowitz, & Abeles, 1999) concluded, these benefits may be reaped in multiple ways. Not only do the arts foster a set of transferable academic competencies such as creativity, intellectual risk-taking, or the ability see multiple solutions to a problem, but arts-rich curricula also appear to enhance a student's likelihood to self-identify as a "learner." Within this frame, the arts are not only learned, they help constitute the process of learning itself.

REFERENCES

Arnstine, D. (1995). *Democracy and the arts of schooling* (p. 86). Albany: State University of New York Press.

Burton, J. Horowitz, R. & Abeles, H. (1999). Learning in and through the arts: Curriculum implications. In E. B. Fiske (Ed), Champions of change: *The impact the arts on learning.* (Available from the Arts Education Partnership, One Massachusetts Avenue, NW, Washington, DC 2001, http://www.aep-arts.org/PDF%20Files/ChampsReport.pdf.)

Bracey, G. (2003). April foolishness: The 20th anniversary of a nation at risk. *Phi Delta Kappan*, 84(8).

Brosterman, N. (1997). Inventing kindergarten (p. 34). New York, NY: Harry N. Abrams.

Cremin, L. A. (1961). *The transformation of the school: Progressivism in American education*, 1876-1957 (p. 33). New York, NY: Knopf.

Daniels, L. A. (1989, July 19). Long seen as a frill, arts education gains support. *New York Times*, p. B6.

Dykema, P. (1936). Significant relationships of music to other subjects. In *Thirty-Fifth Yearbook of the National Society for the Study of Education: Part II Music Education* (pp. 23-32, 33.). Bloomington, IN: Public School Publishing Company.

Efland, A. D. (1990). *A history of art education: Intellectual and social currents in teaching the visual arts* (pp. 77, 88-90, 92, 101-107, 237-240, 240-241, 243-245). New York, NY: Teachers College Press.

Efland, A.D. (2002). *Art and cognition: Integrating the visual arts in the curriculum* (pp. 4, 235). New York, NY: Teachers College Press.

Gardner, H. (1983). *Frames of mind: The theory of multiple intelligences.* New York, NY: Basic Books.

Gardner, H. (1989). Zero–based arts education: An introduction to arts propel, *Studies in Art Education*, 30(2), 71-83.

Gardner, H. (2000). Project zero: Nelson Goodman's legacy in art education,

Journal of Aesthetics and Art Criticism, 58(3), 246.

Getzels, J. W. & Jackson, P. W. (1962). *Creativity and intelligence: Explorations with gifted students* (pp. 2-3). London, UK: John Wiley & Sons.

Getty Center for Education in the Arts (1985). *Beyond creating: The places for art in America's schools.* Los Angeles: Getty Center for Education in Arts.

Hartman, G. & Shumaker, A. (Eds.). (1939). *Creative expression: The development of children in art, music, literature, and dramatics.* Milwaukee, WI: E.M. Hale and Company.

Hechinger, F. M. (1985, April 2). Report tries to remedy neglect of art in schools. *New York Times*, p. C6.

Hilpert, R. S. (1941). Changing emphasis in school art programs, in *Fortieth Yearbook of the National Society for the Study of Education: Art in American Life and Education* (pp. 448-450, 451). Bloomington, IL: Public School Publishing Company.

Hodsoll, F. (1988). *Toward civilization: A report on arts education* (p. 13). Washington, D.C. National Endowment for the Arts.

Hofstadter , R. (1963). *Anti-intellectualism in American life.* New York: Alfred A. Knopf.

Hollinger, D. A. (1987, Spring). The knower and the artificer. *American Quarterly*, 39, 37-55.

Honan, W. H. (1988, May 4). American teaching of the arts is assailed. *New York Times*, p. B10.

Kaagan, S. S. (1990). *The aesthetic persuasion: Pressing the cause of arts education in American schools* (pp. 19-20). Los Angeles, CA: Getty Center for Education in the Arts.

Keene, J. A. (1982). *A history of music education in the United States* (pp. 83–89, 158, 165, 220-226, 268-269, 288-299). Hanover, NH: University Press of New England.

Kwalwasser, J. (1936). The composition of musical ability. In *Thirty-Fifth Yearbook of the National Society for the Study of Education: Part II Music Education* (p.39).

Bloomington, IN: Public School Publishing Company.

Magee, L. J. & Price, Karen R. (1992, April). Propel: visual arts in Pittsburgh. *School Arts*.

Mark , M. L. & Gary, C. L. (1992). *A history of American music education* (pp. 348-350). New York, NY: Schirmer Books.

Mearns, H. (1939). The creative spirit and its significance for education. In G. Hartman, & A. Shumaker (Eds.), *Creative Expression: The Development of Children in Art, Music, Literature and Dramatics* (p. 18). Milwaukee, WI: E.M. Hale and Company.

Meier, N. C. & McLoy, W. (1936). An instrument for the study of creative artistic intelligence. *Psychological Monographs* XLVII, 1, 164.

Munro, T. (1941). The psychological approach to art and art education. In *Fortieth Yearbook of the National Society for the Study of Education: Part II Music Education* (pp. 250, 308-309). Bloomington, IL: Public School Publishing Company.

Mursell, J. L. (1936). Principles of music education. In *Thirty-Fifth Yearbook of the National Society for the Study of Education: Part II Music Education* (p. 5). Bloomington, IL: Public School Publishing Company.

National Commission on Excellence in Education. (1983). *A nation at risk: The imperative for educational reform* (p. 7). Washington, D.C.: U.S. Government Printing Office.

Perkins , D. & Leondar, B. (Eds.). (1977). *The arts and cognition* (pp.3-4). Baltimore, ML: Johns Hopkins University Press.

Renyi, J. (1994). The arts and humanities in American education. *Phi Delta Kappan*, 75(6), 438-444.

Rockefeller, D. Jr. (1977). Coming to our senses: *The significance of the arts in American education*, (pp. 5-7). New York, NY: McGraw-Hill Book Company.

Sautter, R. C. (1994). An arts education school reform strategy. *Phi Delta Kappan*, 75(6), 432-438.

Silberman, C. E. (1970). *Crisis in the classroom: The remaking of American education*, (pp. 180-182). New York, NY: Random House.

Spring, J. (1976). *The sorting machine: National education policy since 1945*, (p.17). New York, NY: David McKay Company,

Surette, T. W. (1939). A general view of music education for children. In G. Hartman & A. Shumaker (Eds.). *Creative expression: The development of children in art, music, literature and dramatics* (pp. 70-71). Milwaukee, WI: E.M. Hale and Company.

Winslow, L. L. (1941). Current practices in school art. In *Fortieth Yearbook of the National Society for the Study of Education: Part II Music Education* (p. 482). Bloomington, IL: Public School Publishing Company.

Wygant, F. (1993). *School art in American culture*, 1820-1970 (pp.3, 4-5, 13, 87-90, 120-123). Cincinnati, OH: Interwood Press.

Zunz, O. (1998). *Why the American century?* (p.50). Chicago, IL: University of Chicago Press.

Making a Way: Youth Arts and Learning in International Perspective

SHIRLEY BRICE HEATH AND SIR KEN ROBINSON

In developed and developing countries throughout the world, governments, non-governmental and non-profit organizations, health officials, and educators recognize the challenge of creating a knowledge-based, civic-minded workforce. Many look to schools to quickly create or adapt existing learning environments to meet the shifting demands of the global community. In advanced nations, formal schooling accounts for roughly 25 percent of young person's day. Here schooling means the maintenance of key norms: separate roles for teacher and pupil, paced curriculum across selected subjects, and paper and pencil (or scripted) displays of learning. For the majority of children and young people throughout the world, these norms will never be a reality. Hopes that schools will provide a passage to steady employment, good health, or civic engagement are unrealistic. "Making a way" for children and young people living in desperate conditions means just that: developing the knowledge, skills, and competencies necessary to meet personal and social needs, often without the support of stable adults, and outside the institution of school.

For the unschooled children of the world, the hours outside of formal education can be an untapped resource for those looking to develop subsequent generations. United Nations committees, development agencies, and local leaders often look for economical means to sustain positive learning situations for older children

and adolescents, particularly in impoverished rural areas and urban zones where many children live on the streets or are heads of households. These youngsters, in particular, are often easy pickings for criminals, rebel soldiers, and global drug rings.

In the face of these dangers, it may seem especially odd that learning through and within arts production wins out. The young can find in challenging high-risk arts ventures, alternatives that keep them learning and even earning in socially entrepreneurial ventures that benefit their communities as well. Innovative, intensive, and sequenced opportunities to participate in the arts can translate into sustained learning for children and youth despite the destabilizing affects of politics, natural disaster, and war.

In ways that learning theorists and neuroscientists have recently begun to be understand, children and young people working together during discretionary time can learn to conduct themselves socially, develop personal interests, take their first jobs, and formulate their ideas about what constitutes a satisfying, worthwhile life. The arts provide opportunities for young people to experiment with ideas and put them into action. Given a respite, young people create dramas, stories, and songs. They draw in the dirt and challenge one another to imitate dance moves. In many parts of the world, children and young people find a way into their own youth arts organizations—more often than not designed both to achieve aesthetic excellence and to meet social needs of neglected populations. Without attention from the wealthy nations of the world or international organizations, youth arts organizations remain almost invisible except for the occasional blip on television screens or short features on the international news page. The absence of a place in international thinking has not kept creation of the arts out of the hands and heads of the young of the world. Throughout the world, young people are transforming the cultural commons of their communities using the arts and exceeding the accomplishments of adults.

LOOKING TOWARD PEACE

Young people see the arts—personally and for their societies—playing unique social and educational roles, and they view their work as real, vital, and necessary. In Addis Ababa, Elami, a homeless teenager, is a member of the Adugna Community Dance Company that grew out of a visit from Royston Maldoom in the 1990s. Maldoom is a world-renowned dancer and choreographer known for his ability to create productions of the highest quality, using novices and populations rarely expected to enter the worlds of modern dance. He is also an inveter-

ate learner, taking every advantage of opportunities to enter into traditional dance and music in which he has had no previous experience. Royston came to Addis Ababa, brought together scores of street children like Elami, and helped shape the circumstances that brought about the Adugna Community Dance Company. Royston refuses the "street" identity of the children. He says, "I do not work with street children. I work with children." All the young dancers know they not only have to train, practice, listen, and learn, but they also have to manage the company. In the past three years, they have drawn international attention and hope to become the only youth-run arts organization granted special status and support by UNESCO (Adugna Community Dance Company).

In Soweto, inside a small, whitewashed building on the grounds of a church, a female voice in British English gives direction to a group of young people, ages 9 to 23, gathered in clumps with their instruments. This is the home of the Buskaid Soweto String Project, an ensemble of string players made up entirely of young people from the near by communities. Finally the practice seems to stop, and a buzz of voices follows. From the cacophony comes a recognizable name—that of conductor, Sir John Eliot Gardiner. He and twelve members of the English Baroque Soloists arrive next week, and the fortunate students who are working along side these master teachers for a week will join them in a concert. Some 80 youngsters out of the 2000 that have applied work together to create CD's, prepare for special regional and national events, and practice strenuously. Music history and theory, the physics of string instruments, and literary texts and musical compositions take place alongside practice and planning. The young musicians develop their own budget for travel, supplies, and the purchase and maintenance of instruments. Founded a decade ago and still led by Rosemary Nalden, a London violist, the Buskaid Soweto String Project grounds its identity and learning to life in Soweto (Buskaid Project).

The existence of such groups in the 21st century follows a long pattern of young people coming together to learn around the arts in South Africa. Films, books, and news accounts came out of the Apartheid years, particularly from Soweto, when the young kept their faith in freedom through dance and theatre work, as well as soldiering. The world-renowned Market Theatre of Johannesburg worked along side The Laboratory Theatre, which consisted only of young actors. These young people helped other theatre groups develop throughout Soweto and other townships across South Africa. By the late 1980s, these groups were celebrated in festivals, such as that taking place annually in Grahamstown.

Even Emdeni, the notorious precinct of Soweto that invented "necklac-

ing"—killing a victim by entrapping them within a burning tire—gave birth to a festival-acclaimed theatre named Thabisong. This group and others like it in several townships across South Africa study drama in one or more African languages, English, and Afrikaans. The young actors learn to read, speak and act in a wide range of roles they may have never actually witnessed in their everyday world, and organize their daily maintenance, travel plans, and program development. In several years, their work has paid off at national festivals, bringing them winning positions, even in the Afrikaans language portions of festivals. This discipline and commitment to representations of themselves as learners—even of the once intensely despised Afrikaans language—strike outsiders as particularly ironic, since it was the Soweto youth who rallied against the imposition of Afrikaans in schools under the Apartheid government. Their violent confrontations with the police and the tragic aftermath were documented in the musical and film *Sarafina* in the 1980s.

War and military strife that bring violence and unpredictability to daily life for children and youth seem to promote the arts, particularly those dependent on listening. Music in ensemble or orchestra enables organized sounds to evoke harmony without any "taking of sides" through words. The Middle East Youth Orchestra, founded by Edward W. Said, the late literary theorist, music critic, and advocate of Palistinian independence, and Daniel Barenboim, the Israeli pianist and conductor, has brought young Israeli and Arab musicians together for more than a decade (Boustany, 2003). Group instrumental work depends on learning to listen and to interpret as an individual for group achievement. Such is the heart of diplomacy.

Music, perhaps more than any other art form, brings with it religious traditions and ethical positions regarding life, death, and the dramas of love. Occasions of performance often invoke the spiritual and take place in sacred places and within life's rites of passage. These complex underpinnings of music, whether Byzantine chants, or Sufi music, or Christian funeral oration, find their way into youth orchestras. Harmony becomes more than the resolution of notes in measures or individual players collaborating in ensemble.

STAGING THE LOCAL

All strife does not take place between organized political, ethnic, or military groups. The primary strife for the young comes from within families and in the context of local limits on provision. Here again, however, the young often find ways of learning within the arts to push through and even to surmount local struggles.

Phakama, a group of young people from Britain and South Africa, began in the early 1990s to work together through theatre to examine their common and diverse challenges. The London International Festival of Theatre (LIFT) is a London-based group dedicated to bringing to attention drama from around the world as a way of stretching ideas and associating with life beyond conventional means. Adhering to a strong faith in the importance of putting young people's voices and leadership in the lead toward such pursuits, LIFT helped initiate Phakama. Trained in running workshops, creating site-based theatre, and including non-trained actors into their productions, Phakama's young members have worked in England, India and South Africa.

Core members of the group convene in unlikely locations for theatre and encourage local youth to bring key issues in the lives of their community into script and performance. For example, in 2000, in a town in northern South Africa, youth from several South African regions joined with Phakama veterans from London to create a drama around women's issues. Violence, AIDS, abandonment, and deprivation became themes of the piece, but grounding the production was the sheer amount of labor performed by women that determined the ongoing life of the village. Staged in two houses across the road from one another, the production brought "audience" members into the first house and its garden, and across the road to the second home. From the garden trees hung verses of songs, poems, and sayings that reflected the women's work, and the audience was invited to examine, perform, and consider each of these. The town police stopped traffic on the road and joined in the (literally) moving drama, which ended in song and dance linking men and women, young and old.

Phakama performed at the opening of the museum on Robben's Island off the shore of Cape Town, drawing on the notorious history of its prison, its residents, and its memory. But Phakama youth do not wait for such celebratory or one-occasion-only opportunities. They work in hostels for youth seeking asylum in England to produce theatre that educates social workers, educators, philanthropists, and the general public about who they are, what they have come from, and where they hope to go (Phakama Project).

In Melbourne, Australia, a group of young people whose families have endured the hardships of refugee camps and years of waiting and hoping for transition, work through theatre in the Horn of Africa Community Association. After a decade or more in refugee camps created through ethnic rivalries in Southern Sudan, Ethiopia, Eritrea, and Somalia, these immigrants, who finally gained entry to

Australia in the 1990s, faced unexpected struggles within their own families. Strong expectations about the division of labor along gender lines separated mothers and fathers from their children. Australian schools had little in common with the "schools" established in the refugee camps or with the traditional values parents held onto for their children.

Bridging century-old rivalries and hatred from their homelands, the elders of the four nations created the Community Association, primarily to centralize information for Australian authorities. However, the young soon took up the model of collaboration and moved it into the arts. They created a theatre group to identify cross-generational crises and to educate school personnel and families. The plots of their productions lay in real incidents. The drama of their stories unfold in theatre-talk sessions in schools, churches, and community centers, opening conversations about tough matters for survivors of refugee experience.

The young of the Horn of Africa Community Association also take responsibility for after-school homework clubs in their community churches. Each session begins with rituals from the four ethnic groups—songs and other forms of representation of traditional and contemporary arts that cut across the warring histories of their parents. Mixed with the serious work of cross-age tutoring for homework in these sessions are fashion shows, hair styling, and exchange of popular music. Adolescents who barely remember their days in the refugee camps have no misconceptions that their younger siblings want and need to be brought into the 21st century culture of Australia, their new homeland. Knowing the arts and interpreting through the arts can help cut across barriers of philosophy, taste, and cross-purpose hopes between the young and the old. The arts also ensure belonging and becoming within an entirely new cultural world.

Such groups find their support in unlikely sources. The Finnish embassy currently supports the Adugna Community Dance Company in Addis Ababa. Some individual members now find sponsorship to continue further training in dance and arts management in England, with expectations of bringing their knowledge and skills back to the full group.

Contrary to the usual models of transmission, where adults view childhood and youth as preparation for adulthood and a future, the young in the arts learning organizations recounted here see the future as now and themselves as real contributors. Some have little or no access to formal schooling, while others clearly have excellent formal educational opportunities, but choose learning environments in the arts that come along with high risk and deep experience. The young people

working in these organizations invariably have taken matters into their own hands with the help of supportive adults. They rise to meet social needs unaddressed or even opposed by their national or regional governments. And they choose to do so through the arts. In India, a group of street children in the Mumbai train station assails a passing woman, clearly a member of one of the elite castes. She learns that a member of their group has just died alone, and the children issue a plea for her to find ways that they can, under such circumstances, call for help "so none of us will die alone." Thus, Child Line, a toll free number available in scores of regions across India was initiated. Through the decade since this incident, Child Line has evolved into a training program for street children who themselves handle the phone lines when other street children call in for help. The children, trained by social service workers and in the geography and demography of their region, then call the service or agency they judge to be appropriate. At their insistence, the children themselves are the public face of Child Line. They work with adults to produce booklets that make clear their origins, purposes, ways of operating, and means of evaluating their work. When, a few years into their development, government administrators insisted that some evaluation of the work of the group must be done, the children met his insistence with their own mandate: train us and we will learn and tell you what is happening (Childline Foundation India). Throughout the work of Child Line, the children have included art as the preferred way of representing themselves. They created a logo, helped design the booklets that explain their philosophy, mode of action, and expectations. By the end of the 1990s, local government ministries had determined that their incorporation of Child Line into the governmental infrastructure surrounding child services could provide secure funding and a broader reach for the group.

When the Ethiopian government could not or chose not to address the needs of hundreds of street children and the rampant spread of AIDS in rural areas, young people moved in through the arts. The Awassa Tukol Vocational Training and Arts Center developed their AIDS Education Circus to help meet the dire need for AIDS education that could reach rural areas. Again, the performers are homeless young people who are self-sustaining, and again, the group began through the initiative of the young themselves (Awassa Children's Project).

Two features mark the development and maintenance of youth arts organizations that develop around the world: recognized social need, and local youth leadership. In impoverished, war-torn, or AIDS-ravaged areas, where there is ethnic strife and limited access to education and employment, youth arts groups emerge.

These organizations direct themselves toward excellence in the arts, to be sure, but they also remain grounded in the impetus of their origins—social needs. Because the needs they address are not high profile, they use their arts excellence to raise the profile of the social needs they see behind their work. The latter fuels the recognized need and applied energy of the youth in areas such as financial management, security, health education, and organizational learning. Their needs for learning, as well as their means, differ markedly from those of students engaged only in formal education. They must take initiative. They must see needs. They must assume responsibility for the future of the organization. The school district office, United Nations peacekeeping force, or International Red Cross office down the street or road, will not pay their rent or the salaries of the professional artists who work with them.

THE NEW WORLD OF WORK

During most of the two hundred year history of formal schooling in the Western world, the young have been prepared within schools to enter manufacturing jobs composed largely of repetitive tasks to be performed in standardized ways for standard products with predictable modes of operation. The 21st century world of work consists primary of knowledge industries that value innovative approaches to work, establishment of new standards, and production of creative products and services.

Organizational innovation, new standards, and imaginative services and products come, more often than not, in youth arts organizations with a commitment to social responsibility, including social entrepreneurship. This acknowledgment does not diminish the need for aesthetic excellence, but exists alongside educational and social goals. This philosophy springs from the sad reality that the causes for which they work and the needs they see within society cannot depend on charitable handouts from adults in power. Such handouts have, in the experience of many of the older youth, evaporated at critical moments, come with a high price of authoritative rule, and curtailed or censored the energies and outcomes valued by the young. Therefore, young social entrepreneurs stress innovation and resourcefulness in order to create social value. They want to sustain their work without a full dependence on adult leadership and charitable funding. The descriptor "full" here is significant, for all youth organizations count on adults who are critical advocates, advisors, mentors, professional artists, and fundraisers, and even the most entrepreneurial of youth organizations must rely in part on philanthropy, governmental funding, or the

charity of wealthy individuals or established businesses. Some young people characterize their relationships with these benefactors as a symbiotic one in which adults get access to the energy and creativity of youth while the young gain the benefits of experienced, attentive, and caring adults.[2]

In Lund, Sweden, over two decades ago, the city decided to tear down an old dairy, now very close to being enclosed within the extending city boundaries. Young people joined to protest the destruction of the historic building and to call for its transformation into a cultural venue for young people. Over the years, "The Dairy" emerged as the most sought-after concert venue in Sweden. Big names from abroad, such as Miles Davis, preferred to play in Lund because of the extraordinary facilities—acoustics, equipment, and crowd control. Regional groups, such as The Cardigans, found The Dairy a place where young concertgoers brought a depth of knowledge of the music as well as appreciation to performances.

The Dairy has, in the past decade, been the site of regular lessons and concerts of at least four different types of music—jazz, rock, folk, and classical—as well as a film venue. The theatre's film section is open for foreign films, classics, and special film festivals. A collaborative committee of young people and music and civic experts govern scheduling of concerts, ensuring equity in scheduling across the four types of music. Young people can come to The Dairy with their friends and find seventeen soundproof rehearsal rooms, several with musical instruments they can borrow for practice. Local music teachers schedule the rehearsal rooms for teaching, and The Dairy collects a portion of the fee for lessons offered. These fees and concert income supplement an annual budget from the city of approximately $250,000 (Heath, 2002).

The Dairy reflects a growing trend among youth-based arts organization around the world: social entrepreneurship. The group brings in money from its concerts and films, but it also serves numerous social needs in the community for a range of ages. Over the years, The Dairy has come to serve as the major apprenticing location for aspiring producers and agents of music. Young musicians start out at The Dairy, but they often go on in a range of fields of music, from acoustical engineering to specialized study in a single instrument. Moreover, because the young people who have worked within the organization over the years gain experience in finance, security services, building and equipment maintenance, lighting and technical design, as well as promotion and publicity, they can move on for further study or jobs in other cities. Several years of experience at The Dairy stands out on any résumé.

Social entrepreneurs working through arts organizations have been around for centuries, generally springing up in greatest abundance at times of central institutional change or uncertainty. From the miracle plays of the medieval era to folk theatre in the farm workers' movement in California in the mid-twentieth century, artists across ages have addressed social change and the need for their economic independence from status quo powers in the society. The devolution of post-industrial governments that began in the 1990s, as well as international terrorist fears and upheavals within world religions, particularly Islam and Roman Catholicism, at the beginning of the next century, spurred artists, young and old, to see the need for new kinds of community arts linkages. Healing, bridging, and connecting in new ways had to come from sources beyond time-honored institutions.

A growing trend to see youth as troublemakers and criminals, spurred policy designed to control young people in the US. Harsh penalties and detention conditions for the young had, by the end of the 1990s, filled many local jails and state prisons with young offenders. A majority of these had suffered abuse and neglect in their families and had failed to find meaningful learning opportunities in schools. The failures of government and business to match childcare provision with the growth of the female labor force left many children beyond the age of eight either on their own with older friends or in organized peer-group activities. Some were fortunate enough to have families who could pay sports and arts fees for team participation and lessons. Others created their own groups and purposes for coming together, leading to a wide range of outcomes for society—some linked with criminal gangs and others with grassroots community organizations. But these approaches to the "leisure" or non-school, non-family supervised time of the young are almost entirely ad hoc in the US and throughout the world.

Largely absent are innovative strategies to involve young people in creating and sustaining organizations through which they work to meet their own and other's needs. Moreover, children in rural communities in post-industrial and developing nations, grow up with television images of a life very different from their own. They often decide early on that their future depends on moving away from their community of birth. Few governments have formed effective coalitions of business, education, and health representatives to slow this exodus. Inevitably migration to urban zones leads to disappointment, and too often to horrible living conditions, poor health, and drug addiction. Transport stations across Europe and parts of Africa became, in the 1990s, irregular and inadequate havens for young refugees and migrants in search of something better than they had in their

devastated homelands.

During the late 1990s, this coalescence of conditions prompted some international development agency offices of nations such as Finland, Sweden, Norway, and national councils, such as the British Council, to respond. The separation of children and youth from traditional societal groundings and the evident institutional gaps led to an increased attention to the potential of work in the arts for the young. The European Union and other governmental agencies of European nations looked especially to the socially inclusive powers of theatre, visual arts, dance, and special events, such as regional or city festivals of art, to reach across ethnic, linguistic, and ability boundaries.

Some arts centers, such as LIFT, went further, insisting on the commonalities of childhood across national contexts. But beyond topics and themes of the dramatic arts, LIFT also edged past the usual in expectations of "normal" alignments of corporations and arts organizations. Through the Business Arts Forum of LIFT, this group reversed the usual expectation of corporate support for the arts. Instead, LIFT, with the help of Phakama, their affiliate youth arts group, brought corporate representatives into the heart of the theatre through seminars, direct experiences with visiting theatre companies, and site-specific works in London. In doing so, they convinced corporations that the kind of learning associated with the arts is necessary within their businesses to activate creative connections, innovative relationships, and an understanding of the cultural commons (Rowntree).

These agencies and businesses began to understand that contemporary socialization of the young, especially those between the ages of 8 and 21, differs significantly from the past. Earlier socialization models that required elders to pass on their wisdom and skills no longer work. Today the young learn largely from other young people, and active experimentation is the favored means of learning. The gaps created by the demands of parental work and the demise of social commitments by civic and religious sectors in many parts of the world, call for inventive means of filling the hours and absorbing the energies of the young from middle childhood forward (Heath, 1998, 2000; Lerner, 2001). Neither post-industrial nations nor fledgling new democracies are doing well at holding the young beyond the ages of twelve to fourteen in appealing environments of learning that enable them to see the need to build civic, health, and aesthetic competencies and sensitivities toward a distant and unknown future.

NEW WAYS OF LEARNING

These social conditions put peer learning, or pre-figurative learning in Margaret Mead's (1970) term, out in front of traditional forms for most of the world's older children and adolescents. Current work in evolutionary biology and the neurosciences increasingly examine the complexities of ways the young learn without verbal instruction (Steinberg, 2001; Rogoff, 2003; Herzog). Social scientists are learning how youth actively engage in shaping and directing their own learning environments. Studies in the neurosciences and medically informed theories of adolescent development suggest that learning takes place optimally during puberty and maturity toward adulthood through active movement, direct experience, and high-risk, engaged-role learning. Juveniles may well be genetically programmed to perceive and experience their environments in species- and age-specific ways in forms far more deeply embedded in the neural infrastructure than previously recognized (Boyer, 1998; Hirschfield, 2002; Turner, in press).

Current studies of the evolution of socialization lend further support to the idea that direct experimentation through active involvement may be the preferred means of learning for youth from a neurobiological standpoint. Sociocultural and economic conditions underscore the need for putting these means into action (Singleton, 1998). The marked decline of time engaged in joint creative work with adults, foreshadowed in post-industrial national trends toward full employment outside the home by both adults, is rapidly spreading internationally. Moreover, in those parts of the world where information and high technologies dominate both leisure and work, actual physical involvement in project-based extended learning opportunities appear less and less in the play of the young. Implications from this decline in manual work are under examination by scientists across the neuroscience disciplines (Wilson, 1998).

In the cases of orphans, refugees, and asylum-seeking youth, their socialization has been almost entirely through their peers and without opportunities for side-by-side learning or apprentice-like experiences with caring adults in stable relationships. Direct roles in active learning, often at their own initiation and under the modeling influence of peers, provide information and skills for transformation into knowledge. Such learning, facilitated by the mobility of youth around the world, has to be portable. Skills and information learned must be taken beyond the immediate context of experimentation or access to role modeling.

Perhaps nowhere are the intricacies of this pattern more evident in highly visible ways than in the skateboard groupings that develop in urban areas. No

instruction from elders comes with the high risks these young take, but they constantly bring in younger members, reshape their environments, and find ways to create their own rules to work around civic authorities. In those cases where civic leaders have brought the young into their planning for safe, challenging, and artful centers, the move to organizational learning, budgetary concerns, and health and safety rules has come to be shared by the young. Hence, they have been able to gain skills that move with them as they grow out of skateboarding and into other kinds of entrepreneurial high-risk ventures. In a number of highly creative civic efforts to work with and learn from youth, skate park creation has been a project tightly integrated with community arts. Essential in these projects is the possibility for young people to remain engaged over an extended period with adult roles for themselves and apprentice-like learning opportunities alongside professionals such as architects, physicians, police, civic officials, contractors, and artists. These learning provisions, created always in arts learning that works toward real creative products, projects, and performances, contrast with the highly segmented, short-term, sporadic task assignments the young who work in fastfood jobs receive (Tannock, 2001).

WHAT DO THEY LEARN?

Finding substantial evidence of "transfer" from practice of the arts to other specific skills calls for segmenting any art into small bits hardly recognizable as "art." There is precious little evidence to support claims that learning within the arts can be the cause of narrow educational ends, such as boosts to scores in mathematics tests.

Meanwhile young artists themselves argue that increased self-satisfaction, confidence, skills in collaboration, and deeper knowledge of resources beyond their immediate environment come as the young work through extended high-demand projects in the arts with professionals as colleagues and critics (Heath & Smyth, 1999). But such reports, along with any evidence that the claimed benefits have holding power, come only when the learning environments in which the young create art carries risk, meaning, and purpose to the participants. The learning that comes from these broad strokes of environment cannot be cut into discrete measurable skills. However, from the few longitudinal studies available, we know that estimations of quality of product and process and competence in collaborative inquiry and critique stay with young artists, gain a cumulative effect, and find their way into other roles when arts organizations ensure that their membership can

move from beginning through intermediate to advanced learning (Heath & Wolf, 2004). Added to these levels of advancement in their chosen art forms are the leadership, fiscal management, and planning skills the young gain.

Youth working through the arts in their communities play strong leadership roles, they identify social needs, but even more important, they keep up a steady call for sustaining community, organizational, and governmental response. Of primary importance to young people working in the arts across national boundaries are issues related to health, environment, social justice, and human rights. In their efforts to chip away at these broad areas of human need, the young consistently work toward improving communication, protection, and learning opportunities for even younger children, the disabled, and others often overlooked in societies of great need. The organizations considered here do not focus on the usual after-school activities. Moreover, casual observers are unlikely to regard their activities in any way that might appear to support schoolwork (Maira & Soep, in press). Their importance lies in the fact that they reflect organizational adaptation by young people who want to learn particular art forms and see these as their way of responding to social needs. In effect, these organizations are the unintended consequences of a coalescence of global and local factors that shape the everyday lives of older children and young people well into their twenties. Into these often desperate situations, the young, invisibly at times, are stepping forward with the arts in many places and numerous ways to fill institutional gaps, undertake social entrepreneurships, and develop hope, and sometimes environments, for healthy living and for their own learning.[3]

The organizations mentioned here represent only a small handful of those that exist around the world and adapt to local conditions through the savvy leadership of youth working with supportive adults. They identify needs, work together toward long-range goals, and establish opportunities for others to learn. For all of the children of the organizations noted in this chapter, achieving wealth is highly unlikely. For many, a job that provides minimal support for a family of four is not possible. For some, escaping either violent death or a slow dying without health-care may be their luckiest break in life. Perhaps the most lasting gift of learning in the arts comes from the adaptive stance upon which the arts insist.

Learning in the arts is all about adaptation, creation, innovation, and maneu-verability. In the study of human development, we know relatively little about adaptive learning—which develops through habituated gains in seeing and judging responses needed to change circumstances. Such adaptation is often thought of as

"transformative learning," and such adaptation comes most often in the human life cycle when tragedy or the highly unexpected descends. Western literature is filled with the pathos of failed adaptation. Narratives, from folktales to opera, depend on audiences' continual fascination with ways to find the means to work through the unexpected turns in life for which there is no curriculum or set of ready skills. The arts (as well as many forms of play) enable anticipation of the need to handle life transformations and keep the human psyche intact. Responses to transforming experiences, particularly those regarded as traumatic, are met in the post-industrial world with an assertion of the need for counseling or other forms of professional help. Rarely is such help possible or available when most needed, even in situations of relative economic plenty. In most parts of the world, such forms of help are never available.

Osman Bah (2004) was a child soldier in Liberia. "I can't remember anything until I was five years old. Then what I noticed was war.... I have spent all my life fleeing." Osman made his way to London in 2003, after every member of his family had been killed. He had been forced into the army to "liberate the people of Liberia," and his own killing as a soldier began as he and other boys and girls were marched across Liberia. "It hardens you, makes you feel high, and cold in your mind. Some of us had soft minds, soft spirits, and sympathies. But when you take these drugs, you don't have any regrets. You kill a person like killing a small chicken."

After months of soldiering, Osman was captured inside Guinea and then allowed to escape and flee. He managed to find his way into the back of a container ship that eventually brought him to England. There he became a refugee under consideration for asylum status. During his time of transition, the Phakama youth theatre of LIFT began a yearlong project working in London with asylum-seeking children and youth waiting to learn their future. Juggling, singing, dancing, working with pyrotechnics, and creating visual arts brought communication among the young, even when they had no language in common. Weekly, they worked through stories, mime, drawing, drumming, and dance to create a drama to be presented in May of 2003. Osman became a leader within the group and a spokesperson for the work of their program. In early 2004, he won approval to remain in England from the Home Office. Today he works in Leeds helping to create a youth theatre group through cooperation with Phakama's older members.

Osman explains: "Through the [Phakama] arts project, I met a boy called Mohammed, from Sierra Leone. We found that we had fought on the same border

between Sierra Leone and Guinea. We found out that we had even crossed the river at the same place. I was asked to talk to him. I told him to think about his future. Don't think you are a nobody; give yourself a chance; keep on thinking courageously" (Bah, 2004). Osman's work with Phakama captures the core of adaptive learning possible through the arts, bringing the past, as painful as it can be, together with plans and hopes for the future for himself and for his peers. Youth arts are "giving a chance" to Osman and many other young people like him to learn and to adapt to a world that offers them little in the way of chances. Their stories give us a chance to see the potential of the arts to help meet the challenge of youth internationally.

[1] Numerous publications explain the concept of social entrepreneurship, often within the broad frame of social responsibility from the corporate sector or for the special purposes of venture philanthropy (Dees, Emerson, & Economy, 2002).

[2] For case studies of two US-based social entrepreneurships, see Heath & Smyth, 1999, a resource guide accompanying a documentary film, *ArtShow* that portrays these two cases. See also the two business cases written for the Graduate School of Business, Stanford, by Smyth on Artists for Humanity (Boston, Massachusetts) and The Point (South Bronx, New York), two socially entrepreneurial youth organizations. See also Miles, Pohl, Stauber, Walther, Banha, & Gomes, 2002).

[3] For further discussion of institutional gaps and their effects on the young, see Heath, 2000; Perret-Clermont, Pontecorvo, Resnick, Zittoun, & Burge, 2004). The context of these gaps and the role of risk in the end-of-century period are further addressed in Beck, Giddens, & Lash, 1994).

REFERENCES

Adugna Community Dance Company
(http://www2.britishcouncil.org/home/arts/arts-for-development/
arts-performing-arts-acd-directory/arts-acd-directory-dance/arts-acd-
directory-tan-dance-ltd.htm)

Awassa Children's Project (http://awassachildrensproject.org/circus.html)

Bah, O. (2004). *I was a child soldier.* Retrieved June 15, 2004 from
http://www.opendemocracy.com/themes/feature_articles-10.jsp

Beck, U., Giddens, A., & Lash, S. (1994). *Reflexive modernization: Politics, tradition andaesthetics in the modern social order.* Stanford, CA: Stanford University Press.

Boustany, N. (2003, December 5). Musicians strike a note for peace and harmony. *TheWashington Post*, p. A 28.

Boyer, P. (1998). Cognitive tracks of cultural inheritance: How evolved intuitive ontology governs cultural transmission. *American Anthropologist*, 100, 876-889.

Buskaid Project (http://buskaid.org.za)

Childline Foundation India (http://www.childlineindia.org.in/cifo1.htm)

Dees, J. G., Emerson, J., & Economy, P. (2002). *Strategic tools for social entrepreneurs: Enhancing the performance of your enterprising nonprofit.* New York: John Wiley & Sons.

Heath, S.B. (1998). Working through Language. In S. Hoyle, & C.T. Adger (Eds.), *Kids talk: Strategic language use in later childhood*, (pp. 217-240). New York: Oxford University Press.

Heath, S. B. (2000). Risk, rules, and roles: Youth perspectives on the work of learning for community development. *Zeitschrift fur Erziehungswissenschaft*, 1.00, 67-80.

Heath, S.B. (2002). Working with Community. In *Strategic tools for social entrepreneurs* Dees, G., Emerson, J., & Economy, P. (Eds.) (pp. 204-243). New York: John Wiley.

Heath, S. B., & Smyth, L. (1999). *ArtShow: Youth and community development.* Washington, DC: Partners for Livable Communities.

Heath, S.B. & Wolf, S. (2004). *Visual learning in the community school.* London: Creative Partnership.

Herzog, J. (in press in French). *Situated learning and Compagnonnage formation: Implications for the education systems of poor nations.* Manuscript prepared for Expose donne au Congres Annuel American Anthropological Association.

Hirschfeld. L. (2002). Why don't anthropologists like children? *American Anthropology*, 104, 611-627.

Lerner, R. (2001). *Adolescence.* Englwood Cliffs, NJ: Prentice Hall.

Maira, S., & Soep, E. (Eds.). (in press). *Youthscapes: Popular cultures, national ideologies, global markets.* Philadelphia: University of Pennsylvania Press.

Mead, M. (1970). *Culture and commitment: A study of the generation gap.* Garden City, NY: Doubleday & Co.

Miles, S., Pohl, A., Stauber, B., Walther, A., Banha, R. M. B., & Gomes, M. (2002). *Communities of youth: Cultural practice and informal learning.* Hants, England: Ashgate Publishing.

Perret-Clermont, A-N., Pontecorvo, C., Resnick, L. B., Zittoun, T, & Burge, B. (2004). *Joining society: Social interaction and learning in adolescence and youth.* New York: Cambridge University Press.

Phakama Project (http://www2.britishcouncil.org/home/arts/arts-for-development/arts-performing-arts-acd-directory/arts-drama/arts-acd-directory-project-phakama.htm)

Rogoff, B., Paradise, R., Arauz, R. M., Correa-Chavez, M., & Agnelillo, C. (2003). Firsthand learning through intent participation. *Annual Review of Psychology*, 54, 175-203.

Rowntree, J. *The unbearable heaviness of money: How to make it lighter; Learning to make space for culture between commerce and communities.* Manuscript submitted for publication.

Singleton, J. (Ed.). (1998). *Learning in likely places: Varieties of apprenticeship in*

Japan. Cambridge, England: Cambridge University Press.

Steinberg, L. (2001). *Adolescence.* New York: McGraw Hill.

Tannock, S. (2001). *Youth at work: The unionized fast-food and grocery workplace.* Philadelphia: Temple University Press.

Turner, M. (in press). *The artful mind.* New York: Oxford University Press.

Wilson, F. (1998). *The hand: How its use shapes the brain, language, and human culture.* New York: Pantheon.

5

Putting the Arts in the Picture: Reframing Education in the 21st Century

NICK RABKIN AND ROBIN REDMOND

It is fall. Fourth graders in a low-income Chicago public school are sitting on the edges of their seats, coiled with excitement, eyes focused and forward, feet tucked beneath their chairs. They are watching and listening carefully to each other and to the teacher and artist leading a lesson linking character development in literature and writing to portrait drawing. These students display body language some artists and educators associated with the Chicago Arts Partnerships in Education (CAPE) have called "The Look." We have seen The Look in several classrooms in this school. It is physical evidence of students' deep engagement in the lesson that is taking place. The results of this engagement are displayed on hallway walls rich with art and writing—clear evidence that engagement is resulting in real learning and accomplishment.

The same day fourth graders in another low-income Chicago school are called to the front of the room to share a bit of good advice they have received from a family member. Most are banalities like, "do your homework," or "don't fight with your sister." The students mumble as they read from bits of decorated paper, and then glue the papers to a cabinet that will become a collaborative creation. There is at least one competing conversation. Most students slouch in their chairs, faces glazed. The hallways here are decorated with posters reminding students of the rules they must follow. One features the headline, "What is Freedom?" The

answers, supplied by students, are mostly about learning self-control. There is little student work in sight. This school's focus on social norms and behavior control seems to prefigure the role of the juvenile and criminal justice systems in the lives of many of these children. Neither engagement nor learning is apparent.

Over two years, School 1 has been using integrated arts education as a strategy for improving student achievement and changing the school's culture and climate. School 2 just started to use arts integration, and is at the very beginning of a learning curve and change trajectory. There is a good chance that School 2 will look a lot more like School 1 in a couple of years. Its students will be doing better, and its curriculum and school culture will be organized around principles of teaching and learning, not behavior control.

The scene we observed in School 1 is being repeated in dozens of schools, many low income, across the country every day. These schools defy expectations in significant ways: First, because they are succeeding in a system that has failed millions of low-income children, and in which closing the "achievement gap" has proven to be a most elusive and frustrating goal; second, because their successes have been generated by moving the arts, perpetually on the margins of education, to the center of teaching and learning.

There are other ways these scenes defy expectations: they don't look like typical classes in art. Rather, ideas, concepts, or themes are linked to an art form or project. Instruction is frequently a team effort, often a collaboration between a visiting teaching artist and a classroom teacher. Curriculum is often designed to find connections between the content of the lesson and the students' own lives and experiences. In School 1's writing and drawing lessons, for example, the subjects of their writing and their portraits were family members. In arts integrated schools, students constantly move back and forth between different methods of inquiry and observation, symbolic languages, expressive modes, formal curriculum, and their own lives. Instruction by art and music teachers is often designed in close consultation with classroom teachers to best align arts learning with educational goals in academic subjects and to assure that students have the necessary arts skills to do complex classroom projects. Instead of art and music teachers enduring life at the margins of their institutions, they often become important leaders in schools' professional community.

ARTS INTEGRATION AND STUDENT ACHIEVEMENT: TESTING A NEW HYPOTHESIS

Over the last fifteen years, researchers have found significant correlations

between arts education and student achievement. Some of these, like arts participation and SAT scores and the so-called "Mozart effect" on spatial-temporal reasoning, have captured popular and media attention. Less well known is an analysis (Catterall, Chapleau, & Iwanaga, 1999) of data from the National Educational Longitudinal Study, which showed that students with high levels of arts participation (measured by classes and extra-curricular activities) performed better than their peers across a wide range of achievement variables. The achievement variation between high and low participators was largest among low-income students, suggesting that arts education has a role to play in closing the achievement gap. A review (Deasy, 2002) of 62 published studies on the academic and social effects of learning in the arts found evidence of transfer from learning in each of the art forms. Transfer was sometimes the result of heightened levels of student motivation, engagement, or confidence, and sometimes the result of cognitive associations between arts skills or concepts and related skills and concepts in other domains.

There has been little investigation, though, that has disaggregated different sorts of arts education, explored their relative strengths, and helped us understand how to maximize the benefits of arts education. Our working hypothesis is that arts integration is a strategy for maximizing the benefits of the arts for students.

In order to test this hypothesis we reviewed evaluation studies of about a dozen substantial arts education projects. We looked for studies that were rigorous, covered multiple years of activity, and were attentive to downstream student outcomes. We found six projects that had released some twenty-three evaluation reports meeting those simple standards (Adkins & McKinney, 1999; Anderson & Ingram, 2002; Baker, Bevan & Admon, 2001; Baker, Bevan, et al, 2003; Catterall & Waldorf, 1999; Corbett, Wilson, Noblit & McKinney, 1999; Education Development Center, 2003; Frechtling, Rieder, Michie, Snow, Fletcher, Yan & Miyaoka, 2002; Freeman & Seashore, 2002; Freeman & Seashore with Werner, 2002; Gerstl-Pepin, 1999; Groves, Gerstl-Pepin, Patterson, Cozart, & McKinney, 1999; Groves, McKinney, Urrieta, et al, 1999; Gunzenhauser, 1999; Ingram & Seashore, 2003; McKinney, Corbett, Wilson & Noblit, 1999; Nelson, 1999; Seaman, 1999; Seashore, Anderson & Reidel, 2003; Wahlstrom, 2000; Wahlstrom, 2003; Werner, 2002; Werner & Freeman, 2001).

Integration was a factor in all six projects, but the intensity and sophistication of integration, and its role in their strategic approaches to arts education varied. We reviewed each study with an eye toward data and interpretation, weighing variations among them in terms of their effects on student outcomes, teacher practices and

beliefs, and school climate. We looked carefully for evidence of the degree to which arts integration was used in each. None of the studies measured the level of integration in the programs directly—its intensity, quality, depth, or breadth—but we found we could estimate their relative levels by inference. We complemented careful reviews of the studies by interviewing program leaders and some of the study authors to confirm our impressions.

Two programs Dan Weissmann introduced in chapter one, CAPE and the Arts for Academic Achievement (AAA) in Minneapolis, clearly made integration the strategic focus of their work. They were both highly integrated programs.

The North Carolina A+ Schools Program (A+ Schools) also made arts integration the core principal of its pedagogical strategy. Education reform was its core goal. A+ Schools was a statewide initiative in 24 mostly low-income schools. A+ Schools did not support teacher–artist partnerships, as did AAA and CAPE, because of limited access to working artists, but instead invested heavily in the professional development of classroom teachers to equip them to deliver integrated instruction on their own.

The goal of the Center for Arts Education (CAE) in New York City was to restore arts education, which had been devastated by cuts in the 1970s, in the city's public schools. It built partnerships between schools and arts organizations, and teachers and artists, much like AAA and CAPE. While overall school improvement was among CAE's objectives, it was subordinate to the reintroduction of arts education, which was understood in itself as a strategy to improve schools. Over time arts integration literally bubbled up as schools, under increasing pressure to improve student achievement, became interested in focusing all available resources, including arts education, on that priority. CAE's use of arts integration was not as concentrated as we found in AAA, CAPE, and A+ Schools, though, and it started to focus its energy on understanding and spreading the practice of integration late in the evaluation period. During the years covered by its evaluation, CAE was clearly less invested in arts integration than AAA, CAPE, or A+ Schools.

The Transforming Education Through the Arts Challenge (TETAC) was a national initiative in 35 schools across the country. TETAC's approach was an elaboration of Discipline-Based Art Education (DBAE), promoted by the J. Paul Getty Trust since the 1980s, and designed to make the visual arts an equal of the academic subjects in its schools. Classroom teachers and art specialists were the principal agents of instruction, and they were trained in DBAE's four "disciplines" (art history, criticism, aesthetics, and production), inquiry-based teaching strategies, and inte-

grated arts instruction. But the instructional strategies of DBAE, which are powerfully focused on the art form itself, dominated the program for the first several years of the five-year effort. As in CAE, integration emerged in TETAC schools over time, but the initiative did not make integration a critical feature of its strategy. Our judgment is that TETAC used arts integration somewhat less than CAE.

Started in 1987, the Arts in the Basic Curriculum (ABC) had the ambitious aim of making high quality arts education available to all South Carolina students, but limited resources restricted it to developing the program in just nine schools. Like TETAC, ABC was grounded in the philosophy of DBAE, but expanded beyond the visual arts to include music, dance, and drama, using arts specialists to deliver instruction. ABC encouraged integration of arts instruction with content from other subjects in its schools, but provided relatively little support for the practice. It appears that integration was a supplement to the focus on discrete instruction in the art forms. Of the six programs, it would appear that arts integration played the least significant role in ABC.

All six of these programs were serious efforts to improve public school education through interventions that used the arts as a lever for change. While AAA, CAPE, and A+ Schools were principally devoted to integration of the arts across the curriculum, arts integration seemed more incidental to TETAC's and ABC's principal focus on rigorous, standards-based instruction in the arts. CAE appears to occupy a place between programs explicitly devoted to integration, and those focused on introducing more and more rigorous arts instruction to schools.

The evaluation reports were all generally positive about the quality of the programs, though financial and human resource limitations may have made ABC the least rigorous of the efforts. Nonetheless, within reasonable limits, the evaluators found evidence that all six were skillfully designed and executed.

VARIABLE OUTCOMES

The evaluations show that test scores in reading and math and other indicators of student achievement rose in CAPE and AAA schools more quickly than in comparable schools in their districts. The evaluations of A+ Schools, CAE, TETAC, and ABC found some achievement benefits to students, but test scores and other indicators of improvement in core academic subjects were not among them. In the end, two of three arts integrated programs were associated with improvements in math and reading as measured by standardized tests, while the programs with lower levels of arts integration were not associated with similar improvements.

The finding that AAA had more effect on disadvantaged learners than other students, and that the effects of the program increased in classrooms that had higher levels of provision are of particular significance. They complement findings (Catterall, Chapleau & Iwanaga, 1999) that low-income students had greater relative gains associated with high arts participation than did higher income students, and they show that those results can be achieved through integrated arts instruction.

It is true, of course, that standardized tests are not designed to capture all of the benefits of learning in the arts. At best, the tests reveal rough approximations of a narrow spectrum of capacities. They almost certainly fail to capture higher order and more nuanced improvements that may be associated with learning in the arts. Teachers who see students daily for classes are likely to capture subtle improvements and developments that the tests cannot. Their observations are supported by findings of school culture and climate improvements in all six programs, the kind of improvements that are associated with achievement gains in school reform studies. (For more detailed information about the findings of all six studies, see the appendix to this chapter.)

Our analysis of the studies of these six programs leads to a simple conclusion: arts integration can be a powerful lever for positive change, particularly in low-income schools and with disadvantaged learners, and it has distinct advantages over more conventional arts education. Of course, we recognize that our analysis is nothing more than that: our understanding of the meaning of studies of six programs. But we are not building our case for arts integration strictly on the basis of these studies. We refer to them to supplement, corroborate, and support the most powerful evidence that we have seen: the work that is done daily in arts integrated classrooms. That evidence clearly leads to the conclusion that arts integration is an enormously powerful strategic resource for improving education, particularly in schools that serve low-performing students. We have not seen equivalent evidence that stand-alone arts education has played such a role in schools.

RECONCILING INTEGRATED AND DISCRETE ARTS EDUCATION

Given the long history of the marginalization of the arts in American education, it is hardly surprising that arts education advocates are skeptical of education policy and its makers. Advocates have defended the place of the arts in the curriculum against assaults and neglect for more than a century. For most arts educators the reason to provide education in the arts is elementary and intrinsic. Within

the world of arts education, this principle is held with religious fervor: the arts are so central to the development and comprehension of human culture that no education is complete without them.

So it is not at all surprising that some in that world find arts integration a betrayal of sorts. They contend that the arts should not have to prove their value for learning in other domains or subjects in order to have a place at the education table. They are valuable in and of themselves. "Were we to test whether math learning transfers to other subject areas, we would most likely find that it does not. But no one would use such a finding as a reason to cut math from the curriculum," argue two prominent arts education researchers (Winner & Cooper, 2000, p. 67). The arts should be taught for the arts' sake, goes the argument, and it is a good one.

Integration's critics also contend that if the arts are not taught with rigorous attention to learning objectives and standards intrinsic and unique to the arts, just as other subjects are, and by specialists in the art forms, they will be taught less well. They believe that when the arts are assigned an instrumental role in learning other material, these intrinsic qualities will be adulterated and diluted, and that the arts will surely be abandoned if educators find more powerful instruments for teaching that material (Winner & Cooper, 2000).

Art and music specialists (and their professional associations) have fought position cuts for decades, and they have come to associate those cuts with the introduction of less expensive arts "enrichment", "outreach", or "access" programs that sometimes bring artists directly into classrooms. Arts integration does have roots in these programs, so it is understandable that it has been viewed as an educational outsourcing strategy and a threat rather than a legitimate approach to teaching art and the rest of the curriculum.

These concerns may confuse curricular orthodoxy with a rigorous curriculum, though. They may confuse legitimate concerns for art and music teachers' job security with learning in the arts.

If the quality of children's artwork is evidence of learning in the arts, then work in School 1 and in similar schools is evidence that students are learning the arts in integrated schools. In fact, it is our observation that the artwork made by students in arts integrated schools is consistently more sophisticated, complex, original, and well-executed than artwork we have observed in many schools with conventional arts instruction. We have been regularly delighted and surprised that children in these schools make work that exhibits an understanding of principles and practice typically produced by students at higher grade levels. We are convinced

their artwork is the result of an approach to arts curriculum that is rigorous, though surely not conventional.

Like learning in other subjects, conventional arts curriculum frequently reduces art to dry facts and elements, or skills necessary to meet state curriculum standards. At its worst, it reduces instruction to "crafts" that are not even shadows of real art. It is little wonder that the artwork produced in this context is uninspired and mundane.

Student work in integrated classrooms reaches a higher level because curriculum and instruction embrace the best principles of teaching and learning. Directly influenced by the challenges and practices of real contemporary art, which is itself, redefining the place and role of art in our society, students in arts integrated classrooms:

1. Are intrinsically motivated to master art skills needed to explore issues that have real social and personal importance, and to express their own ideas about them.

2. Have a sense of ownership, responsibility, and a sense of pride for the work they produce, and have an understanding of the audience for their work beyond the teacher who grades them.

3. Study curriculum that is developed and organized according to the best principles of teaching and learning.

4. Engage practices and issues that are central concerns in contemporary art— blurring the boundaries among disciplines, between "high" and "low" art, and between the arts and other social and intellectual spheres.

5. Are given the time and materials they need, and encouraged to reflect on and assess their work and their peers' as part of the routine of instruction and learning.

6. Participate in classrooms where democracy is valued.

7. Regularly collaborate with teachers, artists, other students, and sometimes community members.

The debate in the world of arts education between integrated and discrete instruction is, in the end, misconstrued. The debate should be about whether arts instruction is consistent with the best principles of teaching and learning. The application of those principles in arts education brings the world into the classroom in meaningful ways, and allows students productive opportunities to engage,

explore, understand, and represent it. When "discrete" instruction in the arts applies these principles, it becomes indistinguishable from "integrated" instruction. When "integrated" arts instruction applies these principles it challenges students and raises the standards of instruction to higher levels. It becomes a vehicle for applying those principles across the curriculum.

Is instruction in schools that practice arts integration consistently rigorous, thorough, and focused? In a word, and to be honest, no. To be fair, the arts integration programs profiled in this book are still young, still inventing new curriculum, and still learning a great deal. In addition to being undercapitalized and competing with other priorities for essential resources, they must negotiate an environment that is inhospitable to the arts, make compromises, and make do. Despite such circumstances, they continue to survive, grow in numbers, and significantly effect students, teachers, and schools. Our enthusiasm for them is tempered by their limits, but strengthened by our belief that they are creating, and will continue to create, extraordinary learning opportunities for low-income children and disadvantaged learners. The critics of arts integration are right about this: no one would demand that math learning benefit literacy to justify the inclusion of math in the curriculum. But there is a deep and widespread presumption that math is an essential component of general education. There is no equivalent belief with regard to the arts. Arts education's advocates cannot argue or will such a belief into broad acceptance. That is why it is so significant that the arts add value to learning in general. That is why it is so important we understand how the arts can be most effective and efficient as levers of learning.

Integrated curriculum promotes transfer among learning domains only if there is real learning happening. Integrated arts curricula may not look like conventional arts curricula, but that is likely to be its strength, not its weakness.

DOING INTEGRATION WELL: WHAT TEACHERS AND ARTISTS DO

The artists and teachers who began working together in Minneapolis, Chicago, Boston, and New York needed to find their way into arts integration. They had no road maps to follow or sample lessons to reproduce. It often took a year of effort to begin to understand what they were trying to do, and longer to get good at it. A study of AAA found that Minneapolis schools developed four models as their program matured (Freeman, Seashore with Werner, 2002). Often their work would begin with a simple artist's residency, a familiar model of curricular enrichment, but not directly related to the curricular goals of the school. With

practice and refinement, it grew to reflect the deeper structures of integration that create the best results for children marginalized by the current system of education.

The elaborated residency was an arts experience that was not directly integrated into the academic curriculum, but nonetheless was intended to cultivate non-arts skills that teachers identified as priorities. Artists led the lessons, as in conventional residencies, but they received active support and participation from the classroom teachers.

Sometimes artists prepared teachers to use an art form in lessons themselves, without the artist. The Minneapolis study referred to this model as capacity building. It gave teachers the tools to work alone, with artists, or with other teachers to "infuse the art skills and concepts with the disciplines of reading, writing, math, science, and social studies" (Freeman, Seashore with Werner, 2002, p. 8).

Sometimes teacher–artist teams integrated concepts from the arts and other subjects so that they reinforced one another within unified lessons. In this co-teaching model, students' focus would move back and forth in an instructional unit from arts to non-arts content, and lessons could be taught either by artist, teacher, or the team.

And sometimes three or more people, including an artist or arts teacher, selected a theme to be addressed through lessons in different subjects. In one school, for instance, a math unit on geometrical shapes, a physical education unit on athletes' stances, an art unit on symmetry, and a media art unit in which students illustrated a story about meatballs rolling off a table complemented a first grade science unit on motion and balance. This was the concepts-across-the-curriculum model.

The co-teaching and concepts-across-the-curriculum models are reflected in language used by A+ Schools when they speak of "two-way integration"—the idea that integration is not designed to privilege either the art form or the other subjects, but to leverage learning in both. But they may be closest to a concept that CAPE has called "parallel processes" (Burnaford, Aprill & Weiss, 2001). The lesson on portraits and literary character development described earlier is a good illustration of parallel processes in action. Portrait drawing called upon the students to carefully observe subjects, combine colors to capture skin tone accurately, notice light falling on a face and how shadows define features, and recognize the symmetry and imperfections of a face. Students did these things as they drew. In subsequent lessons they read vivid character descriptions in literature. They showed their portraits, and talked about how physical characteristics can reveal personalities.

These activities prepared them to write richer elaborated descriptions of characters themselves.

A team of researchers (Baker, Horowitz, Bevan, Rogers, & Ort, 2003) looked carefully at fourteen experienced teacher–artist teams working in classrooms with significant at-risk student populations in New York's CAE initiative. Most of the cases reveal features consistent with descriptions of instruction in Dan Weissmann's and Madeleine Grumet's contributions to this volume. A storyteller and a history teacher, for example, taught a high school American history unit on immigration. Students worked in small groups to produce two narratives—one on the experience of Irish immigrants in the mid-19th century, the other on contemporary family or friends who had immigrated. The unit was designed to promote learning about the elements and dynamics of narrative and stories, to improve students' capacity and comfort in making presentations, develop their abilities to recognize and collect historical data and information, make judgments about what data and information is most important, and demonstrate their understanding of historical issues. It has features that are key to well-crafted integrated instruction:

1. Teacher–artist teams linked an art form and an academic discipline.
2. Student group work in the art form was central to the experience and to continuous assessment.
3. Content included material related in meaningful and direct ways to students' experiences.
4. Units balanced focus on academic content, academic skills, arts skills and arts content.
5. Units included basic skills (like learning historical facts), and higher order skills (like judging which facts were most important).
6. Units usually culminated with an artistic product that demonstrated student learning of content and skills, and contributed to the public culture of the school community.

Calling itself The Music-in-Education National Consortium,[1] a unique association of arts integration practitioners, education researchers, and academics has elaborated a set of ten principles that guide its work. The principles complement the observations we have made about what artists and teachers do when they practice arts integration. The Consortium's principles specify music as the subject of their inquiry and work, but we believe the principles apply equally to the use of

any art form as an element of a strategy for improving education. The principles provide a flexible guide to practice, and suggest the basis for building broader associations among arts integration initiatives (Scripp, 2003):

1. Reforming educational practice: rethinking the role of music as education is essential to reforming educational practice.

2. Site-based change: Music-in-Education will be most effective when conceived in the context of a school's overall effort to improve.

3. Differentiation and synthesis: Music instruction should be both integrated with and differentiated from the rest of the curriculum.

4. School and community: Music-in-Education changes school culture and invokes the school and its community as agents of change.

5. Diverse strategies for teaching and learning: there are diverse methods for implementing music-in-education as an approach to improving instruction in schools.

6. Musicians and society: teaching and mentoring experiences are essential for musicians' growth as artists and citizens.

7. Equity and high expectations: music is compelling and generates unique opportunities for equitable access to learning while invoking and sustaining high expectations for all students.

8. Reflective practice: teachers and musicians build their capacity through documentation, analysis, and sharing of their own work and student learning.

9. Participation in professional community: professional networks are necessary to generate discourse, share practices, develop new inquiry and raise issues for research.

10. Diverse assessment strategies: multiple assessment strategies will be necessary to illuminate the teaching and learning process, refine definitions of quality, and address multiple audiences and purposes.

SPREADING ARTS INTEGRATED REFORM EFFORTS

Many more schools and districts across the country can achieve the successes of CAPE, AAA, and A+ Schools by developing initiatives like them. There are dozens more communities that have the potential to develop serious arts integration programs. Districts from Cleveland to Silicon Valley, and Mississippi to Connecticut already have taken steps in this direction. But it is vital that sufficient resources—intellectual, human, and financial—sustain and develop the work to the

highest possible level. New initiatives will need financial support and will benefit from networking with each other and with more with mature programs.

The Conservatory Lab Charter School in Boston represents an alternate strategic approach to introducing arts integration into school districts. The relative freedom enjoyed by charter schools has made it possible for the Lab Charter to focus on the relationship of music to learning across the curriculum. It is clear from Dan Weissmann's report in chapter one that the Lab Charter is learning quickly and deeply about how parallel processes in music and other subjects can best be engaged. There is a small handful of charter schools across the country that have similar approaches to teaching and learning, including the Children's Choir Charter in Chicago, the Berkshire Art and Technology Charter in North Adams, Massachusetts, and the Creative Arts Charter in San Francisco. None of these, though, is as focused as the Lab Charter on integrating art forms across the curriculum, contributing to broader understanding of how integration works best, and or how to align content and skills in an art form with content and skills in other subjects.

The Lab Charter's relationship with the New England Conservatory provides it with artistic, intellectual, and financial resources that are above and beyond those we have seen in any of the schools in larger partnerships. Clearly, there are good reasons to recommend the charter school model. But its distinctive advantages also define the limits of charter schools when it comes to school reform. Where the partnerships cultivated by AAA and CAPE are within the reach of many schools in many districts, creating an arts integrated charter school requires intellectual and financial resources not widely available and not replicable across many schools. Nonetheless, we believe that the establishment of arts integrated charter schools in other communities that actively contribute to understanding the dynamics of arts integration and learning can significantly complement the larger partnerships. Their value will be amplified if they are networked with each other and to partnerships to share their experiences and learning.

Together, arts integration partnerships and arts integrated charter schools will be a potent instrument for expanding the reach of arts integration, and for increasing our understanding of how to best connect the arts and learning, how the arts can change schools, and how arts integration can move beyond individual schools. Together they will also provide a growing body of evidence of the potential for arts integration as a strategy for improving schools, deepening learning, and closing the achievement gap. If that evidence is well documented and disseminated, we are

confident that the potential of arts integration will become well recognized in education policy circles. There is great potential to develop partnerships and new charters in school districts across the country. The experiences of AAA, CAPE, A+ Schools, the Conservatory Charter Lab School, and others suggest what needs to be in place in order to develop new initiatives that can succeed:

Leadership and intellectual resources: As with all startup enterprises, arts integration requires leadership and vision. Charismatic, creative, committed individuals have been instrumental in the development of the leading partnerships and the Lab Charter. These leaders have the capacity to cross boundaries between the arts and education, and between arts education and school reform. They have inspired others, including funders, to follow them across those boundaries. They have also sought out experts in the domains in which they are weakest. Early on, CAPE worked with the Center for City Schools at National Lewis University, the Algebra Project, the Chicago Metro History Project, and the education schools of the University of Illinois–Chicago, and Northwestern University. AAA had similar relationships with the University of Minnesota and with the Perpich Center for the Arts. These intellectual resources helped energize the effort to bring focus and rigor to integration.

Financial support and credibility: Private philanthropy has played a pivotal role in the development of five of the six initiatives we reviewed. AAA was supported by a major Annenberg Foundation grant that challenged local funders to join the effort. A consortium of local foundations supported CAPE. A+ Schools was initiated and managed by the Kenan Institute for the Arts. A major Annenberg Foundation award and local funders supported CAE. The J. Paul Getty Trust and the Annenberg Foundation supported TETAC. It appears highly unlikely that public arts funding will prove sufficient to drive the development of integrated arts initiatives anywhere. School districts could finance and develop arts integration initiatives on their own, but education policymakers are not likely to embrace the risks involved in what might be considered higher order innovations in the current education environment.

In our view, philanthropic leadership is an absolutely essential ingredient. In addition to providing financial resources, private philanthropy provides a kind of "good housekeeping" seal of approval that leverages good ideas. At its peak, CAPE was able to provide support that totaled up to $30,000 per school, most of that from foundation and corporate grants. This is far less than the cost of a single teacher, but apparently enough to set a process in motion that could influence a whole

school. We believe that the work can be started and sustained for even less per school, but the pace of its development is fueled by the capacity to pay artists, and for teachers' time, materials, and professional development. If the effect of arts integration appreciates with use, as the AAA research shows, then higher levels of provision are likely to result in better results more quickly. Thirty thousand dollars per school may seem like a large figure to arts funders that typically make more modest grants for arts education. We hope that funders with programmatic interest in both the arts and education will consider integrated grantmaking, consistent with the objective of arts integrated education. We also hope that funders will collaborate with each other to build the critical mass needed to launch and sustain complex initiatives, so often beyond the capacity and will of individual funders.

Institutional development: The nature of working in multiple sites, with different populations of students, teachers, and artists demands a high level of independence and initiative at the school level. Centralized organization, though, has enabled AAA, CAPE, A+ Schools, and CAE to raise funds for redistribution that could not be raised by atomized schools or arts education programs; it has provided a venue for connecting practitioners across school sites with a range of intellectual and practical resources—researchers and academics, educational initiatives in other disciplines, professional development, program assessment and evaluation; and it has made possible orchestrated promotion and advocacy of arts integration to the school system and the public. CAPE and CAE have developed as independent not-for-profits with their own governing boards, while AAA found an institutional home within the Minneapolis school system. New initiatives will need to make strategic choices about their organizational character based on local conditions and opportunities. One thing seems critical, though. New initiatives need to craft identities and missions that are unambiguously about learning and arts integration, and they should resist the temptation to promote conventional arts education alone.

Partnerships and Artistic Resources: Most communities, particularly urban communities, have a cadre of artists with substantial experience working in schools. CAPE, AAA, and CAE took full advantage of this resource, and new initiatives would be wise to draw on experienced teaching artists inclined to work across disciplines to lead and staff their efforts. Initiatives can recruit artists individually or partner with arts organizations to provide teaching artists. Involving arts organizations has the advantage of engaging respected institutions that lend credibility to the effort. Those organizations often have educational agendas that are not always well aligned with the needs of school improvement and integration and if they are

inflexible this can become a source of conflict. Artists and teachers during the first years of AAA and CAPE were largely inventing arts integration from scratch. There were few resources to help them imagine integrated curriculum and pedagogy. As a result, these programs spent a good year or more struggling with their identity and direction in every school they entered. Now the learning curve is accelerated as new initiatives can learn from those with strong track records through published materials and networking.

The Artist Imperative: The dynamism of CAPE and AAA results from the introduction of a new element into classrooms—teaching artists—and the creative tension that emerges between teachers and artists. We believe that sustained working partnerships of artists and teachers constitute an enormously important element of good arts integration initiatives. But these relationships are a significant expense, and in some locations, partnerships between teachers and artists may not be a practical option. A+ Schools is one initiative that has shown that integrated arts can be practiced in those cases. We do not know, at this point, whether equally effective arts integration programs can be developed without the direct and active engagement of artists in classrooms. We suspect that they cannot. Artists bring a set of trained instincts and inclinations into schools that come only with years of dedication to an art form. Teachers cannot learn what artists know and do through limited professional development experiences. Nonetheless, we know that there is a great deal still to learn about the costs and benefits of how artists are used in arts integration, and we suggest a flexible approach to this issue.

Arts specialists: No teaching artist can replace the role of art and music specialists in a school. This is likely to be true of dance and theater teachers as well, but they are so rare in public schools—only eight percent of elementary schools have dance specialists and just four percent have drama specialists—and these figures are even lower in low-income districts (National Center for Education Statistics, 1995). As full-time faculty members, these specialists can play teaching, leadership, planning, and coordinating roles that visiting artists simply cannot. They knit together fragmented classroom practices and curriculum into a coherent whole school program. They often organize projects in multiple classrooms that become the leading edge of arts integration in their schools. In a school serving students from the infamous Cabrini-Green public housing project in Chicago, the art teacher, Mathias "Spider" Schergen, has led annual large-scale collaborative projects. These have been focal points for helping students understand profound changes in their community, school, and lives as Cabrini's decrepit high-rises have been

methodically demolished and replaced by new mixed-income housing. One major installation was moved from the school and exhibited at the Chicago Museum of Contemporary Art.

Mission and identity: Student achievement and school improvement were central to the missions and identities of efforts that most successfully integrated the arts across the curriculum. Integrated practice slowly emerged in TETAC and CAE, bubbling up as the programs matured from the schools themselves. But making integration a core value of the identity of the program from the start helps to establish a culture dedicated to the cultivation of arts integrated practice far more quickly. Articulating a mission that embraces the challenge of student achievement, and not restricting goals to a narrow arts education agenda, will best serve new initiatives.

Professional development: Serious arts integration requires serious attention to professional development—for teachers, arts teachers, and artists. Collaboration, curriculum development, and interdisciplinary work are not normative behaviors in most public schools. They need to be learned. What's more, artists and teachers literally speak different languages and inhabit different cultures. Arts integration requires that this cultural gap be bridged in real time with real work. Professional development has the practical purpose of guiding practitioners as they approach fundamental educational issues: how can arts integration improve reading, writing or math skills? It can also provide good models for thinking about curriculum integration built around subject content: how can drama be used to enliven history, or how can dance be integrated with science lessons? It can help teachers and artists understand how integration, at its best, works in two directions: how can students learn to dance better by understanding principles of physics? Good professional development works at two levels. It provides vision and inspiration, and it develops practical skills and ideas for making it work in real classrooms. All the programs have taken advantage of conventional vehicles for professional development—in-service days, summer institutes, and continuing education programs. But the single most important dimension of professional development for teachers in CAPE, AAA, and CAE has been the sustained, day-to-day practice of teachers and artists as they design curriculum and instructional strategies to meet educational goals that are intellectually and artistically challenging. Over the last fifteen years education researchers have learned that the most effective professional development for teachers is experiential; it is grounded in inquiry and experimentation; it is collaborative and connected to teachers' work with students; and it is sustained, inten-

sive, and connected to other aspects of school improvement (Smylie, Allensworth, Greenberg, Harris, & Lupescu, 2001). These qualities are a fair description of much of the professional development we have seen in the best arts integration initiatives.

Theory, research, and assessment: Dan Weissmann's report makes it clear that a strong orientation to assessment and evaluation has been an enormous asset at the Lab Charter and CAPE. Asking teachers and artists serious questions about how learning in the arts is related to learning in other subjects has raised the sights of practitioners, and honored their value as the best sources of information and learning in the projects. CAE has provided some incentives for higher levels of integration in some classrooms, and developed a culture that places great value on assessment at those sites.

In the context of school cultures that frequently dismiss teachers as part of the problem, this approach affirms that teachers are part of the solution. When they are given the authority and responsibility to reflect on their work and make it better, their morale and their practice improves. Arts integration becomes an invitation to personal growth and learning that changes their identity as teachers who are members of a professional learning community that includes artists, and is often extended to researchers and administrators. Of course, the value of research and assessment goes well beyond their practical contributions to professional development. They also contribute to building a theoretical understanding of how arts integration works that can contribute to the growing field of learning and cognitive theory.

School system buy-in: A great deal happens in schools beneath the radar of the bureaucratic hierarchies that govern them, but it is quite difficult for a school to make a significant commitment to changing without the support or acquiescence of its district. Arts integration programs inevitably contend with competing priorities in schools and districts. They must make a case for themselves in an atmosphere so dominated by high stakes testing and "accountability" that the actual business of what students and teachers do in classrooms often seems beside the point. Money tends to attract attention in school districts, though, and arts integration efforts have used their ability to attract private donations to cultivate some support in their school systems. Cash grants have proven to be a terrific incentive for establishing an initial understanding with school leadership and district leadership in Chicago, Minneapolis, and New York. But private philanthropic support has not, and cannot, fund enough activity to reach all the students and schools that could benefit from arts integration. Private philanthropy has been essential to starting

these efforts, but serious public support of arts integration will be essential to develop and sustain them beyond modest demonstrations over several years. In addition, private financing has a downside: it relieves districts of responsibility for funding the work themselves. CAPE has required individual schools to commit funds to arts integration from their discretionary budgets, and the district has made modest investments in its own network of fine arts magnet schools (for which CAPE provides professional development), but the district's commitment remains shallow after more than a decade of successes in CAPE schools. More importantly, private philanthropic support may be as unreliable and unpredictable over time as public support. Foundations often have great difficulty providing "patient" money; they want quick results and a "bang for their buck." Projects should not expect to receive more than nominal support from most districts from the start, but they must develop advocacy strategies to gain district support that can replace private support over time.

TOWARD A TIPPING POINT

In *The Tipping Point: How Little Things Can Make a Big Difference*, Malcolm Gladwell (2000) adapts the insights of epidemiology to understand how and why new ideas, trends, norms, and fashions spread. Gladwell shows that under certain conditions small changes can sometimes "tip" a stable system and lead to a cascade of sustained change. The Chicago and Minneapolis schools Dan Weissmann describes in chapter one started with small changes—the development of a single unit of instruction by a classroom teacher and a teaching artist, for instance. This was followed by changes in teacher attitudes, expectations, and behaviors, improvements in student engagement and performance, and increasing parent support and involvement. These positive developments were recognized and then adopted slowly across entire schools, eventually leading to changes in budget allocations, the norms of school culture, and policies designed to sustain them. Over time, whole schools have come to embrace arts integration as a strategy for improvement.

Not that this sort of school change through arts integration is simple or easy. Successful implementation is profoundly challenging. We have seen schools "tipped back" by forces beyond their walls—district policies, budget cuts, new mandates, accountability provisions, or work rules. We've also seen them tipped back by forces from within—new principals and retirement of key leaders. The challenges faced by American education are enormous, and the conflicting political demands on educators are extreme. To be truly successful, arts integration must move beyond

individual classrooms and schools, and beyond modest networks of schools. Educators and education policymakers must embrace it as an effective and practical strategy for improving schools and student performance at all levels. We must see the establishment of policies, rules, incentives, and norms that support arts integration and encourage teachers to use it. With the possible exception of Minneapolis, we have not seen that happen on a consistent basis in any of the districts or states that have been the homes of successful arts integration programs

THE CHALLENGE OF SCALE

It is reasonable to imagine that over the next five to ten years dozens of arts integration initiatives will emerge and "tip" beliefs and practices in hundreds of classrooms, scores of schools, and in diverse districts across the country. That would be a significant development, likely to mean a great deal to thousands of children in classrooms associated with those initiatives. But "tipping" a few hundred schools is a long way from having a significant impact on an educational system that includes 20,000 school districts. Richard Elmore (1996) has warned that the history of education reform in the US is littered with promising initiatives that have succeeded in a relatively small number of schools, but ultimately failed to have lasting influence on the way education is conceived and organized across those thousands of districts.

Elmore (1996) argues that American education has been deeply resistant to changes at the "core of education," the fundamental beliefs and practices at the heart of teaching and learning. For well over a hundred years, the mainstream of education has viewed knowledge as "discrete bits of information about a particular subject" and student learning as the "acquisition of this information through processes of repetition, memorization, and regular testing of recall" (Elmore, p. 2). The result of this approach is the classroom experience that is, "in its most common form, emotionally flat and intellectually undemanding and unchallenging" (p. 5).

There have always been small numbers of schools and classrooms in which knowledge is understood differently, and teaching and learning are intellectually challenging and emotionally engaged. Elmore (1996) asks why it has been so difficult to expand beyond a small number of schools and into the broad mainstream of educational practice by exploring the fates of the two most significant efforts to make change at the core of education—progressive education and large-scale curriculum reform.

Progressive education, he argues, failed because it took the institutional form

of "single schools, each an isolated island of practice, connected by a loosely defined intellectual agenda" (Elmore, 1996, p. 10 - 11). Progressivism seemed to believe that "good ideas would travel, of their own volition, into US classrooms and schools." When those ideas did travel, though, they often were diluted and robbed of essential qualities. The value progressives placed on individualized education, for example, was broadly adopted only after it had been transformed into a student tracking system that assigned and labeled millions of children as low performers, foreclosing the possibility of individualized learning for the children who needed it the most.

The large-scale curriculum reforms in the 1950s and 1960s challenged many of progressive education's tenets, yet they shared a similar fate. They were based on the idea that learning in school should involve using the tools and methods real scientists, historians, social scientists, and mathematicians use to learn about the world. They encouraged classrooms to be places of experimentation, exploration, and problem solving, not the transmission of facts alone. They encouraged teachers to coach more and lecture less. By focusing on content, curriculum reforms avoided becoming isolated in individual schools. But, Elmore (1996) argues, curriculum reform still substantially failed to change education at its core because, like progressive education, its advocates naively "assumed that a 'good' product would travel into US classrooms on the basis of its merit" alone. Though hundreds of thousands of teachers and curriculum directors received training, tens of thousands of curriculum units were disseminated, and millions of students were exposed to some aspect of these reforms, in the end the "new curricula were shoe-horned into old practices" and "had no impact on teaching and learning at all" (p. 12 - 14).

Arts integration, of course, shares much with progressive education and curriculum reform. It supplements the progressive strategy of developing individual schools with a model that is already linking networks of schools within larger districts and beginning to link those networks to each other as well. It has not produced new curriculum at nearly the large scale produced by curriculum reformers, but it has replaced the domination of university professors in the curriculum reform model with teacher - artist partnerships to develop new curriculum and teaching in schools. In other words, it has linked new curriculum, for which teachers feel a genuine sense of ownership, with changes in teaching practice that make it less likely that that the curriculum will be "shoe-horned" into old practices.

These advantages should not be underestimated. The active leadership of university professionals in the development of new curriculum lent earlier curriculum reform efforts considerable intellectual credibility, but teachers' experiences

often incline them toward skepticism and resentment of top-down initiatives like curriculum reform. Bringing teachers into the process of curriculum development reshapes their identities by giving them an ownership stake in their substantial contributions to the practice and theory of arts integration. Building networks of schools within districts diminishes the isolation of individual schools, creates a critical mass of arts integrated practice, and raises the profile of its achievements.

TIPPING THE SYSTEM?

Our educational system was designed and developed by powerful and pervasive currents reflecting the intellectual, economic, and social trends of a burgeoning industrial economy and a culture at once democratic and deeply stratified. It has been further shaped by more immediate influences—from the "science" of intelligence and testing to the commercial interests of textbook publishers, from the inequities of state school funding formulas to federal accountability and curriculum strategies, from stereotypes about teachers to stereotypes about students. This vast accumulation of historic forces has resulted in the systemic inertia Elmore (1996) sees at the core of education. Elmore's insights about the failures of progressivism and curriculum reform notwithstanding, we suspect that change on a massive scale will not result from marginally better strategic and tactical decisions among school reformers. Instead it will follow fundamental changes in the kinds of intellectual development society requires of its citizens and workers, and fundamental shifts in the ways we understand the role of education in our democracy.

Stable systems reach tipping points under certain conditions, sometimes quite quickly, and sometimes when they appear to be quite resistant to change. The great recent example of such a change was the rapid metamorphosis of communist systems across much of central Europe from 1989 to 1991. When systems reach tipping points, it becomes possible to systematize alternate ideas and bring them to scale. There are signs that our educational system could be approaching a tipping point, though we would be foolish to make a certain prediction of when the system is likely to tip. There is a growing recognition that our post-industrial economy requires a very different set of intellectual capacities than did the industrial economy that shaped the development of our public education system. More than a decade ago, the Labor Department's Secretary's Commission on Achieving Necessary Skills (1991) report argued that our economy would require higher and higher proportions of workers who possessed abundant higher order intellectual and social skills. These new demands are precisely the sort of broader social and

economic forces that will ultimately create an educational inflection point.

Today, more than two decades after *A Nation at Risk*, it appears that the country still is committed deeply to practicing education in the same old ways. "No Child Left Behind" has added a punitive layer to strategies that largely fail to address serious change at the core of education, but the intensification of accountability and fear is also breeding determined resistance. Growing numbers of states and schools systems are expressing profound frustration with the limits of school reform strategies that rely on mandated standards and accountability methods limited to threats. We see evidence of growing receptivity to strategies based on commitment, rather than compliance. And we see growing success and demand for arts integration programs in school districts that literally have defined the crisis in American education.

These are hopeful signs. Elmore's (1996) analysis suggests how arts integration can prepare for this eventuality.

Build a learning community of teachers, artists, researchers, and supporters: The structure of partnerships like CAPE and AAA work against the isolation of individual schools, but many more partnerships must be built in diverse districts. Charter schools focused on individual art forms or multiple art forms should complement the curriculum, and these initiatives should be linked consistently through a national network that serves as a primary intellectual and practical resource for the practitioners. The network should intentionally involve education researchers and policy analysts involved in school reform, evaluation of the work, and theory about cognition, child development, and art. It should make every effort to become involved in the broader education reform discourse and to promote the achievements of arts integration. Networks like this require regular opportunities to meet, both virtually and in real time. They need ongoing discourse of their own, both formal and informal, to advance their practices and knowledge base, and generate new ideas and associations.

Establish a research agenda that serves the community: Arts integration has the potential to contribute a great deal to broader understanding of learning and school reform. The close examination of musical learning that Larry Scripp is doing at the Lab Charter sets an example for one approach to research. It can make parallel processes in the arts and other subjects explicit and help develop a more precise understanding of how the arts promote critical skills, both basic and higher order. Scripp's remarkable and mysterious finding of correlation between reading and musical notation, and math and musical pitch suggests that parallel processes are found in precise relationships among particular skills and concepts in art forms with

particular skills and concepts in other domains *(see chapter one of this volume, p. 41)*. It is likely that artists and teachers with experience in arts integration have a number of hypotheses about those precise relationships, but they have not yet been documented or researched. What we need to learn about the possibilities and potential of arts integration far exceeds what we already know.

We have seen strong evidence of very significant downstream learning and developmental effects associated with arts integration, but that evidence is not nearly rich enough yet. There is a critical need for quality studies that fully capture the downstream effects of arts integration sketched by the studies we have reviewed and a need for a richer understanding of the complex dynamic among the cognitive, social, and emotional dimensions of arts integration.

There is also a need to understand the complicated dynamics of "tipping" educational systems. Research can contribute to this understanding through, for example, case studies that review the ways arts integration moves through and changes schools, and the ways that integration initiatives have engaged district-level policy change. Research can become an impetus in the development of a learning community in arts integration if practitioners themselves become actively engaged in research—through the articulation of research questions, documentation, and reflection on their own practice and their students' learning experiences.

Document new curriculum: The virtues of engaging teachers with artists in curriculum need to be balanced with the virtues of introducing integrated curriculum that does not need to be invented from scratch. As integration initiatives across the country develop new curriculum it should be captured and broadly shared. Thorough documentation of curriculum and student work can easily be shared among arts integration networks via the Internet. Useful curriculum can be developed for different art forms and subjects, at different grade levels, and at different depths of integration. Mature partnerships like CAPE and AAA may someday find that there are significant revenue opportunities in marketing tested curriculum and professional development services to younger initiatives in other districts.

Include arts integration in teacher preparation: Arts integration partnerships are succeeding in changing the practices of in-service teachers, but they are not a strategy for making arts integration broadly available to all students. If arts integration is to become commonly available, classroom and art and music teachers will need to be introduced to its practice and pedagogy in pre-service. One of the objectives of linking arts integration partnerships to schools of education should be

to encourage the schools to introduce the arts and arts integration into their curricula. We have seen examples of courses on integrated methods and curriculum at several schools of education, and we are encouraged that the schools are sometimes teaming practitioners with professors to lead these classes. Ultimately, courses in the arts and in arts integration pedagogy should be required of all certified teachers.

University admissions requirements: Colleges and universities set standards and drive change in high school curricula through their entrance requirements. Minnesota is among the few states in the nation that includes an arts requirement for high school graduation, a policy driven by admissions requirements at the University of Minnesota. Expanding demand for arts education in general will help to set the stage for arts integration as well.

Develop philanthropic leadership: Private funders of various types have played pivotal roles in the development of arts integration. It may have been no accident that they supported a remarkable wave of arts education initiatives, including integrated arts, in the 1990s. The economy was booming, their assets were multiplying, and they could afford to seek innovative approaches to solving complex problems. Arts integration was a beneficiary of the influence of venture capitalism on philanthropy, reflected by an interest in making serious, if speculative, investments in enterprising and innovative new strategies for making change. But with the tightening of the economy in the last several years, funders have found it difficult to sustain old commitments, much less make speculative new investments. Nonetheless, the promise of arts integration is likely to be realized only if private funders make a kind of "buy and hold" commitment to its development. We believe the rationale for making such a commitment is well established.

We know, though, that the remarkable qualities of the arts—their power as tools for exploring, understanding, and representing the world and human experience—give them unique power to contribute to learning, education, and development. The obstacles to broadly using the arts for these purposes appear to us to have far more to do with misconceptions about the arts and learning than with the difficulties of retooling educational programs. The obstacles are primarily ideological, not practical. They are based on false dichotomies between feeling and cognition, learning and expression, higher order thinking skills and the basics, art and academics.

Integrated arts programs in schools in many parts of the country have demonstrated that even under extremely difficult circumstances, in tough schools, in poor communities, and without systematic support, arts integration reconciles

these dichotomies and provides enormous benefits to children. These programs are an authentic strategic option for thousands of schools and communities to address the most vexing educational challenges, and signs of hope for the future of American education.

Arts integration cannot solve all our educational problems. By no means do we think arts integration can be brought "to scale" anytime soon. But when The Look becomes a norm rather than an exception in classrooms, and when conventional measures of student achievement show positive results in the same classrooms, we are in the presence of something rare and valuable. The strategies of arts integration are educationally powerful because they are grounded in deep connections between the arts and cognition, and between learning, social, and emotional development. The biggest obstacles to making arts integration more widespread are beliefs that separate thinking and doing, learning and making, feeling and knowing. The most compelling arguments against these false beliefs are found in arts integrated classrooms.

[1] Founding members of the Music-in-Education National Consortium include the New England Conservatory's Lab Charter School, CAPE, A+ Schools, the Northwestern University Schools of Music and Education, Georgia State University School of Music, Mannes College of Music, the Boston, Atlanta, and Ravinia Festival Orchestras, the Metropolitan Opera Guild, Atlanta Young Audiences, Cambridge, Chicago, Fulton County (GA), Lynn (MA), and New York City Public Schools, and the Kenan Institute for the Arts.

REFERENCES

Adkins, A., & McKinney, M. (2001). Placing A+ in a national context: A comparison to promising practices for comprehensive school reform. In *North Carolina A+ Schools Program: Schools That Work For Everyone.* (Available from North Carolina A+ Schools, Thomas S. Kenan Institute for the Arts, Winston-Salem, NC 27127, http://www.aplus-schools.org)

Anderson, A. R., & Ingram, D. (2002). *Arts for Academic Achievement: Results from the 2000-2001 teacher survey.* Unpublished manuscript, Center for Applied Research and Education Improvement, College of Education and Human Development, University of Minnesota.

Baker, T., Bevan, B., Adams, A.E., Seretis, G., Clemments, P. & Admon, N. (2003). *The Center for Arts Education: The first five years of the New York City Partnership for Arts and Education, 1996—2001.* Unpublished manuscript, Education Development Center/Center for Children and Technology.

Baker, T., Bevan, B., & Admon, N. (2001) Final evaluation report on the *Center for Arts Education's New York City Partnerships for Arts and Education program.* Unpublished manuscripts, Education Development Center/Center for Children and Technology.

Baker, T. L., Horowitz, R., Bevan, B., Rogers, B., & Ort, S. (2003). *Student learning in and through the arts: Research conducted in the Center for Education's Partnerships for Education program.* (Available from Center for Children and Technology/Education Development Center, 96 Morton Street, New York, NY 10017).

Burnaford, G., Aprill, A., & Weiss, C. (Eds.). (2001). *Renaissance in the classroom: Arts integration and meaningful learning.* Mahwah, NJ: Lawrence Erlbaum Associates.

Catterall, J., Chapleau, R., & Iwanaga, J. (1999). Involvement in the arts and human development: General involvement and intensive involvement in music and theater arts. In E. B. Fiske (Ed.), *Champions of change: The impact of the arts on learning.* (Available from the Arts Education Partnership, One Massachusetts Avenue, NW, Washington, DC 2001, http://www.aep-arts.org/PDF%Files/ChapmsReport.pdf)

Catterall, J. S., & Waldorf, L. (1999). Chicago Arts Partnership in Education: Summary Evaluation. In E. B. Fiske (Ed.), *Champions of change: The impact of the arts on learning.* (Available from the Arts Education Partnership, One Massachusetts Avenue, NW, Washington, DC 2001, http://www.aep-arts.org/PDF%Files/ChapmsReport.pdf)

Corbett, D., Wilson, B., Noblit, G., & McKinney, M. (2001). The Arts, identity, and comprehensive education Reform: A final report from evaluation of the A+ Schools Program. *In North Carolina A+ Schools Program: Schools That Work For Everyone.* (Available from North Carolina A+ Schools, Thomas S. Kenan Institute for the Arts, Winston-Salem, NC 27127, http://www.aplus-schools.org)

Deasy, R. (Ed.). (2002). *Critical links: learning in the arts and student academic and social development.* Washington, DC: Arts Education Partnership.

Elmore, R. F. (1996). Getting to scale with good educational practice. *Harvard Educational Review,* 66 (1), 2-5, 10-14.

Frechtling, J., Rieder, S., Michie, J., Snow, K., Fletcher, P., Yan, J., & Miyaoka, A. (2002). *Final evaluation report of the transforming education through the arts challenge.* (Available from WESTAT, 1650 Research Boulevard, Rockville, Maryland 20850)

Freeman, C. J., & Seashore, K. L. (2001). *The problem of reform in urban high schools: A tale of two teams.* Unpublished manuscript, Center for Applied Research and Education Improvement, College of Education and Human Development, University of Minnesota.

Freeman, C.J., Seashore, K. R., with Werner, L. (2002). *Arts for Academic Achievement. Models of implementing Arts for Academic Achievement: Challenging contemporary classroom practice.* Unpublished manuscript, Center for Applied Research and Education Improvement, College of Education and Human Development, University of Minnesota.

Gerstl-Pepin, C. I. (2001). A history of the A+ Schools Program. *In North Carolina A+ Schools Program: Schools that work for everyone.* (Available from North Carolina A+ Schools, Thomas S. Kenan Institute for the Arts, Winston-Salem, NC 27127, http://www.aplus-schools.org)

Gladwell, M. (2000). *The tipping point: How little things can make a big difference.* New York: Little Brown.

Groves, P., Gerstl-Pepin, C. I., Patterson, J., Conrad Cozart, S., & McKinney, M. (2001). Education resilience in the A+ Schools Program: Building capacity through networking and professional development. *In North Carolina A+ Schools Program: Schools that work for everyone.* (Available from North Carolina A+ Schools, Thomas S. Kenan Institute for the Arts, Winston-Salem, NC 27127, http://www.aplus-schools.org)

Groves, P., McKinney, M., Urrieta, L., Gillman, C., Disla, L., Cleveland, D., & Noblit, G. (2001). Wise practices in the North Carolina A+ Schools Program: A practitioners' guide to reforming with the arts. *In North Carolina A+ Schools Program: Schools that work for everyone.* (Available from North Carolina A+ Schools, Thomas S. Kenan Institute for the Arts, Winston-Salem, NC 27127, http://www.aplus-schools.org)

Gunzenhauser, M. G. (2001). Reforming with the arts: Creativity in A+ classrooms and schools. *In North Carolina A+ Schools Program: Schools that work for everyone.* (Available from North Carolina A+ Schools, Thomas S. Kenan Institute for the Arts, Winston-Salem, NC 27127, http://www.aplus-schools.org)

Ingram, D., & Seashore, K. R. (2003). *Arts for Academic Achievement: Summative evaluation report.* Unpublished manuscript, Center for Applied Research and Education Improvement, College of Education and Human Development, University of Minnesota.

McKinney, M., Corbett, D., Wilson, B., & Noblit, G. (2001). The A+ Schools Program: School, community, teacher, and student effects. *In North Carolina A+ Schools Program: Schools that work for everyone.* (Available from North Carolina A+ Schools, Thomas S. Kenan Institute for the Arts, Winston-Salem, NC 27127, http://www.aplus-schools.org)

National Center for Education Statistics. (1995). *Arts education in public elementary schools: Statistical analysis report.* Retrieved April 20, 2004 from http://nces.ed.gov/surveys/frss/publications/95082/3.asp

Nelson, C. A. (Ed.). (2001). The arts and education reform: Lessons from a four-year evaluation of the A+ Schools Program. *In North Carolina A+ Schools*

Program: Schools that work for everyone. (Available from North Carolina A+ Schools, Thomas S. Kenan Institute for the Arts, Winston-Salem, NC 27127, http://www.aplus-schools.org)

Scripp, L. (2003, Summer). From conference to coalition: The makings of a national music-in-education consortium. *Journal of Learning Through Music,* 2, p. 5.

Seaman, M. A. (1999). *The Arts in Basic Curriculum project: Looking at the past and preparing for the future.* Retrieved January 5, 2004, from http://www.winthrop.edu/abc/ABCEvaluation.htm

Seashore, K. R., Anderson, A. R., & Riedel, E. (2003). *Implementing arts for Academic Achievement: The impact of mental models, professional community and interdisciplinary teaming.* Unpublished manuscript, Center for Applied Research and Education Improvement, College of Education and Human Development, University of Minnesota.

Secretary's Commission on Achieving Necessary Skills, US Department of Labor. (1991, June). *What work requires of schools.* Retrieved June 12, 2001, from http://wdr.doleta.gov/SCANS/whatwork/

Smylie, M.A., Allensworth, E., Greenberg, R.C., Harris, R., & Lupescu, S. (2001). *Teacher professional development in Chicago: Supporting effective practice.* Chicago: Consortium on Chicago School Research.

Wahlstrom, K. L. (2000). *Arts for Academic Achievement: Case study sites cross-case analysis.* Unpublished manuscript, Center for Applied Research and Education Improvement, College of Education and Human Development, University of Minnesota.

Wahlstrom, K. L. (2003). *Arts for Academic Achievement: Images of arts infusion in elementary classroom.* Unpublished manuscript, Center for Applied Research and Education Improvement, College of Education and Human Development, University of Minnesota.

Werner, L. R. (2002). *Arts for Academic Achievement. Artist, teacher, and school change through Arts for Academic Achievement: Artists reflect on long-term partnering as a means of achieving change.* Unpublished manuscript, Center for Applied Research and Education Improvement, College of Education and

Human Development, University of Minnesota.

Werner, L. R., & Freeman, C. J. (2001). *Arts for Academic Achievement: Arts integration—a vehicle for changing teacher practice.* Unpublished manuscript, Center for Applied Research and Education Improvement, College of Education and Human Development, University of Minnesota.

Winner, E., & Cooper, M. (2000) Mute those claims: No evidence (yet) for a causal link between arts study and academic achievement. *The Journal of Aesthetic Education*, 34, (3–4), pp.11–75.

Appendix

MAJOR ARTS EDUCATION PROGRAM EVALUATION SUMMARIES

PROGRAM	LEVEL OF ARTS INTEGRATION	STUDENT ACHIEVEMENT	ARTS LEARNING	TEACHER AND SCHOOL CLIMATE
Art for Academic Achievement	Relatively higher	A significant relationship between arts integrated instruction and improved student learning in reading and mathematics reported. Positive effects on all types of students, but often more powerful for disadvantaged learners. The more arts integration students experienced, the larger were their year-to-year gains on tests. 3rd graders who got "a lot" of integrated instruction gained 4.08 points more on the standard reading test than students that did not receive integrated instruction. Low-income girls gained the most with 7 points. Low-income fifth grade boys in highly integrated math classes gained 5.32 points (equivalent to more than a half-year of gain) more than boys in classes that did not get integrated instruction.	Evaluators did not assess arts learning.	Improved communications between students, emergence of unlikely student leaders, better integration of special needs students with the mainstream, improved student teamwork were widely found. Substantial changes in teachers' instructional practices and their roles in improving schools. Instruction became more child-focused. Greater use of revision and improvement of student work. Critique of student work became part of school culture. Risk taking was better supported. Teachers' understanding of students' capacities for learning and leadership also improved. Teaching artists became genuine members of the school community.

Chicago Arts Partnership in Education	Relatively higher	Test scores during evaluation period rose more rapidly in CAPE schools than for the system as a whole or for comparable schools. In 6th grade math, for example, 20% more CAPE students were at or above grade level in 1999 than in 1992, while only 12% students reached this threshold across the district. CAPE improvements were not exceeded in any of 52 evaluative comparisons. Teachers reported student growth in responsibility, self-management, teamwork, reading, writing, math, speaking, creative thinking, decision-making, and seeing things in the mind's eye. Classroom observations by evaluators generally confirmed these reports.	Evaluators did not assess arts learning.	Significant improvement in teacher collaboration, use of community resources, and parent involvement. New leadership emerged among teachers and students. Schools often revised schedules to accommodate more focus on arts integrated instruction. Principals and teachers reported improvements in student motivation, behavior, teacher-student relationships, student-student relationships, and classroom discipline.
North Carolina A+Schools Program	Relatively higher	Teacher surveys indicated all groups of students benefited equally, but evidence that students not well served by more conventional instruction were reached through integration. A+ Schools students "held their own" relative to statewide gains in standardized tests. There was no evidence	Evaluators did not assess arts learning.	New collaborative and communications capacities developed in A+ Schools, and the schools developed a sense of focused identity and purpose through arts integration. Schools built partnerships with local cultural organizations, higher education, and community groups. Parents became more involved in the life of the

PROGRAM	LEVEL OF ARTS INTEGRATION	STUDENT ACHIEVEMENT	ARTS LEARNING	TEACHER AND SCHOOL CLIMATE
		they did better, but the tests were probably not good indicators of the creative learning in A+ Schools.		school. Teacher practice became more student-centered. Teachers took new leadership roles in schools. Schools adopted richer and more substantive assessment models.
Center for Arts Education	Moderate	Anecdotal evidence of gains in individual schools and classrooms, but no evidence of greater gains on standardized tests than in comparison schools. Third graders in more intensive CAE schools had small gains in reading tests, while third graders in comparison schools lost ground on the tests, but this was not a consistent pattern. Teachers and administrators observed that attendance was higher, students were engaged in school and felt more successful, and that children with learning or behavioral difficulties were "often" transformed by their participation.	Teacher reports of student gains in art skills increased in frequency between 1998 and 2001.	Significant and growing numbers of schools reported improvements in school climate over time. Some schools reported development of a distributed leadership model, and some teachers developed improved classroom management techniques.

Transforming Education Thought the Arts	Moderate	Insufficient evidence to claim positive benefits or transfer from TETAC to other subjects. But data did not suggest negative affects on student performance as result of intensified art instruction. Teacher surveys indicated belief that TETAC had broad impact on student thinking, positive affects on student writing, and on the capacity to make connections across subject areas.	More intensive program implementation resulted in higher scores on the arts assessment.	Teacher surveys report higher levels of collaboration, better student behavior, and more parental involvement. Administrators report higher staff morale. Some expressed concern that the arts focus might lower focus on tested subjects. Examination of data on student attendance and suspension rates, and on teacher retention rates showed no indication that TETAC's effects were significant enough to affect those variables.
Arts in the Basic Curriculum	Relatively low	Evaluation did not find clear indication of consistent test score improvement at ABC schools, nor did they find that ABC schools did "better" than comparable schools over time. On the other hand, they found no evidence that ABC schools achievement levels were hurt in any way by the arts focus.	The report notes arts learning was measurably strengthened, but does not specify what measures were considered.	Teachers report higher level of collaboration, better student behavior, and more parental involvement. Administrators report higher staff moral, as well as some concern that the arts focus had detrimental effects on test results in core academic subjects.

CONTRIBUTORS

MADELEINE GRUMET, a distinguished curriculum scholar, is the former dean of the School of Education at the University of North Carolina at Chapel Hill and of the School of Education at Brooklyn College at the City University of New York. She has held faculty appointments at Hobart and William Smith Colleges, the University of Rochester, and the State University of New York at Geneseo. Currently holding a joint appointment in the School of Education and the College of Arts and Sciences department of Communication Studies, she is teaching courses in curriculum theory, teaching, and performance studies. She is the author of *Bitter Milk: Women and Teaching* (1988) a feminist study of curriculum and teaching, *Toward a Poor Curriculum* (with William Pinar, 1976) and many scholarly articles. Madeleine began her career teaching high school English in New York, Philadelphia, and Rochester.

SHIRLEY BRICE HEATH is the Margery Bailey Professor of English and Dramatic Literature and professor of linguistics, emeritus, at Stanford University. A linguistic anthropologist, Shirley is also a recipient of a MacArthur Fellowship (1984) and the author of numerous books including the prize-winning volume *Ways with Words: Language, life, and work in communities and classrooms* (1983) and more than 100 other publications including book chapters, articles, and papers. Her primary interests are the social development of oral and written language, youth development, and organizational learning. Heath is widely known for her research on how young people in under-resourced communities here and abroad learn entrepreneurial and community-building skills that contribute local, cultural, and economic resources.

NICK RABKIN is the executive director of the Chicago Center for Arts Policy at Columbia College, a "think tank" dedicated to the potential of the arts to contribute to the health and vitality of American communities and democracy. Before joining the Center, Rabkin was the senior program officer for the John D. and Catherine T. MacArthur Foundation for cultural grant making. Rabkin was a

founding board member of the Chicago Arts Partnerships in Education (CAPE), and was instrumental in the development of *Champions of Change* (1999), a research report on the impact of the arts on learning. He was the deputy commissioner of cultural affairs for the City of Chicago in the administrations of Mayors Harold Washington and Richard M. Daley.

ROBIN REDMOND is the associate director of the Chicago Center for Arts Policy at Columbia College. Prior to joining the Center, she was the program officer for arts and culture at the William Penn Foundation in Philadelphia, Pennsylvania, where she managed cultural grantmaking and special cultural initiatives. Her career includes experience in arts education and community arts, and she holds a masters degree in public policy from Carnegie Mellon University in Pittsburgh, Pennsylvania. While living in Philadelphia, she worked for Settlement Music School and the Fairmont Park Art Association, where she coordinated the *New Land Marks* initiative. She began her career as an artist-in-residence, teaching photography to inner city youth at the Manchester Craftsmen's Guild, a pioneering youth arts, education, and community organization in Pittsburgh.

SIR KEN ROBINSON, PHD, is an internationally recognized leader in the development of creativity, innovation and human resources. Sir Ken has advised public and commercial organizations in Europe, Asia and the USA. They include the European Commission, UNESCO, and the Council of Europe, Paul McCartney's Liverpool Institute for Performing Arts, New York International Arts Festival, Royal Shakespeare Company, the Royal Ballet and the J Paul Getty Trust in Los Angeles. He has been strategic adviser on creativity and innovation to the governments of Singapore, Hong Kong, and the United Kingdom, where he chaired the National Advisory Committee or Creative and Cultural Education and wrote its report, *All Our Futures: Creativity Culture and Education*. He is the central figure in a strategy for creative and economic development in Northern Ireland, where his blueprint for change, *Unlocking Creativity*, has been adopted by Ministers from all parties. His latest book, *Out of Our Minds: Learning to be Creative* was published by Wiley-Capstone in 2000. In June 2003, he was knighted by Queen Elizabeth II for his outstanding achievements as a leader, writer and speaker in creativity, the arts and education.

MICHAEL WAKEFORD, a cultural historian, is working on his dissertation, "Everyone an Artist: American Art Education, the Creative Self, and the

Transatlantic Politics of Culture, 1925-1960," at the University of Chicago. He has authored papers and presented research for the Center for Arts and Culture, the Illinois Arts Alliance, and the Cultural Policy Center at the University of Chicago.

DAN WEISSMANN is an education journalist who wrote about school reform for eleven years for *Catalyst*, an award-winning independent news magazine that has covered Chicago's school reform efforts since 1990. Weissmann contributed well over 100 articles to *Catalyst*, winning a Peter Lisagor Award in 2000 for a report on student retention, a Casey Medal for Meritorious Journalism in 2001, and awards from the Educational Press Association of America and the National Association of Secondary School Principals.